To Link

with my

Celicia Aqueel

A White Lie

Oct. 2021

WOMEN'S VOICES FROM GAZA

A White Lie

MADEEHA HAFEZ ALBATTA

Barbara Bill
& Ghada Ageel
Editors

UNIVERSITY
of **ALBERTA**
PRESS

Published by

University of Alberta Press
1-16 Rutherford Library South
11204 89 Avenue NW
Edmonton, Alberta, Canada T6G 2J4
uap.ualberta.ca

LIBRARY AND ARCHIVES CANADA
CATALOGUING IN PUBLICATION

Title: A white lie / Madeeha Hafez
 Albatta ; Barbara Bill and Ghada
 Ageel, editors.
Names: Albatta, Madeeha Hafez, 1924-
 2011, author. | Bill, Barbara, 1956-
 editor. | Ageel, Ghada, 1970- editor.
Description: Series statement: Women's
 voices from Gaza series | Includes
 bibliographical references.
Identifiers: Canadiana (print) 20200305158 |
 Canadiana (ebook) 202003o528x |
 ISBN 9781772124927 (softcover) |
 ISBN 9781772125160 (EPUB) |
 ISBN 9781772125177 (Kindle) |
 ISBN 9781772125184 (PDF)
Subjects: LCSH: Albatta, Madeeha Hafez,
 1924-2011. | LCSH: Women,
 Palestinian Arab—Gaza Strip—Gaza—
 Biography. | LCSH: Palestinian
 Arabs—Gaza Strip—Gaza—Biography. |
 LCSH: Refugees, Palestinian Arab—
 Gaza Strip—Gaza—Biography. | LCSH:
 Women refugees—Gaza Strip—Gaza—
 Biography. | LCSH: Gaza Strip—Social
 conditions—20th century. | LCGFT:
 Autobiographies.
Classification: LCC DS126.6.A43 A3 2020 |
 DDC 956.94/5694305092—dc23

First edition, first printing, 2020.
First printed and bound in Canada by
Houghton Boston Printers, Saskatoon,
Saskatchewan.
Copyediting and proofreading by
Angela Pietrobon.
Maps by Wendy Johnson.

University of Alberta Press is committed
to protecting our natural environment.
As part of our efforts, this book is printed
on Enviro Paper: it contains 100% post-
consumer recycled fibres and is acid- and
chlorine-free.

University of Alberta Press gratefully
acknowledges the support received for its
publishing program from the Government
of Canada, the Canada Council for the
Arts, and the Government of Alberta
through the Alberta Media Fund.

Canada Canada Council Conseil des Arts
for the Arts du Canada

Alberta
Government

To those who struggle for justice

Contents

Preface

Introducing Women's Voices from Gaza

THIS BOOK IS THE FIRST VOLUME of a series on Women's Voices from Gaza. This series of seven stories recounts life in Palestine, prior to and after its destruction, narrated by women who lived through those experiences. The collected corpus of their accounts offers a detailed and vivid picture of places and people, of both the past and present, of a people. It traces Gaza's history, a rich tapestry woven of many strands.

The oral history accounts recorded in this series complement a body of work asserting the centrality of the narrative of Palestinians in reclaiming and contextualizing Palestinian history. The research, through which these testimonies were located, solicited, documented, and gathered into a whole, aims to re-orient the story of Palestine by restoring it to its original narrator: the Palestinian people. In addition, the focus of this series is on Palestinians who lived in the Gaza Strip, whether prior to, or as a result of, the *Nakba*, the 1948 catastrophe that led to the collective dispossession of the Palestinian people.

While other works, such as that of anthropologist and historian Rosemary Sayigh, have aimed at "narrating displacement"[1] as a defining experience of Palestinian

people in modern times, this series describes life both before and after the *Nakba* as it was lived by the narrators: in different parts of Palestine, in Yaffa, Beit Affa, Beit Daras, Beit Hanoun, Khan Younis, Bureij, and Gaza, and in exile. More specifically, it provides a full account of life in different parts of historic Palestine, starting from pre-*Nakba* times, through the destruction of Palestine's villages and towns and the dispossession of their inhabitants in 1948, to the Israeli invasion and occupation during the Swiss crisis in 1956, the war followed by military occupation in 1967, displacement and exile, and two *intifadas*, to a failed peace process leading to the current impasse. While the series brings to the forefront experiences of normal life before displacement, dispossession, exile, wars, and occupation, the accounts also brilliantly illuminate much of the small, everyday detail of lives in villages and towns. They recount rituals associated with agrarian cycles, wedding rites, rites accompanying birth and death, as well as aspirations, fears, and hopes. Readers are invited to reimagine Palestine and the lives of those sidelined by traditional history.

Unlike some approaches, where essentialized framing of oral histories collected from displaced and refugee women has allowed researchers to "reinterpret" the outcomes of their research, our narrators own and have determined their narratives. Consequently, these are presented in all their complexity, fertility, and normality. Through their deep collective memories, each individual woman transmitted her own narrative/history, embodying a chapter of Palestine's neglected history. Following Edward Said's observation that, "facts get their importance from what is made of them in interpretation...for interpretations depend very much on who the interpreter is, who he or she is addressing, what

his or her purpose is, at what historical moment the interpretation takes place,"[2] our effort has been to seek out and foreground the narratives of Palestinian women with minimal interference. This has allowed the women unhindered ownership of their own story, with only minimal intervention or interpretation on our part. Our sole interference in each woman's text was editing and positioning it so as to give it greater fluidity and allow it to read as a cohesive piece.

In contrast to works that have focused on women living in urban areas or on experiences of displacement, this series engages with women from the both urban and rural parts of the Gaza Strip, and with Indigenous women as well as refugees and returnees (women who had been exiled and were able to return to Gaza following the Oslo Accords). Although Gaza is small, it is densely populated, and small geographic variances may have significant impacts on how life is experienced. Life in rural parts of the Strip can be very different from urban life, and Indigenous vs. refugee backgrounds make for distinctly different life stories. Such considerations help move us toward a more fully comprehensive and representative account of life in this part of historic Palestine, both prior to and after 1948.

Unsurprisingly, many of the details of the stories recorded in this series overlap, although the women telling them are unlikely to have met each other. This universality of experience provides a multi-layered map in which human history becomes political history, allowing readers an opportunity to see into the heart of life as it was lived in these spaces from day to day. Individually and as a cumulative corpus, the stories offer a new contribution to the fields of both Palestinian oral history and women's studies.

The life stories collected and presented are those of women from distinct, differing backgrounds: a refugee from Beit Daras village living in the southern part of the Gaza Strip (Khadija Salama Ammar, Khan Younis Refugee Camp); a refugee from Beit Affa village living in the central Gaza Strip (Um Jaber Wishah, Bureij Refugee Camp); a refugee from Yaffa City living in the north of the Strip (Um Said Al-Bitar, Hay Al-Naser in Gaza city); a villager living in the north of the Gaza Strip (Um Baseem Al Kafarneh, the border town of Beit Hanoun); an Indigenous Christian resident of Gaza city (Hekmat Al Taweel); a returnee to the Gaza Strip, originally a resident of Gaza city who was displaced and became a refugee after the 1967 war (Sahbaa Al Barbari); and an Indigenous resident of the Gaza Strip living in Khan Younis city who subsequently moved to Gaza city (Madeeha Hafez Albatta).

The seven participants were interviewed over two years in the midst of an acutely difficult period: the late 2000s during the second intifada, while freedom of movement within the Gaza Strip was severely restricted. The women interviewed were carefully selected to represent a variety of backgrounds, whether religious or socio-economic, with different personal statuses and very distinct trajectories. Several parameters such as refugee vs. Indigenous background or rural vs. urban experiences determined the editors' selection of interviewees, in an attempt to record Gazan women's knowledge from a broad spectrum of individual standpoints.

We interviewed each woman in her home or on her farm. In most cases, we met with and interviewed them on their own. In some cases, other family members were present. Interviews in the presence of younger people and

particularly in the presence of daughters-in-law tended to arouse a great deal of excitement and astonishment, often expressed in a mixture of laughter and tears. These occasions were clearly learning experiences, enabling others as well as the interviewers to join these brave women in exploring and narrating hidden chapters of their lives. Each of our interviewees courageously revealed moments of pain, joy, distress, peace, and uncertainty, along with the abiding hope that they had sustained over decades.

Our interviews with each of the women were audio-taped, producing hundreds of tapes that were then carefully transcribed and translated. One of us is a native speaker of Arabic, which facilitated the translations, and the other is a native speaker of English, which much improved the abbreviated English narratives. In a thorough, nuanced process, we returned to each interviewee with multiple questions and requests for clarification, with the result that the research and editing required a full three years. We checked factual details against known events to ensure the accuracy of each story, which we compiled in a way that would ensure the narrative's continuity, cohesion, and harmony.

The narratives, translated as they were told, remain faithful, honest accounts of these women's lives.

Foreword

I ENTERED THE MAIN GATE of the big house and
observed lemon trees in the inner courtyard.

To my right, there was the guest reception room. On top
of it was the study of the grand man, master of the house,
Sheikh Hafez al Batta, the town's distinguished Islamic
scholar, father of Madeeha. He was reading his books on the
balcony, as usual. And as usual, reviewing what was going
on in his household and beyond. As a 12-year-old boy, I was
allowed to cross the next door to the much wider courtyard,
where the women and children lived, slept, cooked, sewed,
gossiped, and frolicked in peace. My admittance was on
account of my friendship with Nadid, Madeeha's brother,
who was my age. We did not stay there long, but went out to
play and do things. Nevertheless, my easy access was crucial
in my knowing more about Madeeha and being able to have
a part to play in her life with her future husband, my brother
Ibrahim.

The rest is in the book.

Madeeha ("the praised one") is a special example of
Palestinian women in the south of Palestine. She lived most
of her life in Khan Younis, the most southern town (or large
village) in Palestine, and was well-educated by the standards

of the time, where the majority of rural women had little education. Women were busy with the business of life, making a living in the fields and raising families. Her education allowed her to be a teacher and a headmistress at a young age. She wrote literary articles that were published in the prestigious literary magazines in Cairo, like *Al Risalah* and *Al Thaqafa*, equivalent to today's *Times Literary Supplement*.

This is not surprising. Her mother came from the respected family Al Idrisi and her father was a learned Islamic scholar. But her own character allowed her to assume extra duties, raising her brother and two sisters after her mother passed away and also her new brothers and sisters in the company of her kind stepmother.

Married to my brother Ibrahim in November 1949, they had a blissful marriage till the last day of their lives.

During the historic crime of the *Nakba*, which took place in 1948, the tiny stretch of land from Gaza City to Rafah, through Deir al Balah and Khan Younis, the home of 80,000 people, was flooded with 200,000 people, the inhabitants of 247 villages depopulated due to the Zionist invasion of southern Palestine.

Madeeha's husband Ibrahim became a refugee as his neighbouring ancestral land, Al Ma'in (Abu Sitta), was attacked on May 14, 1948. Al Ma'in is 8 kilometres away from Khan Younis, separated by a fictitious line, the Armistice line of 1949.

The separation between the two is not geographical or national. It is the difference between a homeland attacked and occupied by armed European settlers, and a homeland under imminent threat, not yet occupied, but under siege and bombardment.

As if that were not enough, disaster struck on November 3, 1956.

The Al Batta household was shaken by loud bangs on their door. The old man opened the door to find Israeli soldiers pointing their guns at frightened women and children, shouting: "out, all men." The old man said there were only women and children. "Get them out. Out. Out." They came from under the staircase.

Then they saw Nadid. "Come here." His mother screamed, "He is a school boy. Here is his school card." They dragged him on the floor. He cried from the bottom of his heart, "Yamma, I am thirsty." His mother pleaded with the soldier pointing his gun at him to allow him a drink of water. He agreed. She rushed to get a glass of water and approached her son's lips when the soldier kicked the glass by his boots and emptied his machine gun in his head. Nadid's blood and the water were spilled on the floor. With an expression of victory, the soldier left.

With God's mercy, Madeeha was not there. She was with Ibrahim in Cairo. But the pain was multiplied by the distance. And the tragedy was not over. Later the same morning, her brother Hassan, newly married with two children, was dragged from his home and shot summarily along with hundreds of other young men in the town. Over five hundred bodies were strewn in the streets. Nobody was allowed to reach them for a day or two. Khan Younis, now empty of men, became the funeral town.

Women had to cope. The task of coping was destined to be the fate of Palestinian women all their lives. The burden has been loaded on their shoulders for over a century, since the treacherous Balfour Declaration of 1917. Britain was entrusted to bring freedom and independence to Palestine. Instead, it betrayed that trust by handing Palestine to wealthy European Zionists keen to create a colony for themselves. Curiously

the anti-Semite Balfour refused to let Russian Jews into England and preferred to create a satellite colony for them in Palestine.

Fifteen years later, the flood of Jewish European settlers in Palestine reached the alarming level of 30 percent of the population. The Arab Revolt (1936–1939) erupted.

Once again, Britain betrayed its duties to protect Palestinian people. The British Army quelled the revolt most brutally. For the first time ever, the villages were bombarded by air. Collective punishment was applied. Villagers were held in cages for two days in the sun without food or drink. Leaders were imprisoned or deported.

A minimum estimate of Palestinian casualties from 1936 to 1939 is 5,000 people killed, 15,000 wounded, and a similar number jailed. More than 100 men were executed, including leaders such as 80-year-old Sheikh Farhan Al-Saadi, who was hanged while fasting during Ramadan on November 22, 1937. About 50 percent of all adult males in the mountainous region of Palestine, corresponding roughly to the West Bank today, where the revolt was particularly active, were wounded or jailed by the British.

While men were rounded up, women cared for their families, salvaged the home supplies destroyed deliberately by the British, and attended to the fields and cattle. They did more than that. They fought battles. Fatma Ghazzal was killed in Azzoun in 1936 in an ambush by an Essex Regiment and was found dead among her men comrades.

Peasant women's mass involvement was physical and direct...Village women...were arrested for being members of the Black Hand band, for writing threatening letters to the police, for hiding wounded rebel fighters, and they

kept secrets...urban women collected money, took part
in demonstrations, sent protests to the government, and
formed women's committees...Schoolgirls held strikes.[1]

And, "police shot a girl during a stoning of forces in
1938."[2] In the battle, "widows of dead fighters also took up
arms...encouraged their 'menfolk' to assist the fighters...[and]
'stirred up' the local population"[3] During Faz'a, they "were
seen running behind their husbands ululating," urging them
into action.[4]

When the *Nakba* struck in 1948, Palestinian women were
the first victims and the first to cope with its effects. The
Nakba is the largest, longest, continuous ethnic cleansing
operation in the history of Palestine. Five hundred and sixty
towns and villages have been depopulated by the Zionist
European invasion of Palestine. Nowhere was this tragic
scene observed more than in the Gaza Strip, when the popu-
lation of 247 villages in the southern half of Palestine was
herded onto the Gaza Strip, which is only 1.3 percent of the
area of Palestine.

The mass exodus did not take place smoothly. It was
dotted with massacres. Villages were attacked at dawn when
people were asleep. At the explosion of bombs, the wave of
machine gun bullets, the women rushed to pick up their
children for safety in the dark, frequently carrying a pillow
instead of a child, shouting for youngsters to follow, carrying
some milk or a little food, and hurrying toward the only gate
the Israelis had left open for them to escape, having blocked
the other sides.

At a distance from their village, they paused to see who
had followed and who was lost, looking back at the village,
seeing the smoldering remains of their houses, fire billowing

from the burnt harvest, their animals wondering aimlessly, and dogs barking in agony looking for their owners.

Above all, women were looking for their menfolk—who had remained to defend as heroically as they could—to see who had been killed, who managed to be safe. Their hearts went out to older men and women and the sick, who could not get away in time and remained. Did they have food and drink? Have they been found by the Israelis and killed?

At that moment of destiny, women had to decide their next course of action: where to go. The most likely route was to go to the nearest village, not attacked yet, where they had friends and relatives. There, they were received warmly. But not for long. Both the hosts and their guests were attacked and expelled. They both sought refuge in a third village.

So, the exodus route grew in length and size, winding its way among pits of danger till the sea of humanity found its temporary repose among trees, or in mosques or schools, in a temporary safe enclave, now dubbed with the new name "Gaza Strip." It became the biggest concentration camp on earth.

The women's odyssey did not finish. They had to return after a lull. They had to brave planted mines and soldiers with machine guns waiting for the returnees (ironically called "infiltrators" by Polish ghetto dwellers, now soldiers, who had come to Palestine's shores in a smugglers' ship in the dead of night). Return they must, to fetch an ailing mother, recover some supplies, or even to give a drink to animals. Many did not return. They were some of the five thousand Palestinians killed by Israelis upon their return from 1949 to 1956.

Some died fighting. Here is the case of a young woman, Halima, of Beit Daras. She joined the defenders of the village,

bringing them food, drink, and ammunition, crossing to the fighting lines. She never came back. Her name remains.

Struggling for life in the refugee camps is another burden taken up by women heroically. At first, they had to keep the tents dry of rain or not blown by wind. They had to find wood for meagre cooking. Soon after, they prepared their children for school under makeshift tents. Then they had to cope with the constant Israeli attack on the refugees in their camps, like when the war criminal Sharon, commander of the notorious Unit 101, attacked al Bureij camp in 1953 and killed forty refugees in their beds.

Seventy years on, women's fight for freedom has never stopped. They are now looking after their families when their fathers, husbands, and even brothers and sisters are killed or taken prisoner by Israel.

Israel has waged several wars upon the Palestinians, a situation never found at any colonial project.

Israel waged a military war to seize Palestinian land. Israel waged a terror campaign, in an endless series of war crimes, to expel and then deny the return of the refugees. Israel waged a falsification war to claim that the refugees left on their accord, not by its actions. Israel waged a false historical and religious war, to claim that Russians, Polish Jews, Ashkenazis, Khazars, and other assortments are descendants from Palestine and that this entitles them after 2,000 years to take it away from its people. Israel waged a defamation, even criminalizing, campaign against anyone advocating justice for Palestinians, like Boycott, Divestment and Sanctions (BDS) or Students for Justice in Palestine (SJP) or Palestine Solidarity Campaign (PSC), making themselves an enemy of international law. Primarily, Israel waged a political war

against Palestinians through the alliance of the US and Israel to veto any UN resolution opposing Israeli crimes.

Women bear the brunt of all these wars. They fight back at all fronts at all times. Just look at what they do in the relative peace of their evenings.

They register their heritage at the tapestry of embroidery. Every Palestinian village had a distinctive motif representing a history and tradition of its own. This artistic museum of Palestinian society can never be stolen or destroyed. It is carried in the hearts and on the bodies of women. Not only does it signify the geography of the village, but its history as well. Motifs depict the 1936 Revolt, the *Nakba*, the village that has gone, the *Intifada*, and the spirit of resistance.

Palestinian women are an invincible, yet unarmed, army. It can never be defeated. It raised a nation of 1.5 million people in 1948. Their army has now grown to 13 million people. Behind each one, a woman made it possible.

Congratulations to Ghada Ageel and Barbara Bill for their tremendously important series of books on Palestinian women, the invincible army. Recording their history is a moral obligation, an intellectual mission, and above all, a service to the cause of justice.

DR. SALMAN ABU SITTA, 2020
Founder and President
Palestine Land Society, UK

Acknowledgements

THIS BOOK and series would not have been possible without the support and love of several people who were extremely generous with their time, comments, directions and encouragement. For all of them, we are sincerely grateful and are eternally indebted.

We will begin by expressing our appreciation to the amazing seven narrators of this series, Madeeha, Sahbaa, Hekmat, Khadija, Um Bassim, Um Jaber, and Um Said, and their families, for so generously sharing their stories and making us welcome in their homes.

We are grateful to our friend Shadia Al Sarraj for her friendship, remarkable support and encouragement.

We would like also to thank Peter Midgley and Mathew Buntin, the amazing editors at University of Alberta Press, who helped us throughout the process of writing by answering queries and providing support. A special thank you to Cathie Crooks for all her incredible support and to all the talented team at University of Alberta Press.

Sincere thanks to John Pilger, Wayne Sampey and the late Inga Clendinnen for their assistance, support and encouragement.

Several people have generously expended time and effort to read sections of our work and offered valuable advice. Professor Rosemary Sayigh deserves special thanks for her generosity in providing us with useful comments. Sincere thanks go to Rela Mazali for her comments on the work and editing skills. We are also grateful to Terry Rempel and Eóin Murray for reading and commenting on parts of the Introduction. Special thanks and unending gratitude to Andrew Karney for all his support, encouragement and friendship. We also would like to thank Wejdan Hamdan for helping in transcribing the stories. She has dedicated many hours in support of this project that she calls a labour of love and resistance.

Finally, thanks to our late parents, who never gave up hope that these narratives would be published.

Introduction

IN PERFORMING their assigned gender roles as life-givers, keepers of family tradition, and culture bearers, Palestinian women have created, practiced, and continue today to practice forms of resistance to generations of oppression that are largely underreported and unacknowledged. This is the case in virtually every part of historic Palestine, but it is particularly true of the Gaza Strip. The Gaza Strip, often referred to simply as "Gaza," is a small, hot button territory on the eastern shore of the Mediterranean Sea, 40 kilometres long, with a width that varies from 6 kilometres in the north to some 12 kilometres in the south. Despite its significance as the heartland of the Palestinian struggle for freedom and rights, the history of the place and its people is often deformed by simplified discourses or reduced to a humanitarian problem and a contemporary war story. The recurring pain and loss its people face are offset by life and vibrancy, by playful and earnest children, by ambitions and dreams.

Around 1.4 million refugees[1] live inside the Gaza Strip (forming some 18 percent of a worldwide total of 7.9 million Palestinian refugees[2]). For Palestinians and Palestinian refugees in general, but especially for those living in Gaza,

the central event in the narrative of their lives is the *Nakba* (the 1948 catastrophe), which led to the dispossession of the Palestinian people, displacing them, appropriating their homes, and assigning them the status of "refugee." In the history of Palestine and Gaza, the catastrophe of collective dispossession is a shared focal point around which they can congregate, remember, organize, and "struggle to reverse this nightmare."[3] Rather than allowing the memory of the *Nakba* to dissipate, time has deepened and extended the communal consciousness of sharing "the great pain of being uprooted, the loss of identity."[4]

In his anguished plea for the departure of "those who pass between fleeting words," the Palestinian national poet Mahmoud Darwish calls for the departed to leave behind "the memories of memory."[5] Darwish's poem is a cry for the value of memory, for the deployment of words, stories, and narratives in the battle for justice. Words and memories, Darwish said, matter. But he also recognized that dispossession is a function of the Palestinian national story. Among the list of items stolen are the blueness of the sea and the sand of memory. These phrases could be references to numerous sites in historic Palestine, but Gaza would have to be among them. There, the blueness of the sea is still available to Palestinians, but the sands of its beaches offer little comfort to those who remain uprooted from the soil of their ancestral homes. (Among them, one of the editors of this work who grew up a short distance from one of Gaza's most famous beaches, al Mawasi, looking at it from among the dense, grey crowd of houses that make up the Khan Younis refugee camp.)

In Palestinian legal, political, social, and historical discourses, the *Nakba* constitutes the key turning point.

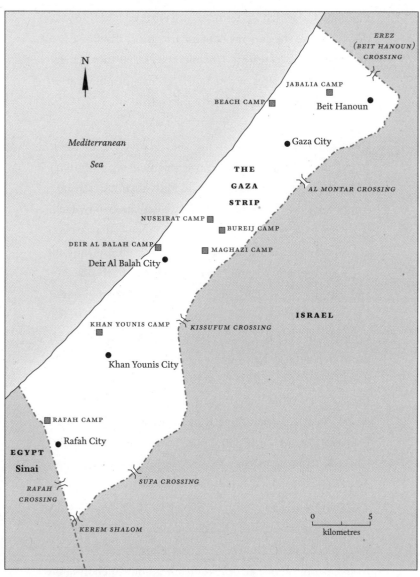

The Gaza Strip.

The rights to which Palestinians are entitled under international law are the shifting benchmarks these discourses and narratives seek to restore. The memories that they struggle to keep alive are sites of resistance against the obliteration of history and the erasure of a vibrant culture.

Gaza's History

In putting together this series, we seek to bring attention to just a few strands of the myriad individual narratives comprising the Gazan tapestry. As we explain below, each story has been woven into the series in nuanced awareness of how it relates to the larger context unfolding at the time.

This larger story is multi-faceted. However, its discrete and varying facets share a common sense of abandonment. Virtually all Palestinians have been abandoned and, in fact, suppressed. That this suppression has taken place through the actions of a group of people who themselves were abandoned and oppressed is one of the most painful ironies of this conflict. When Palestinians cry from the pain of their *Nakba*, this cry comes directly as a mirror of the pain of the Jewish Holocaust—the pain of the Jewish people escaping concentration camps and genocide in Europe. There were cases of people who wanted shelter, security, and freedom. And there were cases of those driven by the Zionist ideology, which, since the days of Herzel and the Basel Congress of 1897, placed a premium on securing a homeland for the Jewish people above all other considerations, including the dignity and protection of Palestinians.

Palestinians have been abandoned by the world, whether by colonial protectorates, like Britain, who signed over "their" land to the Jewish people through the 1917 Balfour Declaration—violating the well-established legal maxim that

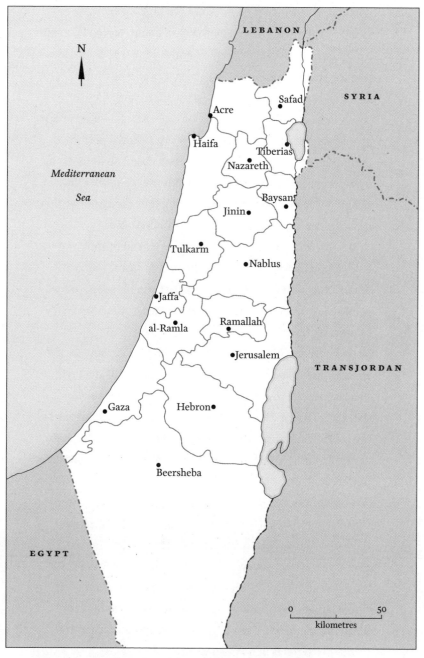

N

LEBANON

SYRIA

Safad

Acre

Haifa

Tiberias

Mediterranean

Nazareth

Sea

Baysan

Jinin

Tulkarm

Nablus

Jaffa

Ramallah

al-Ramla

Jerusalem

TRANSJORDAN

Gaza

Hebron

Beersheba

EGYPT

0 50
kilometres

Palestine, 1947: districts and district centres during the British
Mandate period.

nobody can give what he does not possess—or by some of today's Arab regimes, mainly the Gulf countries led by Saudi Arabia, who view their common enmity for Iran as justification for steadily siphoning off the rights of Palestinians. The latter creates a sense that the Palestinian cause has lost its status as *cause célèbre* of the region and that the Palestinian people are becoming mere footnotes in regional politics. Perhaps most tragically of all, they have been abandoned by both recent and current Palestinian leadership, who have signed peace deals without addressing the core issues of their struggle: the right of return and the 1948 *Nakba*.

It is no wonder, then, that a second strand of the Palestinian narrative is that of alienation from, and lack of faith in, the political structures that should supposedly achieve legitimacy for the rights that Palestinians yearn for so passionately.

Gaza, from a birds-eye view, has always been subject to abandonment and suppression. Its location is of strategic significance: a crossroads between Palestine and the lands to the south (Egypt), Israel (today) to the north, and Europe to the west. The future capital of the unborn Palestinian state, occupied East Jerusalem, is just a short hour-and-a-half drive to the east. Under the British Mandate (1922 to 1948), Gaza was one of the six districts of Palestine. When the United Nations voted to partition the country in 1947, Gaza was to be one of the main ports for the future Palestinian state. Successive Israeli governments have consistently deemed the place and its people a problem and perpetual security threat. In idiomatic Hebrew, the expression "go to Gaza" means "go to hell."[6] Even within the Palestinian narrative, Gaza's history has been pushed into the margins.

The UN library contains a vast body of documentation of the processes and consequences of Palestinian dispossession and occupation, whether economic, social, or legal. Alongside the catalogue of resolutions concerning peace, statehood, and rights (UN Resolutions 181, 194, and 242), the UN has also described the Palestinian refugee situation as "by far the most protracted and largest of all refugee problems in the world today."[7]

In 2012, a UN report predicted that Gaza could be rendered completely uninhabitable by 2020.[8] This bizarre prediction is consistent with the notorious Zionist image of Palestine as "a land without a people"[9] This image has now morphed into one in which a piece of that land has become unfit for human habitation, when its inhabitants number far more than they have at any other point in its history. Perhaps this uncomfortable contradiction epitomizes the core of what should be said about the recent history of Gaza in explaining the current Kafkaesque predicament of its civilian population. Undoubtedly, Mahmoud Darwish would have relished its poignant irony.

Gazan life in the early half of the twentieth century was largely agrarian and market based for its eighty thousand inhabitants living in four small towns: Gaza, Deir Al Balah, Khan Younis, and Rafah.[10] Even the most urbane of the Strip's original inhabitants professed a deep connection to the homeland, and the most harried and overextended of Gaza's lawyers and doctors made time to nurture fig trees or raise chickens. However, the situation changed dramatically with the 1948 *Nakba* when over two hundred thousand refugees arrived on the tiny strip of land,[11] after simply traveling down the road without crossing even a single

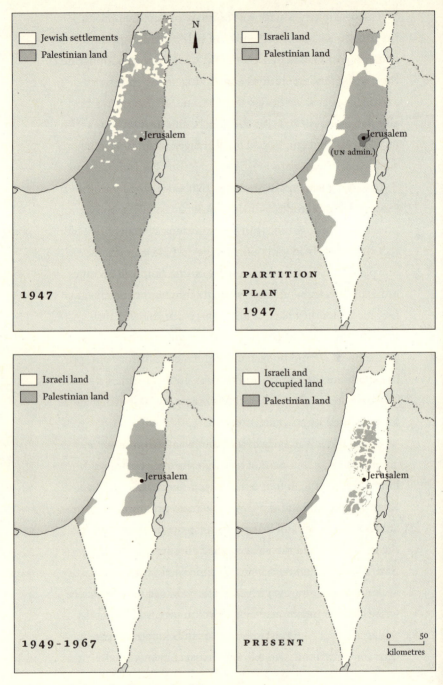

Jewish settlements	N ↑
Palestinian land	
•Jerusalem	
1947	

Israeli land	
Palestinian land	
•Jerusalem	
	(UN admin.)
PARTITION	
PLAN	
1947	

Israeli land	
Palestinian land	
•Jerusalem	
1949–1967	

Israeli and Occupied land	
Palestinian land	
•Jerusalem	
PRESENT	0 50 kilometres

The loss of Palestinian land from 1947 to present.

international border, looking for safe haven. Many of them imagined a sojourn in the Strip, probably for a "few days or weeks."[12] Establishment, in 1949, of the United Nations Relief Works Agency for Palestinian Refugees (UNRWA) to provide vital services such as education, health care, and social assistance seemed to consolidate the status of these displaced persons, despite their abiding hope for "return." Those who attempted to materialize that hope were forcibly prevented from returning and sometimes killed by Israeli forces. According to Israeli historian Benny Morris, in the period between 1949 and 1956, Israel killed between 2,700 and 5,000 people trying to cross the imaginary line back to their homes.[13] Over time, the tent camps turned into concrete cities, where the politics of resistance incubated that would later flourish.

Egypt controlled the Gaza Strip until 1967. During the Suez Crisis of 1956, Israel occupied the Strip temporarily and committed massacres in Khan Younis and Rafah before Israel's military was forced to withdraw. In Khan Younis alone, Ihsan Al-Agha, a local university teacher, documented the names of hundreds of people killed.[14] This period was signified by the rise of the *Fedayeen* movement—a national movement of Palestinian resistance fighters who attempted to mount attacks against the state of Israel, which had occupied and destroyed their homeland. In order to deter Palestinians, Israel constantly attacked and bombarded Gaza. In August 1953, the Israeli commando force known as Unit 101, under the command of Ariel Sharon, attacked the Bureij refugee camp, east of Gaza City, killing over forty people. Two years later, in 1955, the Khan Younis police station was blown up, leaving seventy-four policemen dead.[15]

This period also witnessed tensions between the Egyptians and Palestinians against the backdrop of the Johnson peace proposal in 1955. Endorsed by the UN and the Egyptian government, the proposal sought to re-settle Gazan refugees in the northwest of the Sinai Peninsula. Popular demonstrations protesting the plan were directed against both the UNRWA and the Egyptian administration in Gaza.[16] This wave of focused activism was the context in which the seeds of the Palestine Liberation Organization (PLO) were sown.

The war of 1967, known colloquially as the Six-Day War, left the Gaza Strip and the West Bank occupied by Israel, as well as the Syrian Golan Heights and the Egyptian Sinai Peninsula. Soon after the war, Israel enacted the annexation of East Jerusalem. These developments generated a new set of legal and political structures that extend to the present day. In East Jerusalem, Israeli law applies to all citizens (whether Palestinian or Jewish). However, the Palestinian residents of East Jerusalem are required to hold special ID documents and they are not entitled to Israeli citizenship (unlike the Palestinian Arab citizens of other areas inside Israel, such as Nazareth). In the West Bank and Gaza Strip, the "occupied territories," Israeli military law was applied. When Jewish settlements were introduced (that is, colonial townships for Jewish people planted on occupied Palestinian land), a new legal strand emerged and standard Israeli law was selectively and exclusively applied to the Jewish residents of the West Bank and the Gaza Strip. Such were the emerging features of a regime that has gained increasingly unfavourable comparisons to apartheid rule in South Africa. In Israel and the territories under its control, legal restrictions on people are conditional upon identities and the respective status of these identities within heavily

stratified and discriminatory laws. The regime, in other words, implements a "legally sanctioned separation based on discrimination."[17]

The so-called "Six-Day War" of 1967 resulted in the expulsion of another 300,000 Palestinians from their homes, including 130,000 who were displaced for a second time after their initial displacement in 1948.[18] The defeat followed by the military occupation shattered Palestinians' hopes for return, but energized the national movements led by the *Fedayeen*. To pacify resistance in the Strip, then Israeli Defence Minister Sharon initiated a policy of home demolitions that continues to this day. As people in Gaza were subjected to intensified restrictions on freedom of movement and to increasingly squalid economic conditions, it was no accident that the 1987 *Intifada* was first triggered in Gaza, specifically in the Jabalia refugee camp, and rapidly spread across the remainder of the Strip before it was joined by the West Bank. The uprising was a mass popular movement that held up for six years. It manifested in protests and strikes, in civil disobedience, and in boycotts. Unable to supress the masses, Israel shut down Gaza's universities for six years, denying tens of thousands of students the opportunity to study, including one of the editors of this series. It imposed curfews locking the entire Palestinian population of Gaza inside their homes every night for about six years.[19] An order ascribed to Israel's then Defence Minister, Yitzhak Rabin, directed the Israeli army to break the bones of Palestinian protesters.[20] The images of unarmed Palestinian youths throwing rocks at fully armed Israeli troops captured attention in international media and contributed to a narrative of the Palestinian David fighting Israel's Goliath.

Amidst the heat of the *Intifada*, a peace process was launched in Madrid under the auspices of the Americans and the Soviets in 1991. The process eventually culminated with the Oslo Accords, signed by Israel and the PLO on the White House lawn in September 1993. In keeping with the terms of the Accords, the Palestinian Authority (PA), an interim self-governing body, was constituted. The PA, led by the late Yasser Arafat, along with the PLO leadership, were allowed to return to Gaza and establish a headquarters. Oslo was the pinnacle of Palestinian hopes for statehood and self-determination. Widespread discussions stated that Gaza would become the "Singapore of the Middle East."[21] These hopes evaporated, however, when the Accords panned out as the "biggest hoax of the century."[22] They neglected to deal with the core issues of both the conflict and the Palestinian cause: with the Palestinian refugees, with the right of their return, and with the 1948 *Nakba*.[23] Reflecting his deep frustration at the aftermath of the Oslo Accords, Palestinian historian Salman Abu Sitta, himself a refugee expelled to Gaza along with his family, wrote to PLO leader Yasser Arafat, asking him why the Accords and his ensuing speech at the UN had omitted "Palestine," "Palestinians," and demands for inalienable rights:

> *I wished to hear you, Mr. President, say in your speech: I stand before you today to remind you that forty-six years ago 85 percent of my people were uprooted by the force of arms and the horror of massacres, from their ancestral homes. My people were dispersed to the four corners of the earth. Yet we did not forget our homeland for one minute... Let us learn the lesson of history: Injustice will not last. Justice must be done.*[24]

"Oslo," as the Accords are commonly called, entrenched the segregation of Palestinian communities. In 1994, a fence was erected around Gaza; a permit system was applied to anyone who needed to leave the Strip. This had a drastic impact on the population's ability to conduct anything approximating a "normal" life, while severely weakening the Strip's economy.

The failure of Oslo to recognize the core issues at stake for the Palestinian people was followed by the breakdown of negotiations between the PA and Israel in late 2000. This stalemate provided fertile ground for the eruption of the second *Intifada*. Israel's violence in suppressing this uprising unleashed the full might of the world's fifth largest army against a defenceless civilian population. Daily bombings by F-16 fighter jets became the soundtrack of daily life in Gaza, while Palestinians mounted armed attacks against Israeli military posts inside the Strip and against the army and sometimes civilians in Israeli towns and cities.

In 2001, Sharon declared war on the PA's leadership, security officials, and infrastructure. Israeli bulldozers destroyed the runway of Gaza International Airport, attacked the symbols of Arafat's authority, and bombarded and destroyed Arafat helicopters. These attacks left much of Gaza's internationally funded infrastructure in ruins.[25] Even worse, however, as a form of collective punishment of Gazans, Israel imposed a policy of internal "closure," preventing movement within the tiny Strip. It divided the Gaza Strip into three parts. The principal closure points were on the coastal road to the west of the Netzarim colony (formerly located between Gaza City and the Nuseirat camp) and at the Abu Holi Checkpoint (named after the farmer whose land was confiscated to build the checkpoint), located at the

centre of the Strip. Each time the Israeli army shut down these points, Gaza was split apart, paralyzing all movement of people and goods.[26] For five consecutive years, for Gazan doctors, nurses, patients, students, teachers, farmers, labourers, and mothers, a trip from north to south—ordinarily a ninety-minute round trip—could turn into a week-long ordeal, and dependence on the kindness of one's extended family for accommodations and food until the checkpoints were re-opened.[27]

In 2004, Dov Weisglass, advisor to Prime Minister Sharon, declared his strategy of rendering the peace *process* moribund and his intention to sink it, along with Palestinians' national dreams, in "formaldehyde."[28]

Israeli political activity has always been rooted in unilateralism. The false narrative of a "land without people" permitted the "people without a land"—now instated in what was formerly Palestine—to conduct themselves in absolute disregard of the existence of another people. The latter, like so many rocks and boulders, were simply to be bulldozed flat as the new state was being constructed. Israel's unilateral disengagement from Gaza in 2005, vacating about eight thousand settlers, whose houses and farms covered forty percent of the area of the Strip, was an act of political sleight of hand that allowed Israel to declare itself free of political and moral responsibility for the Gaza Strip, while also declaring it an "enemy entity"[29] in 2007. It could accordingly be enveloped in a siege designed to generate medieval living conditions.[30]

The 2006 free and fair elections that brought the Islamic resistance movement, Hamas, into power were the fruit created by Israel's departure, viewed by many Palestinians as a victory of the resistance, led by Hamas, to Israel's brutal

policies of oppression, as well as to the inherent weakness at the heart of the Palestinian Authority. The latter, which is supposedly authorized to govern, is constrained by severe limitations that effectively disable the centrifugal forces allowing the governance of states. The US and the EU were the parties at whose demand the fledgling Palestinian Authority conducted elections, and these were declared fair and free by all international monitors. And yet, these same parties proceeded to boycott the results (which they found unsatisfactory) and to cut foreign aid to the PA. For the most part, these cuts and the shortages they incurred were imposed upon Gaza (and to a lesser degree, the West Bank).

Declaring Gaza an "enemy entity" allowed Israel to conduct three major offensives against the Strip, in 2008, 2012, and 2014. The 2014 offensive , which lasted 51 days, destroyed much of what had previously functioned as Gaza's infrastructure and institutions, including the complete or partial destruction of at least 100,000 homes, 62 hospitals, 278 mosques, and 220 schools.[31] It also left 2,300 people dead, the majority of these being civilians, and tens of thousands wounded.[32]

Four generations of refugees now live in the Gaza Strip, scattered among eight refugee camps. As of 2020, Gaza is still under siege. Access to the outside world is controlled by Israel, or by Egypt, acting as Israel's sub-contractor. No one can enter or leave the Strip without permits from one of these two powers. According to Oxfam, in 2019, one million Palestinians in Gaza lacked sufficient food for their families. Sixty percent of these Gazans were subsisting on less than $2 a day. Unemployment, measured at 62 percent in 2019, is among the highest in the world.[33] Economist Sara Roy has characterized the pattern as one of structural

de-development,[34] and Israeli historian Avi Shlaim describes it as "a uniquely cruel case of intentional de-development" and a "classic case of colonial exploitation in the post-colonial era."[35] Although the World Bank has said that Gaza's economy is in "free fall,"[36] the Strip has in fact maintained a perverse stasis: formaldehyde, after all, is used to preserve corpses.

Israeli sociologist Eva Illouz recently compared the present circumstances of the Palestinian people to conditions of slavery. These conditions, she said, present one of the great moral questions of our time and are similar, in certain respects, to the slavery that embroiled the US in civil war in the nineteenth century.[37]

The strands of oppression and violence running through the Palestinian tapestry are interwoven with strands of endurance, ability to overcome, and *Sumud*—steadfastness—in the face of injustice. Palestinians still firmly believe in return and in the possibility of justice, even if these ideals have become embattled and tattered. Gaza's high level of concentration on the importance of these narratives belies its tiny size, at just 1.3 percent of historic Palestine. Protesting the circumstances of all Palestinians, the near suffocation of the Gaza Strip, and the international disinterest in both, Gazan civil society launched the Great March of Return in 2018. Weekly protests were initiated along the border fence with Israel every Friday, calling on both Israel and the world to recognize the inalienable right of Palestinians to return to the homes and lands from which they were forcibly removed seven decades ago. The protestors also insist upon a plethora of other basic rights denied to Palestinian people in the "ongoing *Nakba*" of their lives.[38] The World Health Organization reported over 300

Gazans were shot and killed by the Israeli army in the course of these rallies, as of December 2019, with 35,000 more injured.[39] On May 14, 2019 alone, Israeli military snipers killed 60 unarmed demonstrators and wounded 2,700.[40]

The weekly marches are an ongoing journey fulfilling the prophesy of Mahmoud Darwish that "a stone from our land builds the ceiling of our sky."[41] Every independent state formed after "the dismantling of the classical empires in the post-World War Two years" has recognized an urgent need "to narrate its own history, as much as possible free of the biases and misrepresentations of that history," as written by colonial historians.[42] In an analogy to the poetry that represents a highly important oral tradition in the Arab world, we see this book as an effort to capture the poetry of life and the history of a people, expressed by those who live it on a daily basis.

Filling in a Tapestry of Resistance Through Memory Work

The history of Gaza is far richer and deeper than the standard narratives of helplessness, humanitarian disaster, or war story would have us believe. Moreover, as is the case with other post-colonial regions and their histories, Gazan history differs greatly from official accounts and Eurocentric renderings based (largely) on oversimplifications.[43] This series is, accordingly, an attempt to replace detached— and sometimes questionable—statistics and chronologies of erupting conflict with some of the concrete details of actual survival and resistance, complex human emotions, and specific difficult choices. The stories recounted reflect crucial facts and important events through the evidence of lived experience. They contextualize selective reports and

statistics, correcting omissions, misrepresentations, and
misinterpretations.

This series is an attempt to re-imagine the history of
Gaza from the viewpoint of its people. A true understanding
of Gaza entails a reading of the human history beyond and
behind chronologies, a reading that follows some of the
coloured threads that make its tapestry so vibrant. The seven
women whose stories we relate communicate the history
they lived, through reflecting on events they experienced in
their own voices and vocabularies. They shared feelings and
named processes as they understood them, enabling others
to grasp and realize the sheer dimensions of the injustice
to which they were subjected and which they amazingly
withstood.

Israeli New Historian Ilan Pappe has used the term
"memoricide" to denote the attempted annihilation of
memory, particularly that of the Palestinian *Nakba*. A
systematic "erasure of the history of one people in order to
write that of another people's over it" has constituted the
continuous imposition of a Zionist layer and of national-
ized Israeli patterns over everything Palestinian.[44] This has
included the erasure of all traces of the Palestinian people—
of the recultivation and renaming of Palestinian sites and
villages. These practices were recounted victoriously by
Moshe Dayan in 1969:

> *We came to this country which was already populated by*
> *Arabs and we are establishing a Hebrew, that is, a Jewish*
> *state here. Jewish villages were built in the places of Arab*
> *villages and I do not know even the names of these Arab*
> *villages, and I do not blame you, because the geography*
> *books no longer exist, the Arab villages are not there either.*

Nahalal arose in the place of Mahlul, Kibbutz Gvat in the place of Jibta; Kibbutz Sarid in the place of Huneidi and Kfar Yehushua in the place of Tal al Shuman. There is not a single place built in this country that did not have a former Arab population.[45]

In the context of daily hardship, then, memory is crucial. It is a deeply significant site for resisting policies of elimination and erasure. Often, such resistance work takes place within families, and, in particular, through women. Stories of lost homes are handed down from generation to generation and repeated time and again, preserving the names of lost villages and towns, detailing former landholdings, passing on deeds, and recounting traditions and tales about "the ancestors, everyday life, the harvests, and even quarrels."[46] When asked where they are from, most of the children of Palestinian refugee families will state the name of a village lost generations ago.

In recognizing women's diverse experiences as a key to decoding history, we share accounts of women of the generation that experienced the 1948 *Nakba*, told with the backdrop of the master narratives of Gaza, offering new insights into the story of Palestine. The respective narrators enable readers to gain a fuller understanding of the scale of tragedy experienced by each of these women and of its socio-economic and political impacts.

The series draws on the concept of "History from Below" proposed by the French historian Georges Lefebvre, who emphasized that history is shaped by ordinary people over extended periods of time.[47] It also draws on the feminist concept of "Herstory," where feminist historians and activists reclaim and retell the suppressed accounts of

historical periods as women, particularly marginalized women, experienced them. It is in these traditions that we present the oral histories of Palestinian women from the Gaza Strip. The school of oral history, initiated with tape recorders in the 1940s, achieved increased recognition during the 1960s, and is now considered a major component of historical research that enlists the assistance of twenty-first-century digital technologies.[48] In defending the method of recording oral history, Paul Thompson argued, in *The Voice of the Past: Oral History*, that it transmutes the content of history "by shifting the focus and opening new areas of inquiry, by challenging some of the assumptions and accepting judgment of historians, by bringing recognition to substantial groups of people who had been ignored."[49] The historically "silent" social groups cited by Thompson include Indigenous people, refugees, migrants, colonized peoples, those of subaltern categories, and minorities. Such groups have employed the methodology of oral history to counteract dominant discourses that suppress their versions of history. Alistair Thomson argued that "for many oral historians, recording experiences which have been ignored in history and involving people in exploring and making their own histories, continue to be primary justifications for the use of oral history."[50] In efforts to represent the totality of truths, oral history has been recognized as a method of realizing the rights of marginalized people to own and sound a voice, to share and reflect on their collective experiences, and to resist the dominant colonial rhetoric that omits or obliterates these experiences. In this context, Julia Chaitin argues that oral history is not simply an attempt to find an alternative historical text, but also to gather new information that cannot be located by other means as it is undocumented.[51]

Oral history, as a method that both enhances and disrupts formal history, has not yet taken root extensively in the Arab world. Among a few rare exceptions, according to anthropologist and historian Rosemary Sayigh, are the Palestinians "who have used oral and visual documents to record experiences of colonialist dispossession and violence that challenge dominant Zionist and Western versions of their history."[52] In gradually moving "from the margins to the center," this practice has come to constitute the core of Palestinian historiography in the past twenty years,[53] and is deployed abundantly, both formally and informally, in collecting and reviving knowledge that was formerly unrecorded. In response to Edward Said's call for the "permission to narrate," oral history has paved the way for the continued production of archival collections, resisting the ongoing erasure of Palestinian spaces, existence, history, and identity. Sherna Gluck notes that this method not only recovers and preserves the past through the collection of accounts, for example, of the *Nakba*, but also establishes the legitimacy of claim and of the right of return.[54] For Palestinians such as Malaka Shwaikh, a Gaza-born scholar, oral history and memory of the past act "as a force in maintaining and reproducing their rights as the sole owners of Palestine" and as "fuel for their survival."[55]

Over the past two decades, numerous laypeople, nongovernmental organizations, and solidarity workers have joined the intellectual mission of rescuing a history that aims, according to Said, to advance human freedom, rights, and knowledge.[56] That mission has gathered momentum and gained significance in historic Palestine in a context of neglect on the part of the Palestinian national leadership, which has failed to organize and ensure continuous records

or documentation of popular Palestinian experience and of the ongoing dangers posed by the Israeli occupation.[57] The specifics of this violence as a current historical process were highlighted in a book by Nahla Abdo and Nur Masalha titled *An Oral History of the Palestinian Nakba* (2018). The book includes a detailed discussion of the potential of oral history for historicizing marginal experience. It also notes that Palestinian history has not been adequately recorded as the experience of both a community and of individuals and emphasizes the vital role that oral history plays in assembling the Palestinian narrative.

The role of Palestine during World War II features prominently in standard historiographies, but little has been written about its Indigenous population, the conditions of their existence prior to 1948, or their collective life and history before exile. Summing up this gaping void, Said wrote: "Unlike other people who suffered from a colonial experience, the Palestinians...have been excluded; denied the right to have a history of their own...When you continually hear people say: 'Well, who are you anyway?' you have to keep asserting the fact that you do have a history, however uninteresting it may appear to the very sophisticated world."[58]

Scholarly Work on Palestine's History

Many historians and researchers have drawn on both oral and visual history to counter the multi-form suppression and abandonment—ranging from disinterest to fundamental denial—of Palestinian history recounted from Palestinian standpoints. A variety of strategies have been adopted in carrying out such work, and famous among these efforts is Walid Khalidi's *Before Their Diaspora: A Photographic History of the Palestinians, 1876-1948* (1984). Others have presented

individualized narratives, for example, in Salman Abu Sitta's *Mapping My Return: A Palestinian Memoir* (2016), Ghada Karmi's *In Search of Fatima: A Palestinian Story* (2009), and Leila El-Haddad's *Gaza Mom: Palestine, Politics, Parenting, and Everything In Between* (2010). Scholars such as Ramzy Baroud, in *Searching Jenin: Eyewitness Accounts of the Israeli Invasion 2002* (2003), have used oral testimonies in more comprehensive works to gain a fuller understanding of specific events (in this case, Israel's siege on Jenin in 2002), while linking the event in question to collective Palestinian history. Others have recounted the singular history of specific political factions, for instance, Khaled Hroub in *Hamas: Political Thought and Practice* (2000) and Bassam Abu Sharif in *Arafat and the Dream of Palestine: An Insider's Account* (2009). Several online projects and websites, such as *Palestine Remembered*, have also initiated and continue to maintain an ongoing collection and dissemination of Palestinian oral histories.[59]

Nakba: Palestine, 1948, and the Claims of Memory (2007), edited by Ahmad H. Sa'di and Lila Abu-Lughod, is one of the more prominent attempts to incorporate oral history as an essential means of delivering history, justice, and legitimacy for the Palestinian cause, while also linking current events to the recent past. Departing from the *Nakba* as a central event that defines and unites Palestinians, their volume undertakes the injection of collective memory into the overall framework of Palestinian history. Making memory public, Sa'di and Abu-Lughod write, "affirms identity, tames traumas and asserts Palestinian political and moral claims to justice, redress and the right of return."[60] It also challenges the Zionist myth that Palestinians have no roots in the land.

Some authors have taken up Said's idea of the intellectual's mission being to advance human freedom and knowledge.[61] This idea is based on Said's definition of the intellectual as being both detached and involved—outside of society and its institutions, and simultaneously a member of society who is constantly agitating against the status quo. Ramzy Baroud's book *My Father Was a Freedom Fighter: Gaza's Untold Story* (2010), the Indigenous section in Ghada Ageel's edited volume *Apartheid in Palestine: Hard Laws and Harder Experiences* (2016), which includes chapters by Reem Skeik, Samar El Bekai, and Ramzy Baroud, and Palestinian poet Mourid Barghouti's *I Was Born There, I Was Born Here* (2012) are all manifestations of a concept in which the outsider is also the insider, the researcher, and the narrator. The authors of these narratives either spent a large part of their lives under Israel's occupation or returned from exile and experienced the suffering of both the individual and the group. These experiences generated their common aspiration to become intellectuals who would repeatedly disturb and problematize the status quo. In documenting their personal stories and describing everyday life in the West Bank and Gaza, these insider-outsider-researcher-narrators have attempted to link present and past.

Within the broader context of abandoned and suppressed narratives, accounts of women's experiences, elided almost completely from hegemonic histories, open sorely neglected but significant avenues into an understanding of how the past and the present are constituted, reconstituted, and conceived. Women's accounts are particularly vital for comprehending the past and present in Palestine, as they are framed and determined by the ethnic cleansing of 1948. While women's stories are largely marginalized, their

experiences form a cornerstone of the structure of human impacts generated by successive military campaigns against Palestinians and by generations of Palestinian resistance, both military and non-violent. Foregrounding women's narratives counteracts a history in which selectiveness reinforces and supports systems of oppression and displacement through the erasure of authentic voices and the prioritization of male dominant narratives.

The tragedy of 1948 and its aftermath in Palestine have been endured by the whole of society and particularly by women, who have borne the remnants with which to reconstruct lost homes both on their backs and in their hearts. As they have put up and organized tents to house their families, they have cared for and raised children, and queued for hours to receive United Nations rations and handouts of clothes, blankets, and kitchen utensils. They have struggled to keep smiles on their own faces and those of their families in the face of humiliation and bitter pain, in the day to day practice of what Palestinians call *Sumud*. Uncovering the details of their life journeys under such exceptional circumstances reveals a version of Palestinian history that is not only far more complete, but that also acknowledges the central role that women have played in making this history. Sayigh has argued that

> *women have been a basic element in the Palestinian*
> *capacity to survive poverty, oppression, exile. They have*
> *been models of courage, tenacity, resourcefulness and*
> *humour. Though all were victims of expulsion and of*
> *gender subalternity, I would never think of them primarily*
> *in these terms, but rather as people who knew/know how*
> *to live against poverty and oppression. Palestinian women*

have the inner resources to make a good life for their
children. They pack, and move, and set up again in a new
place, among new people.[62]

Research on the role of gender in preserving the memory
of the *Nakba* has been carried out by several scholars who
have attempted to detail and highlight this crucial agency.
In their contribution to *Nakba*, edited by Sa'di and Abu
Lughod, Isabelle Humphries and Laleh Khalili used oral
history to "examine both how the Nakba is remembered by
women, and what women remember about it."[63] It was also
crucial to them to investigate how women's memories "were
imbricated by both the nationalist discourse and the same
patriarchal values and practices that also shape men's lives
and their memories."[64] Their chapter confronts the manifold
predominant narrative and the resulting lack of confidence
that has suppressed women's voices and constrained their
role as a conduit of memory.[65] Palestinian women's lack of
self-confidence vis-a-vis, and exacerbated by, the male-dom-
inant narrative is clearly reflected, for instance, in Sayigh's
quotation from one narrator: "I can't say I know all this
history; others know it better." While this narrator is an
"eloquent history teller" who is familiar with the events she
witnessed, she still designates the task for telling history to
those "who would know better."[66]

Fatma Kassem's book, *Palestinian Women: Narrative
Histories and Gender Memory* (2011), focuses on Palestinian
women living in Israel. Kassem collected the oral testimo-
nies of twenty urban Palestinian women, a group whose life
stories of displacement are rarely noted, even though they
form essential parts of the larger Palestinian national narra-
tive. Kassem, who was born in today's Israel years after the

Nakba, positions herself as both an insider—a narrator of her own story—and an outsider—a researcher—in the volume that aims to reveal "the complex intersections of gender, history, memory, nationalism and citizenship in a situation of ongoing colonization and violent conflict between Palestinians and the Zionist State of Israel."[67] Like Baroud, Ageel, and Barghouti, this positionality allowed her a great deal of freedom in crossing boundaries as an unconstrained outsider while interacting intensively as a trusted insider with the other narrators, whose stories, she said, "shaped" her life "as much as [they] did theirs."[68]

The work of Sayigh exhibits a similar type of direct interaction with the narratives of Palestinian women. She has authored several books examining the oral history of the Palestinians, notably, *The Palestinians: From Peasants to Revolutionaries*.[69] In her work, *Voices: Palestinian Women Narrate Displacement*, an online book, Sayigh narrates the stories of seventy Palestinian women from various locations in the West Bank, the Gaza Strip, and Jerusalem.[70] The interviewees spoke about their lives following the displacement of Palestinians after the *Nakba*. Like most of her influential work, Sayigh's interviews—conducted between 1998 and 2000, just prior to the initiation of this project—investigate displacement and its effects on Palestinian women, and the impact of the *Nakba* on the identity of women and their sense of self. Also considered in her book is the linkage between collective displacement and the critical role played by women in the Palestinian narrative. Sayigh's body of work has not only advanced the destabilization of dominant narratives, making space for a more egalitarian narration of history, it also accurately situates Palestinian women at the centre of Palestinian history, offering a fuller,

more representative understanding of Palestinian history altogether.

The *Women's Voices from Gaza* series is a continuation of the oral history work carried out by many intellectuals and individuals who aimed to assign Indigenous Palestinians a greater role in explaining the dynamics of their own history and to re-orient the story of Palestine by restoring it to its original narrator: the Palestinians. It is a complement to a corpus of work that preceded this series and that asserts the centrality of the narrative of Palestinians, especially women, in reclaiming and contextualizing their history.

A White Lie

The first narrative in our series turns the clock back ninety years and invites readers on a journey of reimagining a once-upon-a-time in Palestine. The story recounts a life of happiness, uncertainty, loss, and also, ultimately, of pride, resistance, and hope. Weaving together many narrative threads, *A White Lie* unearths a version of history long excluded from mainstream discourse, illuminating a vibrant culture, rich community relations, old traditions, and grand resistance. It is the story of Madeeha Hafez Albatta, a woman with the warmth and depth of the homeland. Madeeha was born and raised in Khan Younis, a town in the southern part of the Gaza Strip, and her life took her, along with her family, across mandatory Palestine to Egypt, Jordan, Syria, Lebanon, Tunis, the United States, Germany, Greece, Austria, and Canada. In 1938, with Palestine under the British Mandate, Madeeha had to resort to tricking her family into allowing her to attend college. That trick changed her life forever. She became a teacher while still in her teens and then the headmistress of a school while in her early

twenties, the youngest headmistress in Gazan history and most likely in the entire region.

As a teacher and headmistress, a campaigner for rights, an activist and community organizer, a mother, and a champion of dignity, Madeeha witnessed some of the most turbulent periods of Palestine's recent history. Widely viewed as a symbol of love and freedom, she advocated an honourable life in all these roles. Her life story presents a model of bravery and strength, demonstrating the collective Palestinian will to stand fast and resist the odds. She was among the pioneers to rally her community to guarantee the right to education for thousands of children arriving in Gaza after the destruction of their homes and homeland in 1948. Upon witnessing the influx of hapless refugees, Madeeha immediately began mobilizing community efforts and energies to secure schooling before the arrival of any outside assistance, including that of the UNRWA (United Nations Relief and Works Agency for Palestine Refugees in the Near East). She was the driving force and key organizer behind the refugee schools, which were set up without aid from any international organizations. Madeeha saw education as a crucial means of survival and a way to preserve Palestinian traditions, culture, history, and identity. Building on this vision and mission and on the nucleus she had set up, the UNRWA then took responsibility for the education of refugee children.

In 1956, Madeeha lost both of her brothers, Hassan and Nadid, who were slaughtered by Israeli soldiers together with hundreds of civilian men and youth in Khan Younis. She was forced into the uncertainty of exile, away from her children and unable to return to her home for almost six months, due to the military campaign waged by the UK, France, and

Israel against Egypt, as well as the occupation of the Gaza Strip. Her shock and dismay at this tragedy and her sense of powerlessness and despair, magnified by distance and the inability to support and share with others, approximate the feelings of hundreds of thousands of Palestinians living in exile at the time who witnessed repeated attacks on beloved family members, friends, neighbours, and an entire nation. Madeeha lived on to witness Egypt's defeat in 1967, followed by Israel's military occupation of the remnants of Palestine, including the Gaza Strip, while her husband, Ibrahim Abu Sitta, was deported to Sinai along with other community leaders, forcing Madeeha to live through worry and enforced separation. In 1970, during a short visit to Amman, Madeeha experienced the purge of Palestinian leaders by Jordan's regime, known by Palestinians as "Black September," surviving yet another period of horror away from her family and home. The eruption of the first *Intifada* in 1987 revived Palestinians' hope and spirit of resistance and culminated with the Oslo Accords in 1993 and 1995. The period of hope, which Madeeha shared, was short lived, however, ending in 2000 with the outbreak of the second *Intifada* that manifested the despair experienced by Palestinians. *A White Lie* reveals how these events shaped Madeeha's life and the lives of her family members. It traces the unimaginable decisions and actions they were forced to take in order to safeguard the remains of Palestine, through educating and attempting to protect the family's children, while also caring for extended family and leading the community.

But Madeeha's story provides far more than the account of an individual life under continued and complex political upheaval and war. Her narrative preserves minute details of distinctly Palestinian individual and collective life through

different eras and regimes. It depicts a vibrant culture, old traditions, customs, and other critical features of Palestinian society that readers rarely encounter. The narrative spans her childhood and early adulthood, including her train trips across Palestine and the Levant (Syria, Lebanon, Jordan, and Palestine), providing a picture of ordinary Palestinian family life in the early twentieth century. This period of the British Mandate in Palestine is largely neglected in other works, while those accounts that do exist invariably focus on the political clashes of the time, between Palestinians and the British and later Palestinians and the Zionists. Little mention is made of the rich tapestry of day-to-day life in Palestine.

Madeeha's narrative also uncovers untold parts of the Palestinian story, as it captures the disruption and change in Palestine caused by the 1947 partition plan and the 1948 *Nakba*. Her uncovering of such changes has also been very clear in her literary writings, published in *Al Risala* and *Al Thaqafa*, two prestigious Cairo magazines, which according to Abu Sitta were the closest equivalent to today's *New York Times Review of Books*.[71] The experiences that surface in her tale highlight the role played by civil society in mitigating the national tragedy. Sounding her amazingly resilient voice, the narrative depicts Madeeha reaching out to Gazan civil society to seek help and reflects the immensely impressive response. Records of strong community relations, a healthy civil society, and women's central roles in it are aspects that are largely absent from scholarship on Palestinians. The narrative further reveals the depth of the solidarity of Palestinians from Gaza with their brothers and sisters: the displaced peasants and city dwellers who found refuge in Gaza. Like the other narratives we share in this series,

Madeeha's story conveys the displacement and dispossession with great clarity. It speaks of a land and a people with a culture and history that existed before these events for generations, completely contradicting the infamous Zionist myth of Palestine as a land without a people unproblematically awaiting a people without a land.

Moreover, Madeeha's lived experiences of childhood, adulthood, education, employment, activism, love, marriage, and aspirations draw an image that belies widespread western, orientalized stereotypes of Arab Muslim women. Her story portrays the capacities, strengths, and abilities of Palestinian women and reflects their aspirations and feelings, as well as their engagement with patriarchal social constraints in struggles for change that are analogous to those of women in many other areas throughout the world. It also reveals the racism embedded in common attempts to frame, and in fact misrepresent, the struggle of Palestinian women within their cultural tradition and religion. On top of their inaccuracies, such explanatory frameworks fail to capture the unending forms of violence that militarized occupation has practiced on women in Palestine.

Madeeha's narrative was selected to be first in this series because her life experience and personality overlaps with, corresponds to, and unites all of the women represented (whether a native resident of Gaza, a refugee, a mother of prisoners, a villager, or an exiled returnee). To a large extent, her life journey corresponds to and communicates the collective Palestinian story. As a citizen from Gaza, Madeeha opened her arms and heart to arriving refugees who entered the Strip. In aiding and also, notably, listening to them, Madeeha could grasp the concrete meaning of losing one's

home and being forced to become a refugee in one's own land. A year after the *Nakba*, she was married to one of these recent refugees, a lawyer from Al Ma'in who went on to become a magistrate, a national figure, and ultimately the first mayor of the city of Khan Younis under the Egyptian administration of the Gaza Strip. Together with Ibrahim, on a journey of over six decades, Madeeha managed to raise a family of nine despite formidable challenges and very complicated circumstances. Her chief concern was sheltering her children against the dangers and harm of military occupation and a settler colonial regime that practices apartheid. All this while Palestine—the cause and the people—remained the discernible, steadfast centre of their lives.

The battles that Madeeha waged continue. The children and grandchildren of her generation are now taking the lead and following the trail that she, like so many other Palestinians, blazed seventy-two years ago. It is this generation of refugees and non-refugees, men and women, and boys and girls who have marched for rights and dignity along the razor-wire fences that confine Gaza's residents. Gazan civil society is presenting another model of its people's strategies of mobilization and struggle for justice, which are at once traditional and innovative. Palestinians from all parts of society are participating in the Great March of Return, as a call to the world to recognize their inalienable right to return to the homes and lands from which they were forcibly removed seven decades ago. Gazans are also demanding an end to the notably immoral blockade that denies them freedom of movement, the right to education, the right to life, the right to livelihood, and the right to feed their children, as well as the rights to fish their waters, cultivate their

land, export their products, and to drink clean water and receive medical treatment. These are the same very basic rights that Madeeha struggled to attain.

Madeeha paid heavy personal prices in order for her and her family to struggle for freedom. Today's younger generations protesting at Gaza's borders are also paying heavily for exercising the right to take part in determining their future, and for practicing an advanced form of participatory democracy to call world attention to their slow strangulation by blockade. In peaceful demonstrations and sit-ins, held in the buffer zone imposed by Israel hundreds of yards from the outer perimeter of the fence encaging Gaza, they have narrated and staged a legendary epic of resistance, celebrating the Palestinian survival, traditions, culture, and history that Madeeha worked so hard to preserve. As of the beginning of 2020, protesters have continued to gather every day for well over a year, since March 30, 2018, to sing, dance traditional *dabkeh*, share stories, fly kites, cook traditional meals, and recount memories of what once was their homeland, all while praying for and dreaming of return.[72]

Ignoring their message and disregarding their right to life, Israeli army snipers, stationed in jeeps and military towers behind multiple stretches of barbed wire, with no imminent threat to their lives, are systematically targeting demonstrators with live ammunition. In February 2019, after a year of demonstrations, an independent Commission of Inquiry, set up by the UN Human Rights Council, confirmed "reasonable grounds to believe that Israeli snipers shot at journalists, health workers, children and persons with disabilities, knowing they were clearly recognisable as such."[73] Accordingly, the report found that the Israeli army

might be responsible for war crimes in Gaza against protestors involved in the Great March of Return.

Madeeha died a natural death in her home in Gaza on December 22, 2011, at the age of 87, leaving a legacy that has already become a beacon for the ongoing march of the Palestinian people toward freedom and dignity. A poem written by Maheeda seventy years ago still accurately portrays the current situation in occupied Palestine and in besieged Gaza. It summarizes the agony of Palestinians, their yearning for freedom, and their daily suffering under occupation, siege, and apartheid. It presents a Gaza that is not just a piece of land, but a place in which a history of resistance, resilience, and *Sumud* (steadfastness) has formed. The poem sends an open invitation to the world, urging it to engage with her struggle to save lives and achieve justice.

A BIRD AND OTHER BIRDS

You are lucky birds, flying from tree to tree, rose to rose.
You are happy birds, singing and dancing.
I can't understand your songs and I can't understand your
* laugh because I am imprisoned here.*
Please come and see my tears, my situation, my life.
It's an awful life. I wish to be like you, but I can't.

A
White
Lie

1 / Childhood Days

You are lucky birds, flying from tree to tree, rose to rose.
You are happy birds, singing and dancing.
I can't understand your songs and I can't understand your
 laugh because I am imprisoned here.
Please come and see my tears, my situation, my life.
It's an awful life. I wish to be like you, but I can't.

A WHITE LIE changed my life. If I hadn't told that lie, I am
sure I would have been another example of most Palestinian
women of that time who had children, cooked, and took care
of the home. But my ambition went further than wanting
to be just a housewife, and maybe God helped me to lie.
I convinced my father—who was very strict in a way that
nobody could change his mind—with my lie, and through it
I was able to achieve my dream. I thank God for this.[1]

The Palestinian problems began with Herzl at the Basel
conference on August 28, 1897 in Switzerland,[2] when the
Zionists made up their minds to occupy Palestine. In
November 1917, the British foreign secretary Lord Balfour
issued his infamous Declaration promising Palestine would
be a national home for the Jewish people. After that
Declaration, Jewish immigration to Palestine accelerated,

both openly and secretly, helped by the English. Then the British Mandate started in Palestine in 1922.[3] The English sympathized with the Zionists and their project to colonize Palestine, and opened the doors, legally and illegally, for them to come by sea, in order not to alert Palestinians about what was going on.[4] At that time, Jewish people were a minority in Palestine and lived peacefully with Arabs of Muslim and Christian faiths. There was no enmity between us, but when their numbers increased as a result of the influx of Jewish immigration from Europe, Palestinians began to realize the danger of what was happening. They also realized that the English were conspiring against the Arabs. After the end of the Second World War, the horror of the holocaust was used by the Zionist movement to gain the West's sympathy for their cause.

During the First World War, my father, Sheikh Hafez Albatta, studied at Al Azhar Al Sharif University in Cairo, which taught religion, Arabic, and Islamic Law, and was one of the oldest and most prestigious universities in the Arab world at that time.[5] After he graduated as a teacher, he couldn't return to Khan Younis because of the war, so he worked in Cairo and married the only daughter of a widow. In 1921, his father died and his mother remarried, and all his sisters were sent to different members of the Albatta family to be looked after, so he decided to return to unite the family and take care of them. He told his wife that he was returning and asked if she would come with him; but, her mother would not allow her to go and told her that if she went, she would have to forget her and she would not receive an inheritance. She also told her daughter that the people of *Sham* (the Levant region) were very strong and that she would not be able to live with them. My father's wife hesitated in choosing between her

husband and her mother, but my father had already decided to go, and she chose to stay. When the sheikh divorced them, they both cried.

My father returned to Palestine in 1922, the year it came under the British Mandate. He found work as a teacher of the Arabic language and Islamic religion in the Beersheba school,[6] and brought all his sisters there. At that time, my uncle, Fayez Beik Al Idrisi, was in charge of the police and general security under the administration of the British Mandate, and he sometimes organized horse races for the British. One day, he took his mother, whose origins were in Syria and Turkey, so she didn't cover her face like the Palestinian women living in the southern districts of Palestine.[7] She had recently returned from a trip to Syria, where she had bought clothes for her four daughters and many other things. She brought her daughters to the races, and they happened to sit in the front row across from where my father sat, and he kept looking at one of the daughters and fell in love with her. When the races finished, he wanted to meet this girl and marry her, so he went to his cousin, the mayor of Beersheba, and asked him about her. His cousin asked my father which of the girls he had fallen in love with, but he didn't know her name; he only knew that she had worn a violet skirt and jacket.

The mayor's wife then visited the family to welcome the mother home from her trip. She told her she had heard that her daughters had worn very beautiful clothes at the races and asked to see them. As in most places, the south was underdeveloped, and because Beersheba was small, news spread very quickly, so these clothes had caused much gossip because they were not normally worn by the local people. My grandmother asked her daughters to bring the dresses they

had worn, and when the mayor's wife saw my mother with the violet skirt and jacket, she asked if she had worn them at the races. She said yes, and that her sisters had worn dresses of green, dark blue, and brown. So, my father discovered the name of my mother, the girl he had fallen in love with. Her name was Rabia, and she was the second youngest of the four girls. He sent his cousin to my uncle to ask for her hand in marriage.

My uncle said that Rabia couldn't marry before her two older sisters, but that my father could marry either of those two. My father refused, so again my father's cousin returned and told my uncle that my father wanted Rabia. My uncle told him that Mufida, the oldest, was very skilful at sewing and her hands would bring gold, and because Khayria, the second oldest, had taken care of her father when he was sick, she had inherited a lot of land, more than her sisters, when he died. He returned and told my father what my uncle had said, but my father said he didn't care about gold or land, he wanted to marry the one he had fallen in love with. So, my uncle told his wife and mother that Sheikh Hafez Albatta wanted to marry Rabia, and after a long discussion they agreed.[8] My father was so happy that my mother's family had finally accepted him, and they were married in 1923. In fact, my parents weren't just husband and wife like ordinary married couples; they were very much in love and my father worshipped her. My mother was very beautiful, with white skin and very dark, straight hair. She was also very clever and had very good manners. She was from Nablus and her mother was from Syria, and her great-grandmother was from Turkey. Her father's family was Al Idrisi, from the family of the Libyan King Al Senussi.

My father was employed by the administration of the British Mandate and moved from town to town according to their instructions. My parents moved to the town Al Majdal, the name of which was changed by Israel to Ashkelon, and I was born there on July 8, 1924. My first memory of Al Majdal was on June 1, 1927, when I was almost three years old and my mother gave birth to her second child, my sister Ni'mat. That day, a lady wearing Al Majdal *tawb*[9] came and quickly put her *shash*[10] over the clothesline and our blue towel on her head. Then she entered my mother's room and closed the door. I was surprised at what she did, and more astonished when I heard my mother screaming and screaming, and I didn't know what was happening. I thought this lady was beating my mother, so I beat on the door to try to help her, but it remained closed. After almost an hour, it opened and the lady came out. Before she opened her mouth, I took our towel from her head and put it under my arm and said, "This is our towel."

She said, "You speak about your towel! Come and see the baby! You have a beautiful sister. Come and see, leave the towel." I looked and was astonished because the baby was wearing my blue hat. Before I looked at her, I took the hat and put it under my arm with the towel and said, "This is my hat."

The lady said, "Come and look at your sister, she is beautiful, isn't she?" But I only looked at my mother.

After forty days, my mother went to another room to take her fortieth-day bath as per Muslim tradition, but was afraid that I might hurt my sister, so she took me with her. She put me in the corner on top of the wooden stand that held the mattresses we used for sleeping, and under me were a big

towel, my mother's clothes, and a yellow comb. I was excited and sat singing to the sound of the water boiling on the kerosene burner. Our rooms were built of clay and there were no bathrooms or bathtubs, taps or water heaters, only big basins for washing and copper pots to boil water on the kerosene burner. Suddenly my mother stood up, pulled the towels from under me and covered her head and body. She took me in her arms, opened the door and ran. The water was dripping off her and the comb fell and broke, and I told her, but she said to forget about it, and we ran outside into the main street of Al Majdal. This was the only big street, with clay houses on both sides and some gypsies' tents spread in the area. She had forgotten my baby sister Ni'mat, and on the way she said, "It's enough if one of my daughters is saved. It is better to save one daughter than lose both."

The street was a flood of people, with everybody running south and crying, "God is great! There is no God but Allah, and Mohammed is the messenger of Allah!" But I didn't understand what was happening and why they were running. After five or ten minutes, they became calm and returned to their houses, and my mother ran back to our home, still carrying me. When we came close to our house, our neighbour quickly opened the door when he saw my mother covered only in a towel. When I was older, I heard my mother telling the story of the earthquake that happened when Ni'mat was forty days old. She said, "While I was having a bath, I felt the earthquake. The kerosene burner began to shake, and the pot of boiling water above it shook as well. I was afraid the boiling water would fall on me, so I quickly stood up, covered myself with the towel, took Madeeha and escaped into the street."

Two months ago, I was listening to a radio programme called *Good Morning Egypt* when the earthquake that happened in Palestine on July 11, 1927 was mentioned. They said it was a strong earthquake that hit the whole of Palestine, and I counted back forty days from this date and found it was the June 1st, the date of Ni'mat's birth.

We moved back to Beersheba at the beginning of 1928, when my sister was still very young. Beersheba then was almost empty, with very narrow streets. The main street was long and on both sides were shops, most of them owned by merchants from Gaza. There was a police station and a combined school for boys and girls: boys on the ground floor and girls on the upper floor. It was built by the English during the British Mandate and there was a cemetery beside it. There was a big palace that belonged to *Hajj* Fraih Abu Middain, and some of it still remains. In front of the municipality was a square with a statue of the British leader Allenby, who had occupied Beersheba. Tuesday was the main market day, so merchants came the day before and stayed the night so they could go to the market early the next morning. They stayed in a *khan* where they slept in rooms of clay, in front of which was a big empty square surrounded by a wall and a big gate. Behind this *khan* was the main market-place. The people who owned the *khan* made coffee and wheat bread for the merchants. Bedouin who came to town to sell their animals and produce also spent the night there, and I saw them in their traditional clothes of *'abaya*, *hatta*, and *'eqal*, and at night I could see the smoke of their fires and smell the brewed coffee. My childhood started here.

I used to play with the children of the owner of that place, and I remember his daughter Maryam had a drum that

her mother bought from Al Muntar in Gaza. My brother *Al Shahid* Hassan, the martyr,[11] was born in Beersheba in August 1929, and my aunt and cousin came from Nablus soon after he was born. Before they left, my aunt took me to the market and bought me a doll, but told me to hide it and not play with it until after they had left in two days' time, and not to tell her daughter who was one year older than me, because she would cry. That afternoon, while my aunt slept, I showed my doll to my cousin and told her that her mother had bought it for me and hadn't bought anything for her, and that she had asked me not to tell her. She started to cry, and her mother woke up and became very angry. She gave me some money and told me to take her daughter and buy a toy from the shop beside us. It was safe then to go out. The next day, when I took my doll outside, I saw Maryam and asked her to give me her drum to play with. She said she would if I gave her my doll, but I refused and quickly took the drum from her and broke it and ran home. The girl went crying to her mother and a short time later brought her to our home, complaining about what I had done. I was beaten that day.

I used to play in the streets of Beersheba and once I saw a big group of people running in the streets. It was a very big demonstration, but I thought it was a wedding party, so I ran with them. My mother called me, but I didn't hear and then a neighbour pulled me from the middle of the demonstration and took me home. My mother shouted, "What were you doing there?"

"I was watching the wedding party."

"Stupid! That was a demonstration, not a wedding!"

That year, some Jewish people were killed in Hebron and the English searched for *Fedayeen*. There were dozens of Jewish families in Hebron then and they lived peacefully

with Palestinians. If Palestinians had good fruits, they gave to them, and if the Jewish people baked good bread, they gave to Palestinians. There was no animosity between them, but this relationship was poisoned when Jewish immigrants, with the help of the British Mandate, began to colonize Palestine. Palestinians realized then that the Zionists were preparing to take over the country and would eventually outnumber them, especially in Hebron, so the problems started.

I started school in Beersheba in 1929 or 1930, and I used to go with my father. When I registered in the first class, I went with my neighbour and stood in a line in front of her. The teacher asked me my name, my father's name, and my address, and then it was my neighbour's turn. The teacher asked for her name, and before she came to her father's name, I quickly said that she didn't have a father, and asked how she could give her father's name because he was dead? The teacher was very angry and told me to be quiet.

Once I was playing with my friends outside our home when we saw a very big black cloud covering the sky and thought rain was coming. It wasn't a rain cloud but locusts, which attacked Palestine in 1930. When we saw the locusts, we ran to our homes. When I was home, my mother quickly closed the door because they were everywhere. The locusts ate the plants, trees, and everything green and turned Palestine into a desert, so the British organized campaigns with planes that spread chemicals over the land and killed them. Then they arranged a very big party to celebrate their success and invited the notable people of Beersheba, such as employees of the administration of the British Mandate, the mayor, *makhateer*, as well as the English officers and soldiers.[12] The soldiers played music and organized a horse

race with the Arabs at the party, while some Bedouin cooked a big meal of sheep and bread for the guests. It was a very beautiful party held in a place called Wadi Sabha, and it went from afternoon to midnight. I think it was in April, in the middle of spring, and it became very cold that night because it was in the desert.

The meal was served by the British Mandate administration's employees, and among them were teachers from my school. As they offered food to my mother, they congratulated her on the recent birth of her baby. My mother was holding Hassan, who was then seven months old, and she was surprised and asked why they were congratulating her and who had told them. They answered, "Madeeha." One teacher told her that I had cried at school because I had lost a bag of sweets that I had brought instead of my sandwich, and when the teacher had asked why I hadn't brought a sandwich, I said I had brought the sweets that my grandmother had brought from Syria to celebrate the first week of Hassan's birth. In fact, I had forgotten to bring my sandwich and had lied in order to get one. My mother was very angry when she heard this.

After lunch, there was an acrobatic display by the planes that had sprayed the chemicals on the locusts. When it became dark and we were about to leave, we were told that the program wasn't finished, and a big screen was erected to show a film of how the planes had destroyed the locust plague, followed by a Charlie Chaplin film. I still remember it, and if I close my eyes, I can see what he was doing. Then we took a taxi home. There were a few taxis then, owned by Gazan people working in Beersheba. When we arrived home, I was punished for lying, and also by my teacher the next day.

My father, who was originally from Khan Younis, insisted on being transferred to his hometown, so, in 1931, the British agreed to transfer him as an Arabic teacher to the Khan Younis Boys' School, the only school there. Boys studied until the seventh class (grade) and then went to Jerusalem if they wanted to continue on to high school. My father was very happy about returning to his hometown and bought a *dunum* of land situated in the most beautiful area of Khan Younis. At that time, it was almost empty, with only a few small clay houses. My sister Nadida was born in 1932, a short time before we moved to our new home. She was my youngest sister, and I raised her as my daughter when our mother died. Later, she became a headmistress. She just died a few years ago.

In 1932, my father built our beautiful sandstone house with the coloured glass windows he had dreamed of. Sandstone is not durable like mountain stone so our home only lasted fifty years, but my grandfather's house in Nablus is over one hundred years old and is still standing. In Ramallah and Jerusalem, the houses were the same for a long time because the stone is so strong.

While the house was being built, the baker was busy baking bread, which he brought three times a day for the workers. I remember the donkeys, carrying one big sandstone block on each side, coming from Abasan and Bani Suheila, villages to the east of Khan Younis. It was the first house to be built of sandstone and was like a palace, a landmark of Khan Younis, and people passing by would always stop and look. It had red tiles on part of the roof, and balconies, and a big open area of white tiles in front of the house, with a separate entrance for men leading to the first

floor and another area for women upstairs. When my mother entered, she covered her face and sometimes greeted the male relatives, which made my father angry. He used to tell her not to speak to them because when a woman is covered, she should not speak to men. My father was very strict, but later I succeeded in tempering his strictness, thank God. My mother liked gardening very much and planted the garden with many roses, jasmine, basil, orange trees, and many other fruit trees. I still have a photo of the house, taken from the balcony of my home across the street.

The weekend was on Thursday and Friday, but only in Khan Younis because there were only two Christian families, while the schools in the rest of Palestine had Friday and Sunday as their weekend. Also, Thursday was the main market day and it was important for people to buy and sell on this day. We gained a lot from those weekends of two consecutive days, especially if we wanted to visit my mother's family or my uncles in Jerusalem or the West Bank. We would travel on Wednesday afternoons and return on Friday afternoons. I had been to Jerusalem, Nablus, and Jenin during the school holidays and on weekends with my mother because my uncle Fayez Beik Al Idrisi lived there. I had also visited another uncle in Ramallah, as well as a third uncle, who was a magistrate and lived in Tulkarm. But the first time I travelled outside Palestine was in 1934, when I went to Egypt with my parents.

Every year, the British gave their employees four free train tickets with which they could travel anywhere. After we moved into our new home, my father wanted to use these tickets to travel to Egypt, although my mother was then six months pregnant and hesitant about travelling. But he insisted, so my parents, Hassan, and I travelled to Egypt. I

still remember that first trip to Egypt when I was nine years old. I couldn't believe I was going on the train and tried to imagine how the trip would be. My parents laughed and spoke and smiled at me. We took the train that came from Haifa and went to Al Qantara, where we crossed the Suez Canal and then picked up the train again on the other side and continued to Cairo. We rented a suite in a hotel called The Modern Club in Al Hussein, one of the best areas in Cairo. There were no radios in the Gaza Strip, so I listened to the radio for the first time at that hotel, because in that year Egypt established the country's first radio station. The hotel had a very big hall and the radio, which was the size of a sofa, hung on the wall. When I entered, I heard someone singing and asked my father who was singing. He said, "Look there, that box."

I asked, "How can a box sing?"

My father explained about the radio, and said, "You are lucky that you saw it because this is the first time that Egypt has a radio station you can listen to."

Not far from the hotel a shop sold boiled milk because there were no refrigerators, and I went every day to buy it. One day, I became lost because all the roads were similar, and I didn't know which one led back to the hotel. So, I cried as I carried the hot milk and an old man asked why I was crying. I told him I was lost, and he asked me the name of the hotel and then pointed the way. When I returned late, my father was very worried and angry that I had lost my way because it wasn't the first time I had gone to buy milk.

Two years ago, I visited Egypt, and after praying in Al Hussein Mosque with my niece and cousin, I searched for this hotel and asked a very old man what had been built in its place. I had assumed the hotel was gone because it was

very old in 1934, but he told me it still existed, but that its name had been changed, and gave me directions. I didn't believe him, but I went in the direction he told me. I then asked another old man, who was sitting and smoking an *arqila*, about the hotel. He told me it was two hundred years old and had a new name and was at the end of the road. Nothing had changed except the big hall near the reception area, which had fallen down and hadn't been rebuilt, but instead had been made into a parking lot for hotel customers.

I liked Cairo very much. I saw *The White Rose*, the first film at the cinema starring Muhammad 'Abd al-Wahhāb, the famous Egyptian composer, singer, and actor. We also attended a concert of Umm Kulthūm, and I was amazed at the jewellery she wore over her black dress, and her posture when she stood in front of the microphone to sing. I thought she was singing from memory because she wasn't holding any paper in her hand, and as I listened to her voice, I told my father, "She's really very clever in composition." My father laughed and whispered something to my mother that I didn't hear. Many times, I couldn't understand what they said to each other. Then he asked me, "Why do you consider her good in composition?" I answered, "Because she sings in sequence. She sings that the whole universe shares her happiness: first the air, then the birds and trees, then the rivers and land." He said I was very clever and was surprised that at my age I could understand the meaning of her song.

When we attended Umm Kulthūm's concert, we had left Hassan with relatives who lived close to the hotel, because small children were not allowed. He had been asleep when we left him, but later woke up and cried because we weren't there, so after my relatives tried in vain to calm him, they

brought him to the concert. Sometime before the end, we
heard noises and crying from the entrance of the hall, and
my father saw the guards trying to prevent our relative,
holding Hassan who was crying loudly, from entering. He
quickly went and asked the guards to allow him to take
Hassan to his mother, and promised that Hassan would not
cry, and that if he opened his mouth, we would leave. Thank
God, after my mother took Hassan in her arms under her
veil, he immediately became quiet and slept. It was early
morning, about 2:00 AM, and very cold when the concert
finished, and people rushed quickly outside the theatre to
find horses and carriages to take them home because there
were no taxis. My father waited until the crowd diminished
and then he found a carriage to take us to the hotel. The next
night we went to the cinema, and the third day we went to
the Egyptian museum and the pyramids.

We spent two weeks in Cairo and then travelled to
Isma'ilia, where we spent three days at my uncle's home. He
was a road contractor for the English and had married an
Egyptian. Then we travelled to Abu Hammad Al Sharqia to
visit two of my father's colleagues who had studied with him
at Al Azhar University, and they killed a goat every day for
lunch for us as a sign of their hospitality.

We returned to Khan Younis, and three months later
my mother delivered twins: a boy named Abd Al Azeez and
a girl called Radiyya. My mother contracted a fever after
the delivery and died one week later because there were no
antibiotics, ampicillin, or sulpha. The twins were sent to wet
nurses; Radiyya went to one family and died at four months,
and Abd Al Azeez went to another family and died nine
months later from a fever. He was a very beautiful boy, and I
remembered him and cried for him again when my brothers

Hassan and Nadid were killed by the Israelis in 1956. That day, I cried for them and wished that Abd Al Azeez had lived so that at least one brother from my mother would be with us.

Everybody in Khan Younis cried when my mother died because she was good to everyone. She was the only one who owned a sewing machine, and she taught the women of Khan Younis many skills: knitting, crochet, sewing, and cooking. This made people even more sympathetic, and when we passed in the streets, they would say, "That is Madeeha, daughter of Rabia, that good lady. God be merciful."

From that day, I stopped being a child and became responsible for the family. You could say I went instantly from childhood to adulthood and became a mother to my brother and sisters. With my pocket money, I bought chocolate and sweets and was very happy when I gave them to my brother and sisters. My father remarried one year later in 1936, the year of the Arab Revolt and the six-month strike against the British and their support for the Zionist movement, and in protest of the Jewish immigration to Palestine that undermined our rights to our country; the strike lasted from March to September.[13] After the end of that revolt there were many negotiations between the English and the Arabs, which resulted in many agreements, but at the same time treachery started. Anyone suspected of being involved in actions against them, or even attending meetings to discuss the political situation at the time or how to mobilize and protest against their policies, had their house blown up by the British as a punitive demolition. Village houses were built of clay, so it was not such a big thing to blow them up. The British also sent thousands of those involved in activities against them to a place called Al Sammakh,

close to Tiberias. Their brutal suppression of the revolt left many killed, wounded, and deported. They also hunted and arrested many *Fedayeen*, among them Mohammad Jamjoum, Ata Al Zier, and Fouad Hijazi, who participated in the 1929 uprising that started in Jerusalem and then spread to the rest of Palestine. These three young men were among the *Fedayeen* who led the protests against British Mandate rule and the colonization of Palestine in 1929. They were imprisoned in Acre Prison and hanged in front of thousands of people in a big square.[14] The executions, which took place in June, were intended to silence the resistance. The English wanted Palestinians to understand the message that anyone who resisted would be killed. A famous poem, titled "Min Sijjin Akka" ("From Acre Prison"), that later become a popular song, was written to commemorate these heroes. It continues to be recited and sung by Palestinians throughout Gaza and by those in exile, especially on June 17th of each year, the anniversary of the execution of these three martyrs. This song was the beginning of my awareness of the Palestinian cause, the Zionist project, and British colonization.

The *Fedayeen* attacked the police station, post office, and railway station in Khan Younis and regularly attacked trains carrying English soldiers, so the British began the practice of putting a large number of Palestinians on a small motorized cart in front of the train. If the line was mined or they were attacked, the Palestinians were killed, leaving enough time to warn the following train. I know of many Palestinians who were killed because the cart was blown up, and of course the train stopped before it reached its destination.[15]

The second time I travelled outside Palestine was in 1937. As I said earlier, my mother died in 1934, three months after

we returned from Egypt, and my father remarried one year later. That year, we spent our holidays at the Khan Younis beach because we couldn't go anywhere due to the strike. My father loved the beach, and we spent the whole summer in the area now known as Al Mawasi.[16] We had canvas shelters with roofs of palm fronds, and the people of Al Mawasi were our friends and helped us a lot. We gave them a sack of flour when we arrived, and every day, they brought us freshly baked bread. We brought a kerosene burner and pots to make tea and coffee, and kitchen equipment for cooking, and every week we sent someone to the town market to buy meat, vegetables, and fruit. So, we spent almost three months at the beach, from the day school finished until one or two days before school started. I consider that holiday one of the best times of my life. I have travelled a lot outside of Palestine, and I can say that this beach, with its clean white sand, was the most beautiful I have ever seen in my life. A lot has been written about the beautiful beaches of Tunis, and I have been there, but they didn't look like the Khan Younis beach at that time. Al Mawasi changed after 1967. Now most of the beach area is occupied by Israeli settlements and the rest has become neglected and dirty.[17]

In 1937, my father took his wife on a late honeymoon to Lebanon and Syria, together with Hassan and my half-brother Nadid, the martyr, who was born in September 1936, and me. We took the train from Khan Younis to Haifa, with the free tickets my father received as an employee of the administration of the British Mandate. I had my notebook in my hand and wrote down everything that happened on the journey, such as the time we left Khan Younis and the names of the stations along the way. In Haifa, we had lunch in beautiful restaurants, and I remember a restaurant called

Khairazan, which was situated over the sea and still exists today. We spent three nights in Haifa and visited Mount Carmel, and then went to Acre where we prayed in the Al Jazzar Mosque and spent a very nice time.

After we left Haifa, we rented a taxi, and I wrote down the names of places and information about the area that I got from the driver. We were travelling with two of my father's friends from Khan Younis: one was a merchant and the other knew the area very well. At that time, the borders between Palestine, Lebanon, and Syria were open, so we didn't need a visa or special permission. We were included on my father's Palestinian passport along with his wife, because a wife and children under sixteen were registered on the man's passport, and my father only needed to show the passport to the border guards as we moved from area to area. Before crossing from Palestine to Lebanon, we saw a girl selling watermelons by the roadside. My father's friend offered her five *qersh* for one, but she asked for eight; after some bargaining, she went to ask her mother. She returned a short time later and accepted the money, but when my father's friend took the watermelon, he shouted angrily at her and said she had exchanged it for one that was smaller and not as sweet. He knew because he had scratched a mark with his fingernail on the original watermelon.

In Lebanon, we stayed in a big hotel in the mountains. There were only two hotels, and a long asphalt road with big tall trees on both sides led to them. The place was very, very beautiful and the scenery was amazing. My father and his wife slept in the afternoons, and my father sent Hassan and me to play in the park of the other hotel, because it had swings for children and he didn't want us to become bored. We played there until late afternoon when they came and met us.

From Beirut, we travelled to Damascus and stayed in a big hotel close to Al Hamidiyah Souq, a very big, beautiful market that can only be entered on foot and where one can buy every imaginable thing.[18] We also visited Al Umayyad Mosque and prayed there. Once, after lunch, we bought ice cream at a shop where women and men were segregated. The women were very religious and strict, and when they saw me uncovered with my father, they said, "Look at that girl. She doesn't cover her head and her father looks religious, like a sheikh. How can he allow his daughter to do this? It's not good." My father heard them, and before we returned to the hotel, he bought me a white scarf to cover my head while we were in Damascus. I was twelve years old at the time. While I was there, I also visited my grandmother, who was visiting her sisters and relatives. I spent a very nice time with her, and she gave me some gifts. Then we returned by train to Khan Younis.

In that year, I finished the fifth class and started to think about my future. I felt that I didn't want to be another copy of the women in Khan Younis, sitting at home with my father's wife cooking and cleaning, then marrying one of my relatives or a family acquaintance and having a family. I didn't want to be imprisoned at home. I wanted to see other places, and because I had travelled and seen life outside of it, I always thought it would be a disaster if I lived the rest of my life in Khan Younis.

2 / School Days

IN MY HISTORY, there is a lie that changed the direction of my life and I hope that God forgives me for lying. My father was a very religious and strict man and he totally opposed my wish to study in Ramallah, because from a religious point of view, women were prohibited from travelling without a male escort for safety reasons. Even when a woman goes on pilgrimage to Mecca, a man should be with her to assist and protect her along the way. But I thought that these rules, which were applicable in the old days, were incompatible with our current time, when transportation had become faster, shorter, and safer than the camels and horses that people used to travel with at the times of the prophet.

The lie started when Mustafa Al Dabbagh, the inspector of education in Jaffa region from 1933-1940, came with the British head of education, Mr. Farrell, to visit our school. At that time, there were only two schools in Khan Younis, so they visited the boys' school first and then came to my school and visited our class. The girls' school went up to fifth class and the fourth and fifth classes were combined, with eight girls in the fourth class and four in the fifth class. There wasn't a teacher for each class because there weren't enough

children, so we were divided into two groups and studied different material. Mustafa Al Dabbagh asked the headmistress to choose a girl to recite something from her studies for the guest and I was chosen, and because I was short and thin, I stood on the table where I could be seen. When I saw the Englishman, I wanted him to understand the glory, generosity, and shining history of the Arabs, so I recited a poem from the Palestinian classicist poet Isaaf Nashashibi about Arabs and their values. Mustafa Al Dabbagh translated my words, and they laughed because the meaning of my poem was about generosity. If a beggar visits Arabs, they quickly slaughter their camel to welcome him; they don't differentiate between a rich or a poor man or an Arab or foreigner, because everyone should be welcomed in a good way. After I finished the poem, they lifted me from the table, and Mustafa Al Dabbagh patted me on the shoulder and asked my name. I said, "Madeeha Sheikh Hafez Albatta."

He said, "Oh, this is why you are clever. Like father, like daughter." Then they left the school. After they left, I had a strange idea, to convince my father to allow me to attend the teachers' training college, so when I went home I asked him if the British head of education had visited his school. He said, "Yes, then they visited your school."

"No, I asked whether they returned after they visited us."

"No, they didn't return."

The school had two shifts, with a break usually between 12:30 PM and 2:00 PM before the next shift started, so I said, "Surely they returned but they didn't find you because it was break time."

He asked why, and I lied and said, "When they heard my poem, they said that I should go to the teachers' training college because I am very good, but our headmistress said

that you are very strict and would not allow me to go to Ramallah. The British man said that he had heard of the Sheikh Hafez Albatta and he is very educated. But the headmistress said that he had told you from the beginning of the year that I should attend the teachers' training college, but you refused because it is against Islamic rules to travel without a man. Mr. Farrell then said that there were no male teachers and even the porter was prohibited from entering the school, that the school is only for Muslim girls."

It was true that this school was established to encourage Muslim families, especially religious families and those in villages, to send their daughters to study. There weren't any Christians there because they had their own schools.

My father asked, "Is this right? Did he say this?"

I said, "Yes, this is right." So, he said he would think about it. When he said this, hope began to grow in my heart, and whenever I sat with him, I reminded him of his promise to think about sending me to Ramallah, and how, God willing, I would study there. He told me to be quiet, but I persisted, "No, you said you would think about it. You promised me." He said he would think about it if I continued to be the first in the class, so of course I was.

I began attending school when I was young, but many girls in Khan Younis started school at an older age, because their families lived in villages and delayed sending their children to school until they became mature enough to attend without being accompanied by a family member. Also, some students failed their exams and repeated the same class once or twice, and two girls in my class were engaged and soon to be married, so I was very young compared to other students. I was twelve years old when I finished the fifth class, and that was the highest level of education at that time.

After I came first in the fifth class exam, Miss Helen Ridler, the principal of the Women's Training College and the inspector of girls' schools in Palestine, told the headmistress to allow me to repeat the fifth class the following year, so I wouldn't forget what I had studied and to prepare me for the exam the next year. So, I repeated the fifth class, and occasionally replaced any teacher who was absent during that time. I like reading very much, so when I was bored, I sometimes left the class and read any book I could find. I spent that year reading all the books in my father's library, which was very big and covered an entire wall. I read those books I could understand, and many beautiful stories, and my father told me to put a question mark beside the words I couldn't understand and ask him. So, when I attended the teachers' training college, I was the strongest in Arabic amongst all the girls, who were all two or three years older than me. I was at the top of the class, and among the first top students in Palestine.

The next year was 1936, the year of the six-month strike, and there was no exam. In fact, there was no school during the strike. All of the schools were closed or stopped, except our school, because we had small numbers and nobody paid attention to our coming and going, and because the headmistress cared about education and encouraged us to come. There was an exam at the end of 1936, and three months later, in 1937, there was another exam, and I came first in both.

When she first met me, Miss Ridler said that I was good, but I was young, so I couldn't be sent to a boarding school where I had to take care of myself. At that time, I had very long hair, which my aunt combed and plaited because I couldn't do it myself. I saw that Miss Ridler's hair was up,

not down, and fixed in a bun, so at my next interview, in
1938, I did the same. When she met with me, she asked my
age and realized that I was still one and a half years below
the required age. She asked me who combed my hair and I
told her that I did. She then asked why I did my hair like it
was, and I told her that I wanted to be like her. She smiled
and seemed to like my answer, and then asked who took care
of me, and I answered that I did. Then she asked why my
mother didn't help, and when I cried and told her that my
mother had died, I felt that she sympathized with me.

Finally, I was accepted in 1938, even though I wasn't yet
fifteen years old. When I received the acceptance letter, the
first thing I did was cut my long hair because I knew I would
not be able to look after it. My long plaits were gone. I was
sent a list that included everything I should bring to the
school, and I had to embroider my name with red silk thread
on every piece of clothing because they would all be washed
together. So, every day, from the first prayer in the morning
until midday, I worked on my mother's small sewing machine
to prepare my clothes and things to take with me, and at the
beginning of September, everything was ready and packed.
The night before I was to leave was the most beautiful night
of my life, even more beautiful than my wedding night. I
spent that whole night walking the corridors of our home in
the moonlight. I couldn't sleep, I couldn't even wait for the
sun to rise. I was very eager to go and waited for the sunrise,
moment by moment, until morning came, and the sun
appeared, and then I travelled to Ramallah.

My father took me to the college, then to my uncle's
house, and left, and I stayed with them for three days. Then
my uncle took me to the school. I was very clever in math-
ematics, Arabic, geography, and history. The only subject

I wasn't good at was domestic science. I cried when I cut
onions and had to have a break before continuing, so the
teacher always shouted at me and gave me very low marks,
like sixty-five or sixty-seven out of one hundred; as I had
achieved ninety-eight in Arabic and ninety-nine in mathe-
matics, it lowered my average, even though I remained the
top pupil. I did not like that subject and I did not like the
teacher, who expected me to do everything perfectly. After
a while, though, the domestic science teacher saw that I was
in some distress, and she changed her approach and started
to encourage me. I started to get better marks: seventy-eight,
seventy-nine, and even eighty. In time, my relationship with
the teacher changed and I began to like her. A few years ago,
I saw her death notice in the newspaper and felt sad that she
had died. She was from Bethlehem.

In 1939, while I was at the college, the Second World
War started. All the windows were covered with blue adhe-
sive plastic and it was forbidden to put a light on at night,
because Haifa had already been hit and we didn't want to
be a target as well. We had to feel with our hands along the
walls until we came to the toilet, and then turn on a light.
Ramallah was mainly a Christian city then and had no
mosques, so there was no *muezzin* to call the prayers, so after
I prayed the fourth prayer, I kept the prayer mat beside my
bed while I waited for the fifth prayer. I didn't have a watch
then. My father bought me one when I became a teacher.

The English used all their resources to fund their army, so
there were shortages in everything because the money went
to support the war. They distributed coupons for sugar, flour,
tea, and oil—all the necessary things—but there were only
limited supplies and not enough for the people. They even
stopped people from fishing because they wanted to clear

the sea for the English battleships, so there was no fish, and only brown sugar because the factories that processed sugar were used for the war effort. Then they built a big asphalt road that went from the east of Khan Younis through the Sinai Desert and the northern coast of Egypt, through Libya, Tunis, and Morocco, through all of northern Africa to the Sea of Gibraltar. This road ran parallel to the railway line and was used by military tanks and vehicles full of soldiers.

In 1941, I graduated from the teachers' training college. My father was very proud when he received my certificate, which was sent to the fathers by post, and took it to the Agha family *diwan* to show them my marks. Our studies had been extended from two to three years, because there was no budget for employment after we graduated due to the war. We were the first group of teachers to study for three years, and even when we did graduate, not all of us were employed, but I found a job immediately because I came in first before thirteen other girls. After a few months, another three girls found work, but it wasn't until almost three years later that the remaining graduates were employed.

I was employed at the same school that I had attended in Khan Younis, and my salary was nine English pounds. Later, when I became headmistress, my salary increased to thirty-five pounds. Salaries were raised a little during the war because everything became very expensive. My salary was a great help to my father, and he gave me one Palestinian pound to spend, which still bought a lot of things. When I became a headmistress, he gave me two pounds from my salary. Every *malleem* I took from my father as pocket money I used to buy milk, eggs, and fruit. Every day, I ate four eggs and drank no less than one litre of milk. I didn't care about clothes because that was my father's responsibility, and in

fact I didn't care if he bought me clothes or not. I always drank all kinds of juice—tomato, orange, grapefruit—from our garden, so my health is still good, thank God. My weight was low, but my health was good, and I rarely caught colds and flu like other people.

It was unusual to buy milk in Khan Younis because people who had cows or other animals gave milk to those who didn't. We drank milk every day, and my father arranged with the bus driver who travelled daily to Gaza City to bring us milk in gallon pots. When I became a teacher, my students brought me milk, but when I wanted to pay them, they refused and said that their mothers had sent it as a gift. They became shy when I offered money, but I told them I wanted milk every day and not as a gift, and if they didn't take the money, I would not take the milk. But they kept bringing it, so I threatened that if they didn't take the money, I would fail them at school, so then they accepted the money and every day I received fresh milk.

When I became a teacher, I not only taught but was also active in the women's community. I met women and girls in their houses during the reception days they organized for drinking coffee and tea and gossiping, and I used these opportunities to read and explain verses of the Quran to those who didn't understand. I also helped people solve their problems. Once a group of nine girls came to register at the school, but they were refused because they were older than the enrolment age. When I asked the headmistress the reason, she said that they were eight and nine years of age and the acceptable age for the first class was five or six years, so she couldn't put them with the small children. I became very angry and told her that these girls were from my town and it was the fault of their families that they had not been

registered before. I was teaching the first class and told the headmistress that I could include them in the class and work with them, and I assured her that their level would be better than the rest of the class. Although she was doubtful, I registered them in my class.

I taught those girls and seven of the nine were very clever, more intelligent than my other students. Every lesson was usually forty-five minutes, but the lessons for the first class were thirty minutes, with a fifteen-minute break between each lesson. So, I took my chair and sat with these students under the orange tree in the schoolyard and gave them extra lessons, encouraged them, and checked their homework. By the end of the year, they were the first in the class, and they succeeded year after year until they reached the seventh class. By that time, the last two classes had been added to the school. Two of the girls later left for family reasons, but I thought of the remaining girls when the refugee girls were registered and teachers were needed, and these girls later became headmistresses in girls' schools in Khan Younis. Things like this made the education department consider me as a headmistress, even though I was very young. They heard about my role in the community and how I was helping and taking initiative.

When I was first nominated as headmistress of my school, I refused, because I didn't want to be in charge of my former teachers, who weren't even happy that I was their colleague. I expected many problems, so I refused. However, my father and those who nominated me—Basheer Al Rayyis, the education inspector of the southern area—insisted, and in the end, I couldn't refuse the offer. Their argument was that the school's level had decreased because of bad administration, and they wanted to hire someone from the school who knew

the situation and was clever enough to administer the school and raise its level. A telephone, the first in Khan Younis, was installed at the school, and I was to phone the education department the moment I had any problems.

On my first day as headmistress, I went to the assembly and was so afraid that some of the teachers would physically attack me, which they could easily do because I was small and thin. I was correct in my expectations of the teachers' behaviour. They started lobbying against me in the same way they had done with the previous headmistress, finally causing her to leave, but a committee from the education department helped me to get rid of the ringleader when it saw that she was disturbing my work. The committee went to her father and told him about the problems she was causing at school and said that there were two options to solve the problem: she would be fired, or she could marry and resign. Female married teachers were not allowed to work during the British Mandate, and anyone who wanted to marry had to inform the department one month before, so a replacement could be found. Her father arranged a marriage for her because gossip in the community would certainly result if she was fired. She left the school, and this was a warning for the other teachers to stop causing problems because they knew the consequences. So, they kept quiet, and I was able to administer the school easily and the standard began to rise again.

I became headmistress in 1946. Before 1947, we taught in a rented house, and then the English built our school and a boys' school. At that time the Partition Plan was decided by the United Nations, and according to this plan, the English would finish their mandate and leave Palestine on May 15, 1948. At the opening ceremony for the boys' school, which

was called 'Izz Al Din Al Qassam—named after the revolutionary Arab leader who stepped up for Palestinian rights, challenging the British—the English head of education made a speech in which he said that he knew all of us were waiting for May 15th and the end of the British Mandate, but that he was sure that after this date we would cry for these days.[1] And this happened. By then we had moved to the new school in Khan Younis City, and in 1948, the war, and the problems that forced hundreds of thousands of Palestinians to leave their homes and lands, started. Many people from Jaffa city, Al Majdal, and other nearby villages found refuge in Khan Younis or passed through on their way to Rafah or the Sinai. I saw them clustered everywhere in the Khan Younis streets, and under trees, in mosques, and near the beach. These scenes of the displaced families and their children had a very big impact on me, and many times I cried about their situation.

In July 1948, during the holy month of Ramadan, Lydda and Al Ramle were occupied and their inhabitants, about seventy thousand then, were expelled to the West Bank. People were forced to flee their homes in the heat of the summer after the Dahmash mosque massacre. With the exception of the local people who had very poor weapons, very little effort was made to save these towns, including on the part of King Abdullah's forces. The King wanted to transfer the West Bank to Jordan, and he even collaborated with the Zionist leaders to achieve this goal.[2] The plan was to rid the Gaza Strip of refugees by making them go to Egypt, and then the Gaza Strip, like the northern part of Palestine, would become part of Israel with little to no Palestinians; in return, Israel would agree to give him the West Bank and East Jerusalem and would not attack it.[3]

Israel attacked the Gaza Strip in the hope of frightening the large number of refugees who had found shelter in Gaza into continuing on to Egypt. There was a big battle on December 25, 1948, when Israeli planes attacked Khan Younis and adjacent areas near Al Ma'in, targeting Egyptian army posts and the refugee areas. In fact, they attacked everywhere, but the Egyptian army, the *Fedayeen*, and the people of a place called hill 86, north of Al Ma'in, fought bravely and defeated the Israeli soldiers and prevented them from entering the Strip.[4] There was a brave Egyptian officer of Sudanese origin who should be mentioned: Ahmad Fouad Sadek, the commander of the Egyptian army in the Gaza Strip who succeeded General Mawawi, the commanding officer of the Egyptian forces in Palestine. Sadek had orders from the Egyptian government to withdraw to Al 'Arish to save the life of his forces because there was little hope of defeating the Israelis with his small number of fighters. But he refused. He wasn't only responsible for the lives of the Egyptian soldiers, but also for the lives of Gaza's inhabitants and the protection of hundreds of thousands of refugees, so he decided to continue fighting until the end. He defeated the Israelis and they withdrew from the area east of Khan Younis. Sadek saved Gaza and its people, but he lost his position because he had not followed orders. However, he didn't care and was satisfied that he had done the right thing. Later, he was promoted when he returned to his headquarters in Egypt. He died a few years ago and was given a big funeral because he was a very popular and brave man. So, both King Abdullah and General Mawawi, who was responsible for the loss of a great part of Palestine to the Israelis, among other Arab leaders, could be accused of betraying the Palestinian people.

Soon after the war, the refugees couldn't find places to live, so we opened up the schools as shelters for them and put two families in each classroom, separated by blankets. People even lived in mosques and fields. Every day, my father organized for a sack of wheat to be ground and made into bread, which he then distributed to hungry people. Then the Quakers came to help the refugees and distributed tents and erected them on the sands in the western part of Khan Younis, which was empty then. Once, I was walking home and saw soft and beautiful refugee girls and women collecting rubbish and wood from the streets of Khan Younis for their cooking fires. This scene made me very angry, and I began thinking about how I could help them. Then I had an idea and spoke to Basheer Al Rayyis about finding them a place to study. This was when the Quakers were helping the refugees, before the UNRWA existed.[5]

I told him about the big open area in front of the school where the students played, and I said that I wanted to ask the Quakers for some of the tents they were distributing to refugees so I could gather the girls and teach them there. I wanted to write leaflets telling people to bring their daughters from five to twenty years old to study, and I would classify them according to their age and level. He asked me if I could handle this, and I answered that of course I could. Two days later, he brought other respected community leaders, including Abd Al Haq Abd Al Shafi, a Palestinian chief engineer and the brother of Dr. Haidar Abd Al Shafi, and Mr. Ramiz Mosmar, a Khan Younis Sharia judge, and we discussed the subject. I told them I was planning to divide this new school into separate morning and afternoon shifts, with two schools to every shift, so I would have four schools in addition to the school where I already taught.

After the leaflets were distributed, many girls of different ages came and we registered them. Some had attended schools in Jaffa or other towns and had stopped going because of the war, others had never been to school, and others were due to start school that year. At that time, I had fifteen hundred new students, and my school only had eight teachers, apart from myself, and we worked until 1:30 PM every day. I thought about the number in every class and how many schools it would take to include this number of new students. The Quakers brought tents, and I divided the number of students into four schools: two in the morning and two in the afternoon, so every school had about three hundred and fifty students. Then I thought about teachers. I had been teaching for seven years and many clever girls had passed the seventh class, so I thought that they could teach the new students. I also thought about the girls who were studying at the teachers' training college in Ramallah and who hadn't finished because of the war, and among them was my sister Nadida. The course had now become a four-year program, and she had finished her third year, while others were in their second and fourth years. So, I sent for all of them and told them about the idea of volunteering to teach the new students. I also told them that my sister would be with them and promised that I would try my best to give them employment at the end. The inclusion of my sister encouraged them to agree, as they thought that I had included her because I was sure they would obtain work. Then I went to every house with a clever student who had finished the seventh class to discuss the idea of working as a volunteer teacher for the refugee students. I collected thirty-six teachers and divided them into four groups of nine, and then the Quakers gave us exercise books, pens,

pencils, blackboards, and some chairs. So, every class had a tent, a teacher with a board, a chair, and some chalk, and the students sat on the sand or on mats, and we began.

I supervised these schools between 1948 and 1949, and especially the teachers, because most of them hadn't studied the methodology of teaching, psychology, or education. I received food supplies of sugar, flour, rice, oil, and sometimes smoked fish from the Quakers for the school, so I bought scales and small bags and divided everything into thirty-six small bags to encourage and motivate the teachers, and after a time they became better than qualified teachers.

At the same time, Ibrahim began to send people to ask for my hand in marriage, and at the end of 1949, Basheer Al Rayyis was astonished when I wrote my resignation. How could I resign and leave this work? He told me that I now had the chance to marry and teach as well, because we were under Egyptian administration and their laws didn't prevent married women from working. I told him that I couldn't, even if I was paid one thousand pounds per month. I could either be headmistress or housewife, but I couldn't be both. I was then supervising the five schools and started work before 7:00 AM and finished at 4:30 PM every day. How could I do a good job if I didn't have time for my house? I also thought that if I became pregnant, how could I go to school with a big belly? I am very shy. I didn't even tell my family until I was six months pregnant, and by then they knew from my appearance. I knew I couldn't go to school when I was pregnant, so I told Basheer Al Rayyis to find someone to replace me. He asked who would administer the other four schools and I assured him I could find someone, because among the teachers were former teachers and head-mistresses who had worked in the north but stopped because

of the war. I chose four headmistresses and a replacement for the original school because I couldn't find anyone to work my hours, and they got started.

When the UNRWA began in Khan Younis, they found that there was already an existing nucleus of schools for refugees. They met with the volunteer teachers and promised that if they continued studying and completed *tawjihi*, they could later have a permanent contract, together with benefits. All the teachers agreed, and they were paid monthly from that time, and some of them continued further and graduated from university. Some time ago, I read that the UNRWA was established on December 8, 1949, one month after I left the school and married. So, I can say that I prepared and organized, by myself, the nucleus of the refugee schools from mid-1948 to the end of 1949, without the help of the UNRWA because it hadn't yet been established. After that, the UNRWA became responsible for the refugee schools. I thank God I had this idea, and I thank God I found people to help me implement it.

3 / Marriage

FROM TIME TO TIME, I wrote poems and articles that were published in *Al Risala* and *Al Thaqafa*, Egyptian magazines, but after I was married, I stopped writing because I became busy with Ibrahim and the children, although I still write in my diary every day. Ibrahim used to sit with his friends in front of a shop close to our school, and he would see me when I passed every day on my way to and from school. While he was reading a magazine one day, he saw my name, and after he read my poem, he asked his friend if it was possible that the small girl, Madeeha Albatta, who was famous for her ironed uniform and white collar, and was the only girl who wore shoes, could write good poems and articles like this? His friend said that, yes, she writes in this magazine. He was surprised by the pessimism in my writing after he read my pieces called "The Autumn," "A Bird and Other Birds," and "A Withered Rose."

In "A Withered Rose," I wrote:

Oh, beautiful rose, the symbol of life and love.
Why are you so withered when life is still open for you?
You used to smile and give life, but now you are changed.
How can you give life to your thorns, then die?

So, after Ibrahim read the pieces that I had written, he sent me a letter without including his full name.

On January 15, 1948, my father brought me a number of letters. That morning, I prayed the dawn prayer and then slept again, and had a strange dream in which I saw myself standing in the square in front of the Khan Younis mosque, in front of the castle.[1] A lion was walking in a circle looking at me while people watched and clapped their hands, and every time he completed the circle, he came closer to where I stood. When he looked at me, I stepped back, and then he circled again and repeated the same thing. Then suddenly he took me and flew into the sky and told me not to be afraid because there was nothing to be afraid of. Then I opened my eyes.

I got out of bed and put a pot of milk on the fire to boil while I thought deeply about the dream, and the milk boiled over and spilled without my realizing it. Then my father gave me the letters. As headmistress, I received many letters every day from the education department, and as I went through them, I saw one from Khan Younis and was sure it was from the parents of a girl who had been sent home the day before, and so it would be full of bad words. I thought about whether to drink the milk or read the letter, but I left it because if it contained bad words, I would lose my appetite. When I opened the letter, it was signed with Ibrahim's initial and his family name of Abu Sitta. In his letter, he asked why I was pessimistic in my writing and wondered how a young woman at the beginning of her life would write like this, speaking about autumn and withered flowers and other sad subjects. Finally, he wrote that he hoped that I would remove the black glasses from my eyes forever.

The Abu Sitta family lived in the village of Al Ma'in, an area of 55,000 dunams (about 14,000 acres) situated east of Abasan, a village of Khan Younis and part of the Beersheba district. Before the 1948 war, the Abu Sitta children walked to school, which Sheikh Hussein Abu Sitta, Ibrahim's father, built in 1920 at his own expense. The teachers at the school taught the first four years of education. After completing school there, the sons of Beersheba Sheikhs were sent to a boarding school in the town of Beersheba. Others went to the Khan Younis school and took lodging at the home of Al Haj Abdallah Al Aqqad from Saturday to Wednesday and returned home for the weekend on Wednesday afternoon.

Sheikh Hussein was a well-known figure who did not have a formal education, but had taught himself to read and write. Sitting at various *kuttabs* run by Muslim scholars, he expanded his knowledge through reading the Quran, newspapers, and books on various subjects. He inherited his position (as a Sheikh) from a long line of ancestors who were also Sheikhs. His great great grandfather, Sheikh Dahshan, was a paramount Sheikh among tribes in Palestine, Jordan, and Egypt. Sheikh Hussein first got married during World War I. He had five children: Harba, Mousa, Ali, Salman, and Nadia. Around 1919, Sheikh Hussein's brother Mousa died and left behind a widow and two children, Abdallah and Salma. As was the custom, he married his brother's widow, and she subsequently bore him two sons: Ibrahim and Suleiman. His sons were the first Palestinians to study at Egyptian universities: Ibrahim was the first Palestinian student in the faculty of law at Fu'ad University (later named Cairo University), Suleiman was the first in the faculty of medicine, Ali was the first in the engineering faculty, and Mousa was the first in agriculture.

Many people told Sheikh Hussein to marry off Ibrahim when he finished school in Jerusalem because he was the oldest son. However, Sheikh Hussein said that Ibrahim could marry at any time, but the chance to study was only given once in a lifetime, and he was not going to allow Ibrahim to start his life until he had finished his studies and obtained his degree. After Ibrahim graduated in 1947, he trained at a lawyer's office in Jerusalem, but during the 1948 war travel to Jerusalem was difficult, so he stayed in Khan Younis and planned to open a law office.

After I read the letter, I thought for two days before deciding to write back, and this was the beginning of the exchange of letters between us. Ibrahim's youngest brother Salman and my brother Nadid were both in the sixth class, so Ibrahim gave Salman letters to send to me through Nadid and I sent him letters the same way. Then Salman went to Egypt to study, so we sent letters through the female porter of my school, who became the postman between us. When we exchanged letters, he said he wanted to see me, but I wrote that this couldn't happen because I couldn't abuse my father's trust. If he wanted to see me, I wrote, he should first go to my father, so Ibrahim went to my father's closest friend and asked him to speak to my father about our becoming engaged. When I knew that Ibrahim wanted to see my father, I wrote to him: "Don't think I am tall with white skin and blonde hair. I am not like that at all." In fact, I wanted him to know so he wouldn't be shocked after our marriage, especially because I was very thin and only weighed forty-six kilograms.

He wrote back: "I know everything about you and I still remember your big, pure black eyes, full of intelligence and innocence. The only thing I wanted to know was your heart,

and now after I know this, your image has become very clear to me and I feel I know you very well. Who told you I worship statues?"

A short time after this the subject was closed, because the Jewish militia attacked Al Ma'in and drove the entire Abu Sitta clan from their land after burning their houses. Ibrahim's family then rented a house in Khan Younis, two houses away from us. On May 15, 1948, the British Mandate ended, and all the British offices and departments closed, and problems spread all over Palestine. Altogether, I wrote sixty letters to Ibrahim and he replied to all of them. I still have all the letters I received from him, and also the draft of the first letter I wrote, because I was unsure about whether or not to write and what to write. Ibrahim lost the first fifteen letters because they burned up with their house in Al Ma'in.

My father was very strict when I was engaged, because I had refused to marry one of my relatives and insisted on marrying Ibrahim. Perhaps he was strict because I didn't have my mother to speak on my behalf, and I was the first daughter to be married. Even after the marriage contract was signed, my father refused to let us see each other or meet; he did not allow Ibrahim to give me a ring, but instead his sister-in-law, in accordance with my father's instructions, put it on my finger. Until our wedding day, Ibrahim hadn't seen my face at all or met me alone, and the only time he had ever seen me was when I walked to and from school. I used to cover my face with a long heavy veil in accordance with the social customs at that time; in fact, I kept my face covered the whole time my father was alive and even after I was married. Later, when we moved to Gaza, Ibrahim convinced me to replace it with a shorter one of

Madeeha Hafez Albatta in Gaza in 1955. The photo was taken in a studio in Gaza City.
Photo courtesy of Madeeha's family.

lighter material, and all my sisters did the same thing when they saw me, and my father didn't comment. But all of this changed with my sisters. All of their fiancés gave them rings and visited them, and they sat together and had dinner together. I only wanted Ibrahim, so I didn't argue with my father about these details. I knew that, in the end, we would be together and then could sit and have dinner whenever we wanted. I was patient and didn't care too much about not meeting him before our marriage.

I knew many people, among them women from Jaffa who were experienced in sewing, and when I became engaged, refugee girls and women from Jaffa helped me prepare the necessary new clothes for my marriage. At that time, Jaffa was a modern city, a hub of Palestinian culture and economy, and famous for sewing, embroidery, and its high standards of fashion compared to southern Palestine. These women and girls, whom I had gotten to know when I registered the refugees for the school, embroidered all my clothes,

underwear, and other things needed by a new bride, as well as my white dress and the *burnous* to cover the dress. I still have the *burnous* and when my daughters became teenagers, they used to wear it secretly.

We were married on November 6, 1949. There were only two taxis in Khan Younis and they came from Jaffa, and my brother-in-law, Abdallah, apologized to my father about the lack of taxis to take my family to my husband's family. But my father didn't mind because the two houses were very close. My friends and sister-in-law and I went in one taxi and my stepmother, sisters, and brothers went in the other, while the rest of the family walked. When I was about to step inside my husband's home, Abdallah shot into the air with his rifle to welcome me because he was so happy that his brother and I were finally together.

I loved Abdallah like my brothers because he was a great man and a great freedom fighter. He spent his life, from before 1936 until he was murdered in Jordan in 1970, carrying his rifle on his shoulder and struggling for freedom. A graduate of al-Rawda College in Jerusalem, Abdallah led the resistance against the British in the 1936–39 revolt on the southern front, as well as the resistance against the Zionists thereafter. In fact, Abdallah was among those wanted by the British, so he found refuge in Egypt at the end of the revolt when the British promised Palestinians they would restrict Jewish immigration into Palestine. He returned in the early 1940s, when the British Mandate authorities were preoccupied with the Second World War, and he continued his struggle for freedom. When Ibrahim was fourteen years old, he carried a rifle on his shoulder and waited for the trains with his rifle and hand grenades. Once Abdallah became very angry and even beat Ibrahim

when he caught him sleeping with his rifle while waiting
for the English, wondering how he could sleep in such
a very dangerous place. After the 1947 partition plan,
Abdallah's activities intensified as Zionists started to attack
Palestinians and burn their villages. He gathered men from
his family, including Ibrahim who was
a recent graduate, his old fighters, and other volunteers
from Beersheba and Gaza, and led the fight to defend his
land and the Beersheba district. He was a very brave man
and great fighter.

When the Zionists occupied Ibrahim's family land in
Al Ma'in back in 1948, Abdallah and other fighters tried
to defend it, but of course they couldn't, having only light
weapons to defend against the Zionist militia and their
tanks and bombs. At that time, Zionists, with the knowledge
and support of the British, had manufactured ammunition,
rifles, and military cars, while Palestinians were not allowed
to possess any sort of weapon. Abdallah was not in Al Ma'in
then. He went to meet General Mawawi, the commander
of the Egyptian forces who were preparing to enter Gaza.
Ibrahim, his brother Mousa, and the other fighters and
volunteers defended Al Ma'in with the means they had. They
lost several men and by a miracle they managed to escape
and save their lives when they realized that they were vastly
outnumbered and outgunned by the Zionist militia.

I married Ibrahim when he was a lawyer, and later he
became the city magistrate. He was paid five Egyptian
pounds for every case, and sometimes more. This modest
income was not only for us, but also for our extended family
and poor people, but I managed to keep tight control over
our spending. I wrote down what I bought in a notebook, and
saved money *piaster* by *piaster*. Nobody knew how much I

saved. When I would tell Ibrahim that I wanted to go for a holiday, he used to say that we didn't have enough money, so I would lie and say I could borrow from my family and when we returned, we would repay it. Then I went to my family with the money in my pocket and returned with the same money, which I gave to Ibrahim, and then we travelled. Now I laugh when I read those notebooks and remember those days.

We lived in a small rented house in Khan Younis, and on August 12, 1950, I had my first child, a daughter. I named her Adala, meaning "justice," and it was the first time this name was used in Gaza. I named her this because I liked it, because her father was the first lawyer and magistrate in Gaza, and also perhaps to bring justice for girls. As many know, our society, including the Bedouin, prefers boys, and Ibrahim's family had wanted a boy. Even my father-in-law, whom I considered different from others, was the same, and I was a bit frustrated. It wasn't enough that I became pregnant immediately and had my first child approximately nine months after marriage. I remembered that my mother had girls and only two boys, and her sister had girls, but no boys. All my sisters-in-law had boys, and my husband's family were waiting for me to have one, so when I became pregnant with my second child, I prayed for a son.

I was expected to name my first son Hussein after his grandfather, but I didn't like the name Hussein because it's an old name and I wanted to give my son a modern name. But one night I had a dream about an old man who kissed my stomach and told me that I would have a male child, but I must promise to call my son by his name. I asked him his name and he told me a very strange name, which I said wasn't nice and that the people of Khan Younis would laugh if I called my son this. So, he said to take some of the letters

and call my son this name. It included all the letters of the name "Hussein," so I agreed. When I opened my eyes and remembered the dream, I felt I would have a boy, and if I did, I would call him Hussein. I had a very easy and quick birth, just a few minutes and he was born.

I have a good memory for numbers, not only my children's birth dates, but also my grandchildren's. Since I was young, I have remembered dates and connected them to events. This first started on the day of the earthquake, then continued when my mother died, and then the years passed and the suffering increased with the occupation, and there have since been many, many stories drawn with dates and moments and details on my heart. Adala was born on August 12th; Hussein on October 2nd; Fawaz on March 3rd; Moeen on June 26th; Aida on October 16th; Nawaf on November 6th; Hamed on January 9th; Nasser on February 24th; and then Azza on March 3rd. We are very connected with the number nine, as many events that have occurred in our lives have been connected with this particular number. I have nine children, we moved to this house on September 9th, my son Fawaz travelled to Germany to study international law on September 9, 1971, and married on the 9th of September, and Azza graduated as a laboratory technician on September 9, 1981.

Later, we moved to another house, closer to my family home and much nicer and bigger than the first. It had many balconies, and from one of them we took a picture of my family home. The night we moved to that new home was when I became pregnant with Moeen, because I had him nine months after we moved.

Before Aida was a year old, she was teething and very sick the whole summer, and I thought we would lose her. I was so

tired because of this, and also because at the same time, my brothers-in-law and their families came from Kuwait to spend the summer vacation with us. After this, I told Ibrahim that I wanted a break away from Khan Younis, but he said he had already used his holidays to go on the pilgrimage to Mecca and couldn't take another. No matter what I did, I couldn't help remembering the attack on Khan Younis in August 1955, when Israeli soldiers burned the police station, killed over seventy policemen, and wounded many others.[2] When I looked from the eastern side of my home, I would imagine seeing the fire and the police station burning, and I thought if they had reached the police station, they could reach us. I became so afraid at night that I sometimes even took Ibrahim with me when I went to check the children. This feeling accompanied me for several months. I was so afraid of being in Khan Younis, and I told Ibrahim that if he didn't take a holiday, he would find me one day jumping from the roof of the house. He asked what the matter with me was, and I said that I felt something in my heart, and was so worried and afraid and so tired that I wanted to leave. I think my worries transferred to him because he asked his boss for another holiday. He was a judge then. He was told that he had already taken his annual holiday, but Ibrahim said that he felt really tired and needed a break from his work. When his boss agreed and said he could start his holiday the next day, he couldn't believe it, and when he told me the news, I jumped with happiness. It was October 4, 1956, and we left the next day. At that time, the train to Egypt came late in the afternoon, and I thought that in the one day I could pack the bags, iron and prepare our clothes, and do everything necessary. So, I quickly sent for Salma, a lady who used to work at our home, to come

very early the next morning to help me make date jam, preserve the olives, and crush and preserve red chillies because the season would be finished when we returned.

Adala was in the first class at school, so we decided not to take her. Aida was so sick that we thought it better for her to stay in Khan Younis, where my family could take care of her. Moeen was not yet toilet trained, so we decided to leave him also. We took only Hussein and Fawaz. I asked Salma to take care of the rest of the children while we were in Egypt, and I took them all to my family home, along with a bag containing the children's clothes as well as food and money. My father asked how I could leave my children and where I would leave them, and I answered at their grandfather's home: his home. He said, "But your daughter Aida is very sick." I told him that she would be better off staying in Khan Younis than traveling with us to Egypt, and that I was sure my family and Salma would take good care of them while we were away. He was unhappy with us travelling without our children, but we had already made the decision.

We took the train to Egypt, and as soon as I left the cultivated fields of Rafah and the surrounding areas and saw the desert, I became very thankful and relieved. We arrived in Cairo on the morning of October 6th, as children were going to school. My uneasy feeling was correct: at the beginning of November, Israeli soldiers attacked and occupied the Gaza Strip.

4 / Massacre

ON OCTOBER 29TH, Israeli forces occupied the Sinai
Peninsula. The next day they occupied the cities in the Sinai,
and on November 1st, they began occupying the Gaza Strip.
First, they occupied Rafah and then continued to Khan
Younis, where a group of Egyptian soldiers fired at them,
trying to defend the city. The Egyptians had offices and army
posts in the Gaza Strip, and one unit, with a maximum of
twenty soldiers, in Khan Younis. The soldiers often changed,
because as one group went to Egypt, another replaced them.
There were only a small number of soldiers in Khan Younis
and other towns, because usually most of them were on
the borders; of those, some were killed, and others escaped
when they heard that Rafah was occupied. When these
soldiers heard that the Israelis had occupied Rafah and were
now coming to Khan Younis, they started shooting. The
Israelis thought that there was a large group, so they left
and continued toward Gaza City, which they occupied on
November 2nd, the anniversary of the Balfour Declaration.[1]

In Cairo, we were sent a newspaper—I don't remember
whether it was *Newsweek, The New York Times*, or another
English newspaper—by our representative in the UN, showing
a picture of the Egyptian soldiers lined up against a wall and

being shot by the Israelis. I counted, and there were about sixteen soldiers in the photograph. They even caught the Egyptian governor of Khan Younis and paraded him through the streets and passed by my father's home. After the withdrawal, he was released.

Khan Younis was known as a brave city, a city of *Fedayeen*, of freedom fighters who were heroes and champions of the people. Right after the *Nakba*, Abdallah resumed his activities and managed to organize his old fighters and recruit many young people from the refugees who were eager to liberate their land and return home. So, the Israeli soldiers knew that Khan Younis would fight. They returned to the town on November 3rd and tricked the people. From helicopters flying very low in the sky, they called over loudspeakers for people to surrender and promised to spare their lives if they did so without a fight. They told everyone to go to their homes because they had occupied the city, and they said if people wanted to protect themselves and their families, they should stay in their homes and put white flags on the roofs of their houses because a curfew was being imposed. The people believed what they said, that this would save their lives and that the Israeli army had occupied all of the Gaza Strip, which was now under their control. In fact, they were not in Khan Younis at all, but on the eastern border waiting to enter. People went to their homes, and those who didn't have any white material cut it from their clothes and hung it. My brother Hassan's wife couldn't find anything white, so she used her baby's swaddling cloth.

When they saw from the helicopters that people were obeying them, the army entered Khan Younis and started their massacre of young men from fourteen to fifty years old. They entered houses, and any young males they found, they

lined up against walls and killed, and then lined up the next group and killed them. People tried to escape, but couldn't, and others hid, but the Israeli soldiers killed hundreds and hundreds of people that day. My brother Hassan, a graduate from Al Azhar University, was twenty-seven and married, with a son and a young daughter of four months. He lived in a separate house, but he thought that everyone should move to our family home to be together during that time. He was caught on his way to my father's home with his family, and although he showed them his passport and identity card, and Afaf, his wife, showed them his school card identifying him as a teacher, they didn't care. They lined him and other men up against the fourteenth-century Khan Younis castle, Barquq Castle, with their hands raised, and shot them all. The same day, Israeli soldiers entered my family home and found my children with my brothers and sisters, among them Nadid, hiding under the staircase of the house. They pulled Nadid out from among them, and while the children followed and he screamed, they dragged him across the floor of the room. His mother was pleading to the soldiers that he was a schoolboy, so that they would leave him, but they didn't listen to her. The soldiers kept dragging him amidst the children's screams, and then they shot him in the chest with several bullets. His blood ran onto the floor and the children cried. The soldiers then went to the houses next door and dragged out more young men amidst the cries and screams of their families, lined them up against the wall of the Khan Younis castle, and shot them. Nadid had been waiting to travel to Egypt to attend Cairo University because he had been accepted to study accounting. His permission was delayed, and while he was waiting, the Israelis invaded. His fate was to be killed instead. At the time we were stuck

in Egypt, but we were told all the details by my family and children. Although my son Moeen was two and a half years old then, he still remembers the murder of his uncle in front of him and the blood flowing toward the door of the house.

All the men from our street except Ibrahim were lined up against the walls on the street and shot. In fact, they went searching for Ibrahim and broke our doors and burst into our home, but they didn't find anyone, so they took Ibrahim's certificates and our photos from the walls and smashed them on the ground and trampled on them. They also broke many things, such as a glass cabinet full of crockery and glasses. They shot into the wardrobes, and when I returned, I found many dresses with burns and holes from the bullets. After hundreds of men were killed that day, the order came to stop. That carnage continued for three days.

After the soldiers stopped shooting, the people who had survived took the bodies. My father brought three bodies to his home: my brother Hassan, and two men from a neighbouring family who were not natives of Khan Younis. One had come with his wife from Jerusalem, and she couldn't deal with this tragedy alone, and the second was the brother-in-law of the first martyr's wife, who had come to join Nadid to attend the university. So altogether there were four bodies. My father went to a neighbour, a merchant, for material to cover the bodies. Our neighbour told him that martyrs were not washed or covered with shrouds like other dead people, and my father replied, "Yes, they are martyrs, but they are also victims. They weren't killed while defending their country, but were massacred." After he had washed and covered them, he placed the four bodies in the middle of the house and prayed for them, and then put them on a cart borrowed from the neighbours, and with my sisters, who carried shovels

to dig the graves, went to the cemetery. It was still curfew that night they walked to the cemetery, and I can't imagine my sisters and children, at their ages and in those circumstances, with my father, digging and burying these bodies. That memory, which is too terrible to think about, was dug into their hearts and minds.

After his two sons were killed, and as he knew that they were searching for Ibrahim, my father became frightened. He told Adala that if someone asked her name to say she was Adala Albatta, and not that she was Ibrahim Abu Sitta's daughter, or her life might be in danger. He didn't tell the others because they were very young.

After the Israeli occupying forces had control of the area, people continued to escape, by walking or by camel or donkey, through the Sinai Desert because the Israeli army didn't control every area. Abdallah also succeeded in escaping from Khan Younis. He walked from Khan Younis beach to Rafah and on to Al 'Arish, and then some Bedouin from the Sinai helped him cross the desert on their camels and go on to Cairo. Had he been caught as a person wanted by the British and the Israelis, he would have been killed. So, Sheikh Hussein and all of us were relieved when we saw him. We saw people in Cairo who had escaped, and when Ibrahim asked them what had happened, they told him of the horrible massacres in Khan Younis and of my two brothers who had been shot and killed, but he didn't tell me.

My father-in-law, Sheikh Hussein, was stuck in Egypt with us. He had come one month before us, and when he wanted to return, he was stopped by the invasion. We were all together in one flat, and when Ibrahim and Abdallah wanted to smoke, they left the room where we all sat because they didn't want to smoke in front of their father. Although

he was thirty-three years old, married with five children, and a Magistrate, Ibrahim never smoked in front of his father out of respect. My father-in-law became very angry and told them to smoke in front of him, even though he knew they didn't want to, because he wanted us all to be together. While they were smoking in the same room, Abdallah told Ibrahim and his father what had happened in Khan Younis and other places, but they still didn't tell me about my brothers, and I was so worried and felt that they were hiding something from me. I didn't know until January 1957, when they finally decided I should be told and Ibrahim broke the news to me. I couldn't believe them at the beginning because my mind rejected it. But then when I saw Ibrahim's grim face avoiding looking into my eyes, as well as all the faces around me looking to the ground, I started to comprehend what had happened. I didn't know what to say or how to react, or how to accept it. The place was full of men—Ibrahim's brother Salman, who was studying engineering in Cairo, my father-in-law, Abdallah, my two sons, and even the man who helped us—so I went to my room. As soon as I entered the room, I felt like a bomb had exploded because I couldn't stand this terrible news. I was almost four months pregnant with twins, and suddenly the floor was full of blood. I had miscarried. I could not even stand on my feet, and I was hysterical. Ibrahim supported me. He took me to the bathroom to wash and he cleaned up the blood on the floor. Then he put me to bed.

I couldn't eat and spent seven days in my room, crying for my brothers. Nobody knew I had miscarried; they all thought I had a bad flu and was still grieving the loss of my brothers. After I had recovered a little, Ibrahim rented a flat so we could be on our own, and I took our two sons and went there. I

registered them in a kindergarten that ran from the morning until the afternoon, so I could be alone with my grief and sorrow as long as I could, and not show my children my suffering and pain. I was so tired and shocked and almost crazy, crying all the time and not able to concentrate on anything. Because of this, one day when I was alone, I spilled some boiling oil on my hand and burned it badly. I screamed loudly from the severe pain and quickly rushed to find my wallet to go and buy some medicine. I ran into the street with my hand in the air, trying to find a pharmacy, but because I wasn't familiar with the area, I didn't find one on our street and ran for a long time until I found one. The pharmacist examined my hand, applied some cream, and bandaged it, and when I asked if I needed antibiotics or penicillin, he said the cream was enough, and so I left. Five minutes later, I found him following me with my wallet, which I had left behind.

Ibrahim used to go to Palestine Radio in Cairo for news of Palestine. He was always so sad and shattered because of the news he had received about the Gaza Strip that he looked like he had been beaten, but he didn't ever say a word. When he arrived that afternoon, he didn't notice my hand in a sling, but asked why I wasn't eating. When I started to cry, he noticed my hand. That whole night, I couldn't sleep and cried from the pain, so the next morning when Ibrahim went to the radio station, he told a friend what had happened, and his friend sent his mother to our home to help me. She advised me to go to another pharmacist for my hand because of the continuous pain. As soon as I went outside, I saw a pharmacy in front of the apartment and was surprised that I hadn't seen it the day before. This pharmacist had studied in Germany, and he asked whether I'd had a penicillin

injection and advised me to have one immediately. He gave me penicillin and made a cream for me of penicillin, sulpha, and vitamins all mixed together, and told me to come every day so he could check and clean the wound and replace the bandage. I was so afraid that my hand would be damaged, but he said not to worry because he was giving me the correct treatment, and that in the end, I would not be able to tell the difference between both hands. I went to him for eighteen days, and in the middle of the treatment my fingers became so swollen that my wedding ring had to be cut. The jeweller said he would fix it when I had recovered, and when my hand was better, he fixed the ring without payment; he just thanked God I had recovered.

When I discovered that Abdallah was sending someone to bring his wife and children to him, I asked that he also bring our children and Salma, and with the help of some Bedouin, they arrived on February 5, 1957. When I didn't see Aida among them, I asked Adala if she had died, but she said, "No, here she is." I was surprised at how much she had changed. She had become very fat and her face was big and healthy, because during the curfew everybody had fed her a lot; so, she didn't walk early like the rest of the children, who had walked at one year. She walked at eighteen months.

We remained in Egypt until the Israelis left Khan Younis and the international observers came, and the Egyptians had returned to administer as before. The train started again from Cairo on March 21, but we didn't take it because we wanted to be sure that it would arrive safely. A friend of Ibrahim was in Egypt the same time we were there and tried to return two days before us, but he reached Al Qantara and couldn't cross the Suez Canal because the Israelis had occupied the area, so he returned to Cairo. We took the third

train to Gaza and arrived in Khan Younis on March 23rd. While we were on the train, Moeen saw a soldier wearing a green uniform, and he screamed and cried, "Jews! Jews!" I told him, "No, that is not a Jew, he is an Arab and he won't harm you." The soldier asked what was the matter and why Moeen was screaming. I told him that my son had recently come from Gaza where he had witnessed the murder of his uncle and seen lots of blood, and that now he was afraid of anyone wearing a green uniform because for him it meant murder and killing. While I was explaining to the soldier, Moeen cried, "The Jew wants to shoot me," and I comforted him.

When we returned, we saw the destruction of Khan Younis and the damage to our home, but I didn't care because I wanted to be with my family, and I spent most of my time there. The place was full of sorrow and grief, and everyone in the city and the camps was dressed in black. All of Khan Younis dressed in black for more than five years, and even when they stopped, their hearts were still black with grief. Everyone had lost a father, brother, uncle, son, friend, or neighbour. After the Israeli withdrawal, people organized funerals because they weren't able to express their feelings during the occupation, and we had one for my brothers. Then came the time for helping the widows and orphans of the tragedy, and although year by year the sorrow decreased, it remained in people's hearts.

In 1958, while Ibrahim was mayor of Khan Younis, he investigated and recorded the names of one thousand people who had been massacred. He reached this number, but there were another five hundred whose names and details he couldn't register. These fifteen hundred people were massacred by Israeli soldiers, and I consider this to be one of the worst

massacres in history. I always wonder why nobody mentions the Khan Younis massacre that was committed on November 3, 1956 and why it has not been publicized, because the tragedy was so great that we can say it lives in everyone's home. I don't know why this is. I can understand why the Egyptians ignored it, because they left us and escaped. I can understand the western world including America not mentioning it because of their blind support of Israel, and I can understand that America ignored it because it didn't want to admit that Israel committed a war crime in this massacre of innocent civilians. But the thing I can't understand is why Palestinian television hasn't given it sufficient coverage, and I always raise this question. We have to shed light on those victims, and at least publicize what happened. The day before yesterday, the forty-fifth anniversary of the massacre,[2] I reminded the Ministry of Education and asked for a minute's silence for the dead. Palestinian television interviewed me and other guests about it, and I told about how I received the news when I was gone, and about my feelings. In fact, it is very terrible to get news like this when you are away. You want to be with your family, but you can't go. You need to support your family, but you yourself need support. You are alone, very far away, and devastated. You are shattered and worried twenty-four hours a day. You can't sleep, you can't do anything, you can't even return.

Sharon was one of the leaders of the army in 1956. He was the commander of a paratrooper brigade deployed during the Suez War,[3] when Egyptian prisoners of war were killed in the Sinai Desert. Many Egyptian soldiers crossed the Sinai in their escape to Egypt when they heard that the Israelis had occupied the Gaza Strip. During this time, Israeli soldiers were landing by parachutes in the Sinai Desert, and

they caught many soldiers who weren't able to reach Cairo, as well as soldiers already there. They killed many of them, but there was still a large number of prisoners of war; they didn't return these prisoners to Egypt because they wanted to defeat Abd Al Nasser by killing his army.[4] At that time, Abd Al Nasser had an important position in the Islamic and Arab world and played a very important role in uniting the Arab world. A group of Israeli soldiers was ordered to shoot some of the soldiers and bury the rest alive. Therefore, many young Egyptian soldiers were killed after they were caught and many others were buried alive, which is against all human rights laws and international agreements to protect prisoners of war.[5] The soldiers who left Gaza and couldn't cross the desert were annihilated in the Sinai, and it was a horrible massacre. Egypt still demands compensation from Israel for the families of those prisoners, and has published, in both Egyptian and international newspapers, lists of names and of the numbers of prisoners of war killed in the Sinai.[6] It has demanded an investigation into what happened in the Sinai, but there has been no response. I think that lists of prisoners have been given to international human rights organizations to be investigated.

Our trip to Egypt saved Ibrahim's life, as most of the young men of his age were killed during the war, and if he had been in Khan Younis, he would surely have been among them. My feeling was right that October, when I was worried all the time and wanted to leave Khan Younis as quickly as possible. I don't know why I felt that I had to leave; my heart was always heavy then, because I thought something bad was going to happen. Ibrahim always told me it was strange that I made him leave then, because he had already used his holidays that year; also, it was October, the beginning of the

academic year, and not summer, when people usually took their holidays and travelled. He said that he later understood the meaning behind my wanting him to leave Khan Younis, and that it was luck that he was given that holiday. It was a strange request at the time, but later he understood.

When they withdrew from Gaza in 1957, it was the first time ever that the Israeli army had withdrawn from a land they occupied, and it was because they didn't have a choice.[7] Three countries entered that war: France, Britain, and Israel.[8] The French and British were not concerned about the Gaza Strip; they were more interested in the Suez Canal, Port Said, and other places, so they left it for the Israelis. But all of them were partners, and the French and British, because they are colonizing countries, provided assistance to the Israelis in all areas: military equipment, weapons, and approval to do whatever they wanted. Even now it still runs in their blood. Look what's happening in Afghanistan. Britain runs after America even though it has no interest or partnership, but it's in their blood: the blood of the colonizer. Britain colonized the world and then brought the Israeli occupation to Palestine in 1917, when Balfour, Britain's then foreign secretary, promised to make Palestine a national home for the Jews.

When the three occupying forces withdrew from the Sinai and the Gaza Strip in 1957, international observers came, but the people of Gaza didn't accept their administration in place of the Egyptians and demonstrated to demand their return. During these demonstrations, a Palestinian called Mohammad Mishrif was shot and killed by an international observer, when he climbed the wall of what is now the legislative council building and replaced the UN flag with the Palestinian and Egyptian flags. The next day, the

demonstrations spread, with demonstrators chanting the same thing: "Our flag should always be waving because Mohammad Mishrif raised it." It was then decided that the Egyptian administration would return, and the international observers would serve on the borders. The Egyptian administration returned on March 14, 1957, and we celebrated this day, called "Withdrawal Day," every year in the schools.[9]

When Gaza was occupied, nobody thought that the Israeli soldiers would leave the Gaza Strip, and in fact they also didn't think they would leave. The proof of this is that the day before they received orders to withdraw, they brought in electricity poles and equipment to install electricity in Khan Younis, and when the order was issued, they didn't have time to take the equipment with them. This was good for Khan Younis because at the end of 1957 and beginning of 1958, electricity was installed, not everywhere, but in some places, and it was a historical event. We had electricity in our home in 1958. During that time, the UNRWA improved its education programs and health and social services for refugees, and the Egyptian administration also helped the refugees and the people. The situation improved a little compared to before, but we were still cut off from the West Bank. If Ibrahim or anyone wanted to go to Jerusalem or the West Bank, he had to travel to Cairo by train, and from there, by plane to Amman, and from Amman to the West Bank via the Allenby Bridge.

5 / Occupation

IBRAHIM WAS MAYOR between 1958 and 1964, and it was a golden era for Khan Younis. He did many things for Khan Younis and found work for many people throughout the municipality, which was possible because the situation was very difficult. He built and fixed roads and dug four additional wells and built four reservoirs, so instead of having one, we had five reservoirs of sweet water that was not salty as before. The water even reached people living outside of Khan Younis, and the citizens were angry because those outside the municipality boundaries did not pay for water, but Ibrahim told them that he couldn't deny water to people just because they lived outside the municipality. He also built the Unknown Soldier Square in front of Barquq Castle in Khan Younis, but Israeli soldiers destroyed it when they occupied the Gaza Strip in the 1967 war. It was rebuilt when the Palestinian National Authority (PNA) came.

Ibrahim was responsible for building Nasser Hospital, and on the opening day, the Egyptian administrative governor came with many Egyptian officials and important people from Khan Younis. Many gave speeches in which they thanked the governor, but after they finished, he said that

the one to thank for building Nasser Hospital was Ibrahim Abu Sitta:

> *For a long time he has been telling me of the necessity of building a hospital in Khan Younis and I told him there was no possibility, but he kept pushing until he had convinced me. He told me that Gaza has two hospitals, the Baptist and Shifa, where we always send sick people but many die on the way because of the distance. So we need a hospital, especially for emergencies, for those thousands of people. The hospital will not only serve Khan Younis but all the southern area so it will decrease the pressure on the other two hospitals. He kept giving me all these reasons until I agreed to build the hospital, so all of us have to thank this man.*

This was February 24, 1960, and I was in the last days of pregnancy. I was visiting my family and felt the baby would soon arrive, so I told them I felt sick and went home. When I gave birth, I never sent for my family to be with me. Usually when I felt the birth pains, I told them that I was tired or cold and wanted to sleep or rest at home, and not to come and visit me. And they believed me because they didn't know the exact month I was due. After I had delivered, Ibrahim would tell them the news. This time I felt very strong pains in my back, which became so severe that I phoned the office of the railway station to send the midwife who lived next door. Unfortunately, the office was closed at night because the train only came once during the day. The pain was so strong that I was forced to send Salma to my parents' home to ask them to fetch the midwife, and my two sisters went to her home, which was very far away. As I felt

the baby coming, my sister-in-law arrived because she knew the midwife would be a long time and was afraid something bad might happen while I was alone. She found me already boiling water and preparing aniseed tea and the necessary things for the baby. She helped me to my bed, and a minute later the baby arrived. Ibrahim came at that moment and she congratulated him on the birth of his baby son, but he was surprised because he thought that only a midwife could deliver a baby. She asked him to bring the midwife and he also brought a doctor, who assured him that everything was fine and asked what he was going to call the baby. He suggested we call him Nasser after both the hospital and Gamal Abd Al Nasser, and we agreed.

After I was married, I participated in community activities. I was invited by schools to give speeches on special occasions such as Mother's Day, Withdrawal Day, and other national occasions, and I used these opportunities to encourage and raise the political level of the young generation and remind them of our land and our right of return. I considered all the Khan Younis girls, including the teachers and headmistresses, as my daughters because I knew all of them. I had taught most of them and those I hadn't taught were my colleagues, or they had taught me. I did this a lot, and in fact I'm not so good at housework and don't have the patience for it. I was more interested in reading and writing, especially poetry. I also encouraged the teaching of illiterate people because the Islamic religion encourages people to learn and study. The first word in the Quran is "Read," which is an invitation to learn. Many times, I taught women to read the Quran with its correct rules for reading and listened to them and corrected their mistakes. I still read the Quran every day and listen to it as well.

In 1961, I had eight children, and Ibrahim was repre-
senting the Palestinian Lawyers Syndicate together with Dr.
Haidar Abd al-Shafi and Mr. Mounir al-Rayyis, mayor of
Gaza. They travelled to America for three months to repre-
sent Palestinian refugees at the UN, so I attended a sewing
course organized by the UNRWA for thirty refugee women
and girls. Some of them were married and their husbands
had fled during the war and couldn't return. I was able
to sew from my mind and from what I saw, but not from
patterns, and I really wanted to learn the rules of sewing and
take part in the course, which was held in a big hall in a girls'
school. So, I studied with the girls and women, all of whom
were illiterate, and discovered that none of them could hold
a pencil and needed my help when they wanted to make
measurements. I became so sad, and was even sadder when
the married women brought me the letters they had received
from their husbands to read, and asked me to reply to them.
I told them they should learn to read and write because I was
sure they didn't want anyone but themselves reading their
husband's letters. I said I would try to help them, and I went
to the course supervisor and offered to teach the women
and girls to read and write. I told her that I needed about six
months for the course, and hopefully after that time they
would be able to read and write themselves. All I needed to
start was permission to use the place, a blackboard, and some
chalk. The sewing class finished at 1:00 PM, so I could teach
from 1:00 to 3:00 PM because my husband was overseas, and
I had two housekeepers at home who could take care of the
children.

She agreed, so I started to teach the women. I could feel
their strong desire to learn. They always urged me to give them
more and more, so I brought books from Lebanon meant for

illiterate education to teach them with. After two months, they were reading small articles in the newspapers, and at the end of the course, they were each able to write letters to their husband. During the course, they couldn't believe that one day they would read their husband's letters and also answer them. I always pushed and encouraged them by saying,

You have minds and you are clever, and you have the will to learn. Your problems resulted because your families didn't send you to school, so now is the time to correct that mistake and learn. I want you to keep reading and writing at the end of this course, and if you don't have newspapers or magazines you have the Quran. Everyone has the Quran at home and if you continue reading from it you will not forget these skills.

In February 1961, a conference for Arab lawyers was held in Cairo. As well as being mayor of Khan Younis, Ibrahim was head of the lawyers' syndicate, and he also had a legal office in Jerusalem. The lawyers took their wives to Cairo, and Abd Al Nasser invited the magistrates and the heads of the various lawyers' associations to stay after the conference so he could entertain them with a trip to Luxor, which was very beautiful. There were forty-five of us and we visited Aswan and stayed in the best hotels, and Abd Al Nasser put a yacht at our disposal for a trip down the Nile. Then, after we returned to Cairo, he sent for us in the late afternoon. I asked the messenger if the wives were included but he didn't know, so I told him that if the wives were not included in the invitation, they would not let their husbands go. The man returned and said that everybody was welcome, but not that day, the next day at the same time. I said that for sure Abd

Al Nasser had postponed the meeting because he needed time to shave, do his hair, and iron his shirt!

The next day we met Abd Al Nasser in the centre of a big empty hall. It was the first time that I had met him in person, but this was not the case with Ibrahim, as he, as well as Abdallah, had led many delegations from Gaza to meet with Abd Al Nasser. People came through the front door and were greeted by him, and then passed by the guards behind him to go through another door, which opened onto a verandah and a garden beyond. Everyone said very polite and formal things when they met him, but when it was our turn to shake hands, I said to him, "I am from Khan Younis and on behalf of all Khan Younis people, particularly widows, orphans, and those with tragedies in their lives, I tell you that the blood of the martyrs and the people who were massacred is on your hands, and is your responsibility, from this day to judgement day." Ibrahim tried to shut me up, but Abd Al Nasser's eyes filled with tears, and he squeezed my hands and said, "If you are from Khan Younis, I can say I am from 'Iraq Suwaydan because I fought there, and I feel the Palestinian cause like you and more, and I am waiting for the day I can avenge all our martyrs, both Egyptian and Palestinian, and all those who were massacred." It didn't mean that he was Palestinian, he was Egyptian, but he had

< Top: *Madeeha Hafez Albatta with her husband Ibrahim Abu Sitta on their trip to Egypt for the conference in February 1961. The photo was taken at the construction site of the High Dam in Aswan.* Photo courtesy of Madeeha's family.

< Bottom: *Madeeha Hafez Albatta on the trip to Egypt in February 1961. The photo was taken in Luxor at the Valley of the Kings (Wadi El Molouk) ancient site.* Photo courtesy of Madeeha's family.

Photograph of Madeeha with Jamal Abd Al Nasser, Egyptian president from 1952–1970. Photo courtesy of Madeeha's family.

fought for Palestine, and 'Iraq Suwaydan was a village in the area of Al Majdal. And because he was under siege in Al Faluja for a long time before being forced to withdraw, he still wanted to seek revenge against the Israelis.

After Abd Al Nasser had finished welcoming everyone, he asked for a photo with the Palestinian delegation and the lady from Khan Younis, so Ibrahim and I climbed the steps and stood on either side of Nasser for the photo to be taken. Zuhair Al Rayess, the other member of the Palestinian delegation, was late in joining us and he came rushing up the stairs and barely lined himself up for the photo just before the photographer snapped the shot. He stood beside me, sensing that it might be too late to walk to the other side to stand next to Ibrahim as etiquette would require. When we returned to Khan Younis, Nasser sent the photo, and

on the back was written, *To Madam Ibrahim Abu Sitta from Jamal Abd Al Nasser*. In the years that followed, we always had a laugh with Zuhair about his awkward posture when he visited us and saw the famous photo hanging on the wall of our guest room.

I have two surviving brothers: one is a teacher in Khan Younis, and the other a doctor in Libya. When my brother wanted to study medicine, my father sent Abd Al Nasser a telegram reminding him that he had promised to help families of martyrs and that his son wanted to study medicine, but he never replied. In December 1962, Ibrahim took Adala to Alhimiyat Hospital (which has now been demolished) in Gaza, where we discovered she had meningitis. No doctor in Khan Younis knew about this disease. She had a high fever and was vomiting, and she even vomited the medicine she was given. The next day, Ibrahim had intended to travel to Yemen as part of the Arab Lawyers Union, and early the next morning, while we waited for the driver to take him to the station to catch the train to Cairo, we heard a knock on the door and my sister-in-law's voice. She told us that my father was very sick, so we went to see him. He told me, "You see Madeeha, Abd Al Nasser did not answer the telegram and did not keep his promise to help Ya'la." I told him that I was sure he wanted to help, but maybe he didn't have time. Then his condition became worse and Ibrahim fetched a doctor, who declared him dead.

In Muslim culture, we bury our deceased on the day of their death, and so Ibrahim sent his apologies and did not travel that day. It was a holiday in Gaza and Egypt, so all the government offices were closed and the mosques announced that my father had passed away. As it was a holiday, all of Khan Younis, the Egyptian administration, the Egyptian

governor of Gaza, and judges attended his funeral at midday, after the second prayer. Ibrahim then traveled that night, taking a taxi for the five-hour journey to Cairo, 400 kilometres from Gaza, to meet his friends and fly to Yemen the next day. When he arrived in Egypt, he placed an obituary in the newspaper on behalf of the Khan Younis municipality, and Abd Al Nasser saw it and remembered the telegram. He sent us a telegram by the order of the Egyptian President to accept the student Ya'la Hafez Albatta at the medical college in Cairo as an exception, and he had dated it for the next day with his signature and stamp. We cried with happiness and wished my father could have been alive to see it.

My brother studied medicine in Egypt at the beginning of 1963, but he lost his residency right when the 1967 war started and couldn't return to Khan Younis. So, he became displaced, along with about two hundred thousand Palestinians who happened to be outside Gaza and the West Bank when the war erupted. In 1971, he became engaged to his cousin and went to work in Saudi Arabia. Then he returned to Egypt, bought a house, and opened a clinic, and later went to Libya and is there still. He has visited a few times, but he is still displaced. He wants to come home and open a clinic and work so his children can live in their homeland, and hopefully he can return if the situation improves. We want to help him return because he has been in exile long enough. This is the problem of Palestinians: they are displaced, in exile. Everyone has their own problems, but in the end, it is the same problem. The same story, but with different characters.

At first, I thought it was my stepmother's mistake that she did not apply for an identity card for my brother. I thought he might have received one then, if he had returned

shortly after the war, but he didn't. I did this with Adala and Hussein when we sent them to Kuwait one month after the 1967 war to study for *tawjihi*. We thought the occupation would only last for three or four months, and we were afraid they would lose the academic year. While they were in Kuwait, the Israelis conducted a census and they were not included, but when they returned, we applied, and they received their identity cards. But maybe my brother's situation was different because he was away when the war took place, and it was impossible to get an identity card for him while he was gone. In fact, the whole purpose of doing the census right after the war was to deprive as many Palestinians as possible of their residence rights, by denying them identity cards. His mother, just as many other thousands of Palestinian mothers, could do nothing to challenge that policy and reunite her family.

The morning of the first anniversary of my father's death, I prayed the first prayer and went back to bed, but I couldn't sleep because I was remembering my father. Then I slept until about 9:00 AM, and while I was sleeping, I had a vision of my father lying on a mattress with an empty mattress beside him. A white *jalabiya* was on his mattress, and I picked it up to take it and told him that it wasn't his because it was too small. But he told me to leave it because it belonged to his dear friend who would come to be with him today. I opened my eyes and wondered what it could have meant, and then I turned the radio to the Egyptian station, where I heard an obituary for a sheikh from Al Azhar University and then understood my father's words. It was really strange that I dreamt that exactly one year after my father's death, and it was correct.

After I had eight children, I tried natural birth control in which I avoided the fertile days. In 1963, I was sitting on the balcony looking at the sky and saw the moon and thought it was the beginning of the month, which meant it wasn't a day I should avoid. When I looked at the date in the newspaper the next day, I found it was the middle and not the beginning of the month as I had thought, so I became worried, and the next month I found I was pregnant. I was unhappy at the beginning because I already had enough children and didn't want more. But after I thought more about it, I believed that God wanted to give me another child and had made me confused about the date, so I accepted God's will. In 1964, I had Azza, and after that I was very, very careful with dates and times.

Before we built this house in Gaza City in 1964, I gave Ibrahim one hundred and fifty [Egyptian] pounds I had saved from the housekeeping money, and I told him I wanted to build outside of Khan Younis on the land we had in Gaza, and he agreed. We moved here on September 9, 1965. Before, there were no buildings in front of this house, and because it was built on a hill, we had a view down to the sea. But, look now, the area is full of buildings.[1]

In 1964, the Egyptian administration employed five Palestinians from Gaza, and gave them five portfolios: health, education, civil affairs, land and properties, and law. Ibrahim was given the civil affairs portfolio, and for the first time Palestinians replaced Egyptians. Ibrahim was still going to his office in Jerusalem, and in order to reach it, he had to travel from Khan Younis to Cairo, to Amman, and then to the West Bank. He was also a member of the Palestinian Liberation Organization's (PLO) executive committee when

Ahmad Al Shuqairy was chairman. Ahmad Al Shuqairy was originally from Acre and represented Saudi Arabia at the United Nations. Then he started the PLO, and in 1964 became its chairman, and in time the Fatah movement became strong and took over the leadership.[2] Al Shuqairy organized military training camps for Palestinians in the Gaza Strip, many areas of the West Bank, Syria, Jordan, and in many Arab countries. We used to celebrate his visits to Gaza, and when Ibrahim was mayor, he organized a reception and lunch for him at Khan Younis beach. He only stopped coming after the 1967 war. His last visit was on March 7, 1967, to celebrate Victory Day, the withdrawal of 1956, where he made a speech in Yarmouk Stadium in Gaza City and visited the *Fedayeen* training camps in the Gaza Strip.

In 1964, the Palestinian Women's Union in Gaza was established, led by Yusra Al Barbari. I was a board member and responsible for literacy, so three days a week I trained teachers in teaching methodology and how to deal with children's problems, especially in young children. Then, in 1965, the PLO organized a women's conference in Jerusalem, and I was among sixteen women from Gaza, eighty from the West Bank, and many others from various Arab countries who attended. We travelled from Gaza to Cairo by train, then to Amman by plane. At that conference, I was elected along with three others to represent the women of the Gaza Strip through the women's union. During the conference, it was arranged for us to meet King Hussein in Amman, but for some reason he cancelled the meeting. The organizers suggested that we visit Al Shuqairy's Palestinian military group instead, where we had lunch and I gave a speech about the importance of their role in helping the Palestinian cause.

Madeeha Hafez Albatta in Jerusalem in 1965. The photo was taken at a women's conference in Jerusalem organized by the Palestine Liberation Organization (PLO). Photo courtesy of Madeeha's family.

When we returned to Gaza, the women's union met in the PLO office on 'Omar Al Mukhtar Street, but it was closed after the 1967 war.

I used to visit the UN schools and other schools to speak to the girls, trying to promote and raise awareness of the Palestinian cause and the role of women in helping with the situation, and to give hope that one day we would have our own state and our rights would be returned and we would

return to our land. Sure, we would suffer, but this would end if we were united. We also organized meetings for women and students in the Al-Jala' Cinema, monitored by officials from the Egyptian administration to ensure that we didn't use the space for other purposes or go against their policies.

Ibrahim was a member of the PLO executive committee from 1964 until around the end of 1966 or beginning of 1967, and had been given a leave of absence as the director of civil affairs to work full time as the head of the PLO popular resistance committees. In January 1967, at a meeting in Cairo with Al Shuqairy and other PLO members, he asked for permission to organize young men for military training, to use their energy instead of them sitting in the streets doing nothing. He wanted to do this rather than asking for help from Egypt, Jordan, or other Arab countries because he believed that only Palestinians could fight to have their rights returned. They disagreed, so he resigned and returned to his work with the Egyptian civil administration. This was fortunate for us because when the Israeli army occupied the Gaza Strip in 1967, he had already left the PLO and had nothing to do with them. If he had still been connected with the PLO, the Israelis would surely have killed, jailed, or deported him.

In 1967, the Israelis occupied the Gaza Strip, and the first thing they did was open the Allenby Bridge without restrictions so that Palestinians could leave but not return. They didn't issue identity cards[3] for people then, so they wanted as many people as possible to leave. Ibrahim's former deputy in the PLO advised him to leave with him before they were arrested because they had both been members of the PLO, but Ibrahim refused. He told him that he would never leave his home whatever happened, because if he went, he would

never be permitted to return. Also, if he left, many people would follow him, but Ibrahim thought that they should stay on their land and encourage people not to leave, whatever Israel did. This man was very afraid. As many Palestinians who were involved in PLO activities did, he left for Egypt, but Ibrahim stayed.

On June 5, 1967, as his driver waited to take Ibrahim to work, I saw from the balcony an Israeli plane flying over the sea. Then I heard shooting and bombing, and the Egyptian army shot down the plane and captured the pilot. It was the beginning of the war.[4] Ibrahim found out from his colleagues that Israel had attacked Egypt, and he came and told us, so we moved downstairs where it was safer. The shooting became heavy and continuous and we didn't know where it came from, or any other news, so we prayed, read verses from the Quran, and made *Du'aa*. The next day we heard that the Israelis had occupied Shaja'iyya, an eastern suburb of Gaza City, and then Al Nasser, a northern suburb. When I heard this, I told Ibrahim to take Fawaz and Hussein, who looked older than their ages, and leave. Ibrahim asked where they should go and I didn't know, so I said, "Go anywhere. Go to the fields, the fields of grapes, the fields of fig trees, Wadi Gaza, anywhere, but don't stay here. I don't want to repeat what happened to my brothers in my home. Please take them to a safe place and hide." He hesitated as he didn't know where to go, but I insisted, so he left with the boys after I gave them a bag full of bread and food and some clothes. The boys were very afraid of the shooting and could hardly walk, but their father kept urging them to lift their feet and walk. They finally found shelter with other people who were hiding under fig trees in the fields of Sheikh Ejleen, a few kilometres south of our house.

The next day, Israeli soldiers came to our home. Nasser was young, and I used to send him to Um Yahya, the gardener's wife, for bread. That day, he came to me and said, "I saw Israeli soldiers outside the walls of our home and they asked me about my family and told me to bring all of you, and raise your hands in the air." We were downstairs with the gardener's wife and children, watching from the small windows, when they ordered us outside, and I became so scared and thought it was now our turn to be killed. I called for the children to go out with their hands raised, and I tried to recite some small verses of the Quran, but my tongue couldn't form the sentences and I couldn't remember any verses, even the short ones. It was against my dignity to raise my hands, so I ran after the children raising and lowering my hands, pretending to show them and telling them to keep their hands raised. The children stared, because they were already doing this. Adala was very weak and thin because she hadn't eaten anything for three days, and was wearing her uniform because the day the war started she was ready for school. She thought they would kill us like they had killed her uncle in front of her eyes, and she was shaking, while my other small children cried. The Israeli officer spoke Arabic and asked why she was shaking, and she said she was afraid they would kill us like they did her uncles. He asked who they were, and she gave their names, Hassan and Nadid Hafez Albatta. He told her not to be afraid because his soldiers had no intention of harming anyone.

I saw Abu and Um Yahya and their son, and also a neighbour who owned a shop, already facing the walls with their hands raised. The soldiers asked me where my husband was and I told them he was in Egypt, and when they asked why he was there, I told them that he had married another

woman. When they saw us shaking, they told us not to be afraid and asked me about Abu Yahya and his son. I told him he was the gardener, and when he asked me about the shop owner, I said he was our neighbour. Then we were ordered back downstairs with Um Yahya, and they took the men, pointing their guns at their backs, toward the area in front of the house, which had been an Egyptian army camp. I was sure they were going to kill them, and as soon as we went inside, we heard shooting. I said, "I'm sure that they have killed them like they did in Khan Younis in 1956." Adala and I looked at each other and both thought the same thing, but Um Yahya did not understand what had happened because she hadn't had this experience. I don't know how the time passed until the late afternoon, and then we saw Abu Yahya and his son, with their hands raised, returning. I couldn't believe they were alive. They told us that many young people had been taken in buses and thrown out at the Sinai border with Egypt. Others had been killed, and the rest, who were old or very young, were ordered back to their houses.

I planted many vegetables such as cucumbers, tomatoes, *mulokhia*, mint, and other things in our garden. Once, Nasser went outside and ate some cucumbers, and Hamed followed him and brought one back to us. When I discovered this, I went crazy and shouted at them because I was afraid that if the soldiers saw them, they would be shot. They started to cry, and I realized that they were bored from being inside this small shelter for so long, so I organized things for them to do to fill their time. I didn't want them to go outside at all because if they did, they might not return. Curfews were imposed every night from late afternoon until early morning, and sometimes during the day if there were problems, such as the *Fedayeen* shooting at the Israelis or their

tanks or jeeps. Sometimes the curfews were lifted for a short time so people could obtain food. The next day, there was a short period in which the curfew was lifted, and my children helped collect some vegetables to give to neighbours who had big families and nothing to eat. At that time, even if the curfews were lifted, not many shops opened, and if they did there wasn't much to buy. Once, when I sent my children with vegetables for the neighbours, on their way home, Moeen and Yahya played near a tank close to our home, and even climbed up and sat on it because no soldiers were there. When other soldiers saw the boys, they shot at them. I heard the shooting from my home and didn't know what was going on. They quickly got down off the tank and crawled toward our home, and when the soldiers saw they were young children, they stopped shooting. The same day, Hussein and Fawaz came for more food because they had finished their supply, and they told me their father was well and waiting in the area beside Wadi Gaza. I gave them food and told Hussein to take Moeen with him, and Um Yahya asked them to take Yahya as well so they would be safe. The four of them took the food and returned to Ibrahim.

The war lasted for a week. Then Ibrahim and the children returned, and we went back upstairs to live, but everyone was afraid for a long time. The Israelis imposed curfews during the night and sometimes during the day for many years after 1967. In the beginning, the curfews were long, then they were gradually reduced to being only at night, and then stopped. As time passed after 1967, our hopes that they would withdraw after a few months, as in 1956, decreased. When the Israeli occupation controlled the area, we couldn't travel to Egypt directly, but had to go first to Jordan through the West Bank and from there to Egypt. Adala and Hussein

had finished their eleventh-grade exams, and one month
after the war, when the way was open again through the West
Bank and Jordan, we obtained permission from the Israelis
to travel to the West Bank. We were optimistic that the
Israelis might stay three or four months and then withdraw,
and we didn't want them to lose the school year because we
didn't know when the schools would reopen. So, we thought
to send them to join their uncle in Kuwait to do their *tawjihi*.
We went to Nablus and stayed with my uncle, and the next
day Ibrahim took the children to the Allenby Bridge, where
his brother was waiting on the Jordan side, and they went
from there to Kuwait.

After the 1967 war, an Israeli administrative governor
took over the Gaza Strip, and we went to his office to ask
for identity cards for Hussein and Adala. I think his name
was Beni Metiv. When he saw our name, he recognized the
family and told us that he knew Ibrahim's brother Abdallah.
Metiv had been a commander of a battalion when Abdallah
was a leader of a group of *Fedayeen* in Beersheba, and in
the battle of Al Ma'in in 1948, he knew where Abdallah was
and had wanted to find him and kill him. But, on that day,
Abdallah had left the area and he didn't know he had gone.
When they occupied the Abu Sittas' land, he entered their
house and took all the books in their library and found some
family photos, which he gave to us. He also gave us a book he
had written in Hebrew, *The Planters of the Desert*, and wrote
on its first page, "To the Abu Sitta family. I wish to God
that there could be peace between us," because he knew I
understood Hebrew. This book is about Jews who lived in the
Negev in the Dangur Colony (also called Nirim in 1949 and
now has taken the name Nir Yitzhak), located approximately
15 kilometres from Al Ma'in. The book also mentions the

above story concerning Abdallah. He spoke Arabic because he was a Jew who lived close to Al Ma'in where the Abu Sitta family lived, and he knew many things about the place and people. Then he issued the identity cards.[5]

After 1967, the Israelis tried to make Ibrahim return to work under the Israeli civil administration. An Israeli officer from the civil administration came to our home at midnight during a curfew and tried to convince Ibrahim, but he refused and said he couldn't work in an occupation administration. They told him that he would be a director as before, but he said he would be one in name only, as there would be other Israelis over him to draft the plans he would be forced to implement. The soldiers knew that in Bedouin society a son respects his father's words, so the officer went to his father and tried to convince him to make Ibrahim return to his work by saying he would need it to survive and feed his family. Ibrahim's father told them, "What are you saying? Are you crazy? Have you lost your mind to think that my son would work in your government? Get out of my sight and don't return."

Ibrahim made this decision when the five Palestinian directors of the Egyptian administration decided that only the directors of health and education should return to their positions, because the nature of their positions was not political but administrative, so they would still be helping people. The remaining three directors resigned because their staying would not be helpful for the people; rather, it would have furthered the aims of the occupation. I supported Ibrahim in his decision because I believed that he would be useless and only fulfilling Israeli orders, not his own plans, so he would just be an instrument in their hands. So, we lived on a small pension from the Egyptian government, and every

year he went to Egypt to collect it. We also have land in Deir Al Balah, so we lived off both. In fact, it was really hard for us after 1967. The income from the land was not enough because of the children's education expenses, but Ibrahim's brother sent money and supported us for a long time. We managed with that generous support, which continued until the children graduated and started to work.

The soldiers didn't return, but they kept us in their minds. They deported and detained Ibrahim for three months in the Sinai Desert, after accusing him of organizing activities against the occupation.

6 / Black September

IN 1969, Fawaz was in grade 10. Like many of his genera-
tion, all his thoughts and questions were about our lost land
and the ways to gain back our freedom. He had many friends
that he spent lots of time talking to and playing with, and
with whom he also shared similar ideas, enthusiasm, and
anger against the occupation. On the other hand, Hussein,
my eldest son, rarely played in the streets like the others,
but concentrated on studying, reading, and learning English.
As we are a family who highly values education, Ibrahim
decided that he would take Fawaz to Egypt to join Hussein
so he could better focus on his studies. They went through
Amman to Cairo, where Ibrahim registered Fawaz in school.

While Ibrahim and Fawaz were in Cairo, two armed
attacks took place in Israel, and Ibrahim was accused of
planning one, a big explosion at the Hebrew University in
Jerusalem. He had suddenly left to travel with his son, and
so the Israeli authorities thought he had escaped. On every
Israeli radio news bulletin, Ibrahim was accused of planning
operations in Jerusalem. I was boiling when I heard this. In
fact, there was no connection between Ibrahim and these
incidents. But because he was a respected community leader
and active in the nationalist cause, the Israelis wanted to

keep him out and make him afraid of returning, because they didn't have any evidence to use to get rid of him.

One night, while Ibrahim was in Egypt, Israeli soldiers came at midnight to search our home. I knew they would come, and I knew it was them because it was curfew, and nobody knocked at the door during curfews except soldiers. I had already searched the house and burned all the papers relating to the PLO, even invitation cards for special occasions—anything that could harm Ibrahim, because I expected them. The only thing I didn't find was a copy of a letter that Ibrahim had sent before 1967 to Abd Al Nasser through the Gazan governor, complaining about the Egyptian administration. When I didn't find it, I thought that Ibrahim must have gotten rid of it, so I told them they wouldn't find anything. I had also hidden my gold and money at the bottom of the flour container under the flour.

Soldiers went upstairs and downstairs searching every corner, and our dog barked as I went with them from room to room. They found the letter I hadn't been able to find, and a soldier asked about it. I said, "I kept this paper for you because I expected your visit. Do you know what it says? It's a letter from Ibrahim to Abd Al Nasser complaining about the administrative governor in Gaza, and it was sent through the same governor. I kept it to show you how much freedom and democracy we enjoyed during the Egyptian era. So, you can take it to learn about freedom and democracy." He asked for a copy, and I told him to take it because we had one hundred copies. Then someone came from the downstairs library with a book. He asked about it, and I asked him if he could read Arabic. He said, "Of course," and read the title, so I asked him who the author was: "Is it Ibrahim Abu Sitta? This book is sold on the streets and we bought it like anyone

else. What's wrong with that?" He didn't say anything more, but he took the book.

The built-in wall closet in one of the rooms had an upper storage shelf for suitcases, blankets, and mattresses, and I didn't have time to check there, but the soldiers climbed up and looked inside and found Egyptian army boots. They asked me what they were, and I replied, "Boots."

"We know," they said.

"As you know, they are boots that belonged to the Egyptian army, who escaped after you occupied Gaza. My children brought them to wear, but I didn't agree. So, I hid them so they wouldn't wear them."

They kept searching, but didn't find anything to accuse Ibrahim with, so they left. I was astonished at the large number of soldiers and jeeps and tanks surrounding the whole house. Anyone looking from outside would have thought that they had come to occupy a military establishment. They thought I was stupid because I had young children and would not be aware enough to know they would search my home, and so they thought they would find something to accuse Ibrahim of and imprison him. But thank God, I was aware of this. They came and left without finding anything.

There were no phones to Egypt or Jordan, so I sent letters to Ibrahim with people who travelled outside Gaza, and asked what he was going to do, return or stay abroad. He replied that he would return to his home and his family whether they agreed or not, because he was innocent and had nothing to do with those explosions. I once sent him a letter with my midwife, who put it in her *shash* over her *tawb*. In that letter, I told him that if he knew he was innocent, to return and not think about them because they wanted to keep him out and fragment the family.

His brother in Kuwait, Suleiman, and his lawyer friends in Gaza advised him not to return because he would be arrested. They asked me to write telling him not to return, because he would be arrested on the Allenby Bridge and taken to the Al Mascobia prison in Jerusalem. They said that a short time before, a Palestinian prisoner from Nablus had been killed in that prison, and that if Ibrahim returned and the Israelis decided to get rid of him, they could assassinate him and create a story. So, I sent him another letter telling him of his friends' advice not to return because of the things that had happened to this man. But he wrote back saying he was innocent and would return to his home, and to wait for him on April 7th. If he hadn't returned after this date, I would know that he had been arrested and I was to find a lawyer for him, at least to transfer him to Gaza prison. After he had settled Fawaz in Egypt, he went to Amman, crossed the Allenby Bridge, and returned to Gaza.

The night before, I didn't sleep even for a moment. I read verses from the Quran and prayed to God to return him safely. The next day I waited for him, and in the late afternoon, Ibrahim arrived. When I saw him, I couldn't believe that he was there with me, and he told me not to be afraid because he was innocent and didn't have any connection to the Jerusalem explosions. Ibrahim returned at the start of a week-long Jewish holiday in April 1969 and was surprised that he hadn't been arrested. He spent that night at home, and the next day phoned the Israeli administration to say he had returned and whether they wanted anything from him. They sent for him the same day and he went in his car, a Peugeot, which was then the only such model in Gaza and Israel. The soldiers always looked at it, and even touched it, when they saw it. Since it was a holiday, no officers were

present to question him, so he was detained and the car taken, but he was treated politely and the car was later returned. He was put in an officer's room and able to keep his own clothes, not made to wear the prison uniform, and I was even asked to bring him a change of clothes. When the Jewish holiday was over, he was taken to see the administrative governor of the Gaza Strip, who was a good man. Ibrahim told him that he wasn't involved in the attacks or anything political or related to the military, but only in improving the situation of the people in terms of education, health, and their living standards, and in helping them in this difficult situation. They had a long conversation, at the end of which the governor apologized for his detention, released him, and asked to see him a week later.

When the news spread that Ibrahim had been released, people visited him during that week, and then he returned to the governor, who asked him about the situation in Egypt the month before. The only thing that Ibrahim could tell him was that they were very self-confident about defeating the Israelis and regaining their occupied land. Ibrahim had felt this when he attended the funeral of a martyr while he was there. The governor was very polite and told him that he would be happy to help with any request he might have. After 1967, the Israelis had tried to impose their curriculum rather than the Egyptian *tawjihi* curriculum, but as many know, Arab countries would not recognize the Israeli *tawjihi*, so our children were not able to attend universities in Arab countries. So, Ibrahim asked that the Egyptian education curriculum be reinstated in Gazan schools, and for *tawjihi* to be put under Egyptian responsibility. The governor agreed as long as there was no Egyptian interference in Gaza. He advised Ibrahim to take a delegation from the education

department in Gaza to discuss this matter with the Egyptians, so they went to Egypt and met with the education ministry and organized the curriculum. Before they left, Abd Al Nasser met with them, and at that meeting he decided that Palestinian students, who were mostly refugees, would receive free higher education in Egyptian universities and also be given financial assistance to help with their living expenses. That was the beginning of the return to the Egyptian curriculum and *tawjihi* in Gaza. In July 1969, UNESCO brought the sealed examination papers to Gaza, which were sealed again after the students finished their examinations before being taken to be marked in Egypt. Then, the results were sealed once more and sent back to Gaza.

On July 2, 1969, Ibrahim, Faisal Husseini, and Dr Haidar 'Abdel Shafi were exiled to the Sinai. All were respected community leaders and active in the Palestinian cause, but the Israelis had no evidence of wrongdoing; if there was any, they would have been taken to court and imprisoned, but instead they were exiled. Ibrahim was sent to Al Hassana and the others were sent to two different places, all in separate vehicles so they couldn't speak with each other. They were detained for three months before being allowed to return, again in separate vehicles, at midnight on the 2nd of October. The next day, people came to welcome Ibrahim. The administrative governor gave the order for them to return. He finished his work as governor of the Gaza Strip at the end of September, and before he left, he ordered that detention in exile was not to be extended for these three people. I still have the letters with the Israeli deportation order, including the option to extend the period of detention.

The Palestinian resistance increased after the occupation. In 1970, a group of high school students, including our neighbour, was accused of throwing a hand grenade at Moshe Dayan's jeep on 'Omar Al Mukhtar Street. Unfortunately, it missed him and injured some bystanders. Our neighbour was not part of that attack, but Israel arrested all of those who had any connection with this group. He was jailed for a few months. The soldiers raided his home in the middle of the night, and after his home was searched, he was arrested. We woke up to the screams of his mother that night. He was released on condition that he lose his identity card and not return to Gaza, and his family agreed because there was no other choice if he was to be released. He became displaced. His family did not visit him during the four months of his imprisonment because the situation was very difficult. It was only in 1995 that he was able to come back, after the Oslo II Agreement was signed. Life in the refugee camps was even worse than in Gaza City, and the *Fedayeen* were stronger there. To diffuse and quell the resistance, in 1971, Sharon demolished rows of residential homes in the Khan Younis and Rafah camps. Entire families ended up in the streets and became displaced for the second and third time. Those were horrible days.

We suffered a lot in our lives, and as a mother, I was always worried about the future and about my children. The future under the occupation with a husband like Ibrahim and with young children was difficult. In 1970, Ibrahim and I travelled to Cairo to see our children. We flew to Amman, and from there we flew to Egypt. After we crossed the Allenby Bridge and reached Amman, we heard shooting from the clashes between Palestinians and Jordanian soldiers, although

Black September hadn't yet started.[1] We flew from Amman to Egypt on September 1st, stayed for two weeks, and then quickly left for Amman, so we could return to Gaza before something happened. Hussein was then studying engineering at Alexandria University, and Adala was studying history at Ain Shams University in Cairo. Moeen, who had joined his siblings that year, was not happy in Egypt, so Adala suggested we send him to study in Kuwait and live with his uncle there. Eventually, Moeen returned to Egypt to study medicine and be with his brother and sister.

There is a big Palestinian community in Jordan, and before 1970, there was also a large number of Palestinian fighters there with the PLO. King Hussein was afraid of the increasing power of the Palestinians and accused them of planning to overthrow him, and he decided to get rid of them. Ibrahim's brother Abdallah was then the leader of a group of fourteen hundred Palestinian fighters with the PLO outside of Amman. He didn't allow his group to go into the area of Amman because he knew that they would be killed if they did. Abdallah was a really good and strong man who cared about his people and his nation. By the end of May 1948, the Gaza Strip was full of refugees, as many Palestinians had been forced to flee from different parts of Palestine, leaving behind their lands and homes. The people of Gaza and the West Bank, represented by their *makhatir*, mayors, and other active people, then formed a committee for refugee affairs. Abdallah was elected as the general secretary of the Executive Committee of the Refugees' Conference in Gaza, which was supported by the Egyptian government. Initially, there was another committee in the West Bank, but its representative agreed with King Abdullah of Jordan to the transfer of the West Bank committee to

Jordan, so there was only one committee situated in the Gaza Strip. Abdallah participated in many international conferences around the world and travelled to many Arab countries to bolster support for refugees, representing them and liaising with the UNRWA and other organizations to guarantee that they would receive the essential services that would sustain their life in the camps until their return to their homes. Together with Ibrahim, he also received many delegations visiting the refugee camps in Gaza, including those of Che Guevara on June 18, 1959 and Jawaharlal Nehru in 1960. He worked in this capacity until the defeat of 1967, after which he was not allowed to return to Gaza, instead joining the hundreds of thousands of displaced Palestinians. After 1967, the work of the committee stopped; then the committee reformed when several active people in the community told Ibrahim they would support him if he replaced his brother and revived its work, and he did. Abdallah was also the general secretary of the PLO during the time of Al Shuqairy, and he became the PLO ambassador to Qatar. But, as he believed he was born to be a fighter on the ground and not in an office, he resigned and went to Jordan, where he wore a uniform and led the resistance groups in Jerash.

Ibrahim and I returned to Amman from our trip to Cairo in 1970 in the late evening of September 16th. We were worried when we arrived. The atmosphere was frightening, and you could feel that something terrible was going to happen. The streets were empty, with very few taxis to take us to my brother-in-law's place. Then we discovered that one of our bags was missing, and when we called the airport, the telephone lines there had been cut.

The next morning, martial law was declared. Curfews were imposed and people ran to shops for food supplies. I asked my sister-in-law to buy some flour, but she said she already had some, and the next day when the bread was finished and I wanted to make more, she brought a small packet, enough for cakes or small things. It wasn't enough for one meal, but in fact we didn't care much about flour or food. We only cared about staying alive.

We were stuck at my brother-in-law's home from September 16th to 30th. The situation was very hard and dangerous, and we heard the sounds of shooting and clashes all the time. A curfew was imposed for a long time, and we listened to the news on a small battery-operated radio. There was no food, water, or electricity, so whoever had food ate and whoever didn't starved. A respected religious man, whose name I have forgotten, opened his home to anyone who wanted shelter during the curfew. He asked the supermarket in front of his home to bring all the food to him to feed the hungry people, and he promised to pay for it later. Many people went there, and he saved their lives.

Once during the curfew, Jordanian soldiers knocked at the door of our neighbours' home. We heard a lot of shooting and then they left. One week later, when the curfew was lifted for an hour and people rushed to the vehicles that brought water to the area, we thought about our neighbours and wondered who would go to see what happened in their home. Ibrahim said he would go, because he was a fighter with his brother from 1936 and was strong and brave. Another neighbour, a woman, went with him, and as they got close to the house, they saw the door was broken and they could smell something very bad. As soon as she entered, the woman started screaming and quickly left. We asked her what was in there,

and she said, "What is there is a horrible thing. I can't tell you what's there. I can't tell you what I saw."

Ibrahim found the bloated bodies of a pregnant woman and her two teenage sons, and her husband huddled in a corner smoking, while two other young children, four and five years old, were just sitting there. Ibrahim took the two children and shouted for an ambulance. At that moment, a boy from the neighbour's family came on his bicycle to ask about them, and when he saw what had happened, he shouted, "What did those sons of dogs do? They weren't Palestinians, they were *Sharkas*." He left on his bicycle, shouting and crying, to tell his family. Then the ambulance came and took away the three bodies, and meanwhile the curfew was imposed again. We brought the two children home and I quickly brought them some milk, but when the girl saw it, she cried, "We don't want milk. We hate it." So, we searched for other things to feed them. I later found out that after the murder of their mother and brothers, the children had survived on a can of milk powder by dipping their fingers in the can and licking them.

There were many horrible stories during Black September. One Palestinian woman had married in Amman and had a small son. She was in her last month of pregnancy and during the curfew she felt the baby coming. There were no doctors or midwives in her area, so her husband went to their neighbours for help. Four of them came, but Jordanian soldiers saw them go from one house to the other, breaking the curfew. They broke down the door and burst into the house and asked why they had broken the curfew. The neighbours explained, and the soldiers saw the woman screaming in pain, so they said they would help in their own way. They shot the pregnant woman in her head and stomach, then the four

neighbours, the child, and the husband. This was one family's tragedy, but I am sure there are many similar stories.

Once, soldiers knocked at my brother-in-law's door and ordered him to open it, but he was hesitant. I was wearing my prayer dress, with a long white skirt and white waist-length veil, as I was reciting the Quran day and night and seeking God's protection. I opened the door—and maybe I could do it because I had been through similar situations before and I was strong. I faced the soldier and spoke in a Bedouin accent, "It is shameful that you are coming to a Jordanian home. What do you want from us? Do you want to kill your own people? It will be to your shame to do this."

He said, "We heard you are hiding Palestinians in your home."

"What are you saying? We are your guides to Palestinians! We are from Al Tayaha tribe, and if anyone harms you, we will eat him with our teeth!"

He asked to see our passports, so I quickly brought mine, and said, "Look, my name is Madeeha Albatta from Al Tayaha tribe!" while he looked at it, and I don't think he knew how to read. He told me to show him the house, but there was no electricity and it was so dark that I had to light matches while they looked under the beds and sofas and in the corners, and then they left. As soon as they left, we heard shooting as Palestinian fighters shot at the soldiers leaving the house and I think one of them was killed. The Palestinians thought that these soldiers had killed us because usually when soldiers entered a Palestinian home, they killed everyone inside.

After the shooting stopped, we heard knocking on the door again. When I asked who it was, a soldier said, "Open the door! Palestinians are shooting at us, and we are sure they are hiding somewhere in your house." I opened the

door, and he said, "Look! We were three, and now we are two because one was killed." I was like the best actress, screaming and pretending to be very angry and sad about the soldier who had been shot. They wanted to search the house again, so I let them in, and again we searched the same places using matches for light. When they were sure that nobody was hiding, and while I was crying for the dead soldier and saying bad words about Palestinians, the soldier asked if I needed flour or wanted bread. I told him no, the only thing I wanted was for them to be safe. So, they left, and I closed the door again and heard the sound of an ambulance coming to take the soldier's body away. In fact, we saw many horrible things in our lives, and in my opinion not even a big book is enough to contain all of them.

On September 28th, we heard the news of Abd Al Nasser's death, and Ibrahim went crazy because he couldn't believe this had happened. We didn't sleep that night because his death added to our tragic problems. The next day, we heard a jeep stop beside our house and soldiers went to speak to some neighbours. One of the soldiers told them that they had been sent by a high official in the Jordanian army who had a relationship with them and who had arranged for them to be taken to another place. When we heard this, we went outside and told them that we were from the Amman tribes (which was almost correct) and asked them to take us out of the area, because my father-in-law, Sheikh Hussein, was very sick in Gaza and we had left our children alone there. We said we only wanted to be taken to a place where we could find a taxi. The soldier told us he couldn't do it that day because they had come to take this family, but he promised to take us the next morning and told us to be ready at nine o'clock. He was very good, and we trusted him, but during

the night I wondered whether he would come or not. The next morning, he came and took us out of the area in a jeep, and at the same time the curfew was lifted. When we arrived in the other part of Amman, we found life going on as normal: coffee shops were open, radios were playing songs, and people were walking in the streets. I burst out crying. I had some Jordanian Dinars, and before the jeep left us at the taxi station, I bought chocolate and biscuits and asked the soldier to take them to the house we had come from. Later, my brother-in-law's daughter said it was the most delicious chocolate she had ever eaten.

As the Israeli women soldiers checked our bags at the border, they asked our opinion of the situation in Amman, and I told them the Jordanians were doing the same as the Israelis did to us. We went through the border and there were no other people or workers, so Ibrahim carried our bags one by one to a certain point, and I stood beside them as he brought the rest. Then we went to my aunt's home in Jericho for a short rest. I hadn't washed in the fifteen days we had spent in Amman because there was no water—we had hardly managed to find water to drink—so the first thing I did was wash. Then we ate a little and left for Gaza. My aunt asked us to stay the night, but we refused because we wanted to return as quickly as possible to our children and Ibrahim's sick father. We took a taxi and arrived home, and I kissed the ground and the steps of our house one by one because I couldn't believe that we had arrived safely. My children had prepared a meal, and I cried when I saw the food because I remembered the Palestinians starving in Amman, and I knew they couldn't find any food to keep them alive. Many Palestinians were killed in Amman and there wasn't enough room to bury them, so their bodies were carried to the

mountains and burned.[2] The sky was full of smoke from the bodies, and it looked like the pictures that came from the World Trade Center. I heard that King Hussein flew his plane and watched from the sky.

On November 3, 1970, my father-in-law died, and on December 8th, almost forty days after his death, Abdallah was murdered in Jordan. When the events of Black September ended and an agreement was reached between the PLO and the King, the Jordanians pursued some of the PLO leaders. Abdallah's relatives in Jordan who had connections with the army warned him that he was on a death list and to escape, but he refused to leave his men. He said he would live or die with them, but he would not leave until the last one's safety was guaranteed. On the morning of December 8th, Abdallah was with his two-year-old son, Suleiman, when agents from the Jordanian Intelligence service came for him. He was ordered to leave his son and go with them, and still we don't know exactly what happened to him. Some people told us that they saw his body among thousands of other bodies, and others said they saw his body being dragged by a Jordanian tank through the streets of Jerash.

Thank God, Abdallah died after his uncle, because if Sheikh Hussein had been alive, he would surely have gone mad from the shock. He loved Abdallah very much, and before his death, he wrote his will, giving Abdallah five hundred *dunum* of Al Ma'in land in addition to his inheritance. In his will, he wrote, "When you return to our land, divide it amongst you as I will mention later, but Abdallah is to have the biggest part. In addition, I give him a certain piece of land, about five hundred *dunum*." This piece was the best of his land, and this gives an idea of how much land the Abu Sitta family owned before the Israelis occupied it in 1948.

7 / 1973 War

IN 1973, Hussein graduated in Alexandria. Ibrahim went to see him, because he had found work in Libya and wanted to go there directly from Egypt. To get there, Ibrahim travelled to Cairo through Cyprus because that was the only way to leave the Gaza Strip. The border to Egypt was closed to everyone except for the Red Cross, which helped university students obtain permission from the Israeli side and then took them in buses to Cairo through the Israeli/Egyptian border. For a long time, the Egyptians had secretly planned for the 1973 war, which started in October during Ramadan.[1] The Egyptians placed advertisements in their biggest newspapers and international newspapers that stated that army officers were allowed to make the pilgrimage to Mecca, and listed hundreds of them as going. But this wasn't true. It was a trick so the Israelis wouldn't expect an Egyptian attack when their officers were thought to be away. Also, war usually stops during Ramadan, so the Israelis did not expect one to occur at this time. The Egyptians were at the peak of readiness and chose the holiest day in the Israeli calendar, *Yom Kippur*, and the Jewish *Shabbat*, to attack because the Israelis would be busy celebrating that day and would not be prepared. The Israelis then controlled the eastern part of the

Suez Canal and the Egyptians controlled the western side, and the Egyptians prepared everything necessary to cross it. To reach the eastern part, the Bar Lev Line[2] had to be destroyed and the Egyptians succeeded in breaking through different parts of it.

The first wave of Egyptian soldiers carried with them powerful pumps. They used them to draw water from the canal and direct it through water cannons to blast large openings in the high sandy embankments that the Israelis had built along the canal to protect the Bar Lev Line. This enabled the mass of Egyptian armoured divisions and vehicles to cross the canal on floating bridges and pass through those openings into the Sinai desert behind the Bar Lev Line. The Egyptians then attacked from behind and destroyed all the strong fortifications of the Bar Lev Line and captured many Israeli soldiers. The fall of the Bar Lev Line in such a short time was a miracle because it was very strong, so it was a very big victory. Israeli propaganda had declared that nobody could destroy the Bar Lev Line and that they were invincible, but the Egyptians broke this legend and defeated that army, entered the Sinai, and continued on their way to liberate the rest of their land.

I turned on the radio and heard that land troops had attacked the Israelis occupying the Sinai and a battle was in progress. I couldn't believe the Egyptian troops were fighting the Israelis, and that they would liberate their land and our land from Israeli occupation. I kept listening to the news until midnight, and then I heard that the Egyptians had crossed the Bar Lev Line and thought they would soon reach Al Qantara, then Al 'Arish, then Gaza. Then I heard that the Egyptians had passed through Al Qantara and I jumped with happiness. I thought that they would take Al 'Arish the next

day and then they might be here, and then the Israeli military occupation would end. We hoped the 1973 war would last a long time and liberate our land, but orders were given to stop it.[3] If the war hadn't ended, the Egyptians might have at least liberated the Gaza Strip.

The next day, Israeli soldiers came asking about Ibrahim, who was still in Egypt, and searched our home looking for papers that might give them some information. They didn't find anything, and as they were leaving, they said in Hebrew that they should go to the house of the old mayor of Gaza, Muneer Al Rayyis, who was a sick old man by then. The Israelis thought that because Ibrahim and he were Gazan leaders, they might have some important information. I understood what they said, so I quickly telephoned his home. I waited a long time and thought that the lines had been disconnected, when a Jewish voice answered, and I asked to be connected to the home of Muneer Al Rayyis. His daughter answered, and I told her, "Look, your cousins are on their way to your home to see your father, so prepare him for the visit. Do you understand what I am saying?"

The girl said, "Yes."

I also told her that they had just left our home and if there was something not clean, or if things needed to be gotten rid of at home, to take care of it because her cousins should find the house clean. The girl said she understood, and I rang off. In fact, since the time that the radio announcements had accused Ibrahim of planning the attack against The Hebrew University, I had gotten rid of any papers related to the PLO and anything political that might harm us. So, when they came in 1973, they didn't find anything.

When the war finished, Ibrahim returned to Gaza, coming back from Cairo through Cyprus. He phoned us from Cyprus

to say when he would arrive at the airport, as there was no telephone communication between Egypt and Israel, so Adala and her fiancé and I went to collect him. On our way, we saw the Israeli cars, jeeps, and tanks full of soldiers and military equipment returning to Israel from the Sinai. This was November 1973, and Adala was married on November 30, 1973. So, in 1973, Adala found work, got engaged, and married, Aida completed *tawjihi*, and Azza was at school. Hussein also graduated that year and worked in Libya until 1975. Now he is in Riyadh, working as the manager of an engineering company that builds hotels.

At the end of 1978, I learned to drive, and I asked a girl who was being taught with me if she knew me. She said no, so I asked her whether she had ever heard my voice on the telephone, and she said no. Then I asked if she remembered a woman who had phoned in 1973, saying that her cousins were coming to her home. She said, yes, she remembered, and asked if I was that woman. She said that since then she had prayed for God's blessings for me because of the warning, and she had wondered many times who I was because I hadn't given my name. She thanked me, and from that day on we were friends.

The situation was getting more difficult, and Ibrahim and I decided that Hamed should leave Gaza and go to study in Egypt with his brothers or in Kuwait under the supervision of his uncle. So, Ibrahim went to the civil administration in Jericho and applied for permission for him to travel as he wasn't yet sixteen and was still on his father's identity card. He also organized a separate ID card for him to travel. I took Hamed to Amman, as Ibrahim was prohibited from leaving Gaza then because the Israelis thought he might meet with the PLO. We travelled via the Allenby Bridge. When we

crossed over to Jordan, we obtained visas to Kuwait and went to his uncle's home to arrange his studies. Hamed was very young and we felt it would better for him to be with his uncle's family. Then I flew to Egypt, and from there I returned to Gaza with the Red Cross.

Hamed did not like studying in Kuwait and wanted to go study in Egypt and to be with his brothers and cousins, so his uncle, after consulting with us, sent him to join Moeen, who was studying medicine in Alexandria. Hamed shared a flat with him and his cousins and attended high school.

We highly value education and were worried that Hamed wouldn't settle in while in Cairo as was the case in Kuwait, so the next year, when Nawaf and Nasser finished *tawjihi*, Ibrahim and I took them to Cairo for university and moved Hamed from Alexandria to Cairo, and rented a place for the three of them. We registered Hamed in a high school in Cairo in September 1976. Then we stayed with them for a year to get him settled, and when he passed his exams and finished the school year in May 1977, we gave him money and told him to concentrate on his studies and his future because he had already lost time. Hamed finished *tawjihi* and got high marks. Immediately, Moeen sent a letter for him to apply to the university in Buffalo, in the United States. At the end of 1981, Moeen sent word for Hamed to travel there quickly so he wouldn't miss the new semester at the university. Hamed studied mechanical engineering in Buffalo starting at the beginning of 1982, and we visited him in 1985. He eventually moved to Canada in the early 1990s and got married in 1995.

When we returned to Gaza from Cairo in 1977, we found out that one of Ibrahim's relatives, Anwar, had been arrested. I decided to go to visit him with his family. At that time,

families were allowed to visit prisoners every fifteen days, while before we had been able to visit every month. Three adults and one child were allowed to go, so I visited with his mother, his wife, and his son. I drove them to the Ansar 2 prison in Gaza, which was beside the Israeli civil administration building, and we stood in line with others who were there to visit prisoners. I hate that place, so I always avoid looking at the area when I pass because I remember the thousands of Palestinian youth held there, the torture they undergo, and the suffering of their families. When we went to visit, we stood behind a long bench in front of the windows that separated us and the prisoners on the other side, and we spoke to them from a distance. Around 10:00 AM, they called us and we were taken to the place where the prisoners were waiting behind the wires of the windows. We walked toward Anwar's window and his mother was in tears when she saw him. Anwar was happy to see us, and while we were chatting with him, I heard a woman weeping very loudly next to us. I guessed she was the mother of the prisoner who was standing next to Anwar. The prisoner was pale, and he stood bent over. The right side of his face was very blue, and his eyes were red. His mother could not stand like us, but kneeled on the floor, and she started to cry out in a loud voice, *Yamma, Yamma, Ya Habibi Yamma* (my dear son, my beloved son). The mother was asking her son what had happened, while the two young women with her cried and the child with them was silent, staring at the soldiers. I did my best to avoid crying, but at the same time I felt my heart was crying, in fact, bleeding, for the young man and his mother. At that moment I remembered my two brothers, Nadid and Hassan, who were killed in 1956. I remembered my father and how he bore that agony.

I remembered Nadid and the feelings of his mother when he was taken and shot before her eyes. All these agonies came before my eyes when I was looking at Anwar, the other prisoner, and his mother and all of these young men held behind bars. The mother kept weeping, and naturally I, along with many other prisoners' families, went to calm her down, but none of us could. All the people started to shout "God is great," and ask God to avenge them. There was chaos and soldiers came in and the visit was cut short. When we got into the car, Anwar's son kept asking questions about the situation in Ansar, and about why we were ordered to leave. He asked one question after another, and neither his mother nor his grandmother responded. I passed the boy a candy I had in my bag and asked him to tell me what sort of toys he liked so that I could buy him a present.

I was shaking from the horror of the injustice as we returned home, and I don't know how I drove from the prison back home. That day, I was supposed to go to a party to celebrate my brother's new home in Khan Younis. But all the happiness had vanished from my heart as I felt that man and his mother's pain deeply. I don't know how I dragged myself to Khan Younis and joined the party. On our way back to Gaza, I asked Ibrahim to stop at a funeral at a friend's home, and as soon as I entered, I started crying. People tried to calm me. They said that even the daughter of the deceased was not so upset as I was, and told me that everybody has to die, that this is their fate. But I couldn't stop crying, because I needed to empty myself of all the pressure I had been under the whole day. I cried for Anwar, I cried for my two brothers, I cried about the situation, the difficult life, the lady who had died, our people, and all of the people who live under conditions of injustice. When Ibrahim saw me, he

asked me what was wrong with me and why I was so sad, but I opted not to tell him, as I know the heavy weight that he carries on his shoulders. Ibrahim is very sensitive. He is the type of man who hides his feelings and doesn't express them, while women have the patience and means of releasing pressure and expressing their feelings. I love him and didn't want to add more to his full plate, so I preferred to hide what I saw in the prison and my own feelings, rather than make him feel as helpless as I felt. The next day, Ibrahim followed me around the house and eventually I told him the story and could not hide my tears, as doing that would have made him worry more. Ibrahim looked carefully at me and left.

He drove very fast and I heard the car hit something, and then a few minutes later, our neighbour came and asked what was wrong with Ibrahim. Before I could answer her, another neighbour came and asked the same question, and I asked them why they said this. They said that he usually said good morning, but this time he didn't even look at them and his face showed he had received very bad news, and he had even hit the side of the garage with the car. So, I told them the story of the prison and about my own feelings, as I felt their sincere worry about Ibrahim. Our neighbours cried.

8 / Waiting for the Curtain to Rise

IN 1976, Nasser was already studying medicine in Alexandria.
Also in that year, Ibrahim was given ten university seats to
be allocated, at his discretion, to deserving Palestinian students
who did not meet the high admission requirements, or
whose social and economic circumstances were such that it
was vital for them to get a university education and hence a
better future for themselves and their families. Ibrahim
allocated the ten seats according to the criteria and based on
his knowledge of the potential candidates and their families'
circumstances. Two examples from that group of ten students
stand out. One was a top student who had obtained very high
marks and whose sole ambition was to study medicine, but
his marks were not high enough to get him into medical school.
He is now a well-known physician working as a department
head in Gaza's Al-Shifa Hospital. The other candidate wanted
to study law, but his marks did not meet the cut. Ibrahim
gave him the last available seat because nobody in his family
had ever gone to university, and his family was still mourning
the recent death of his oldest brother who drowned in the
sea. He is now a successful lawyer in Gaza.

In that same year, Nawaf got accepted to study at the school
of business, but his heart was set on studying engineering.

He pleaded with his father to allocate one of the available engineering seats to him, but Ibrahim refused and went on to award the seats to deserving students rather than to his own son. Ibrahim is a very good man with a heart of gold and a loving father who wants the best for his children, but his principles and his sense of public duty would not allow him to award a university seat to his son at the expense of a more deserving student. Nawaf took the option of repeating the school year in order to improve his marks, and he was eventually accepted in September 1977 into the Engineering Department at the University of Alexandria.

While Nawaf and Nasser studied in Alexandria, they lived in an apartment with Moeen. An American exchange student named Mary lived in the same building, and Moeen got to know her and invited her to meals and occasions organized by the Palestinian student council to raise the awareness of foreign students about the Palestinian cause. Over time, Moeen and Mary fell in love with each other, and Moeen told me that he wanted to marry her. I said that it was his decision, not mine. He wanted to meet her family in America, and we agreed that if he passed his exams, I would help him by giving him the money to visit them, so in 1978 he passed his exams and met her family. The family liked him, and he and Mary got engaged. The same year, I went to Mecca to perform pilgrimage and while I was there, my sister phoned me from Riyadh and congratulated me on Moeen's marriage. I told her that he and Mary were only engaged, but she said she had spoken to him two days before in Alexandria and they had been married there. I thought she was mistaken. When I returned to Gaza, friends welcomed me, and one of them, whose daughter was studying with Moeen in Alexandria, congratulated me on his marriage and said

Madeeha Hafez Albatta on a trip to Egypt in 1980. The photos were taken in Alexandria. Photo courtesy of Madeeha's family.

the wedding party had been very nice. When I heard this the second time, I felt it must be true, so I phoned Moeen and he confirmed it. While this was a surprise to me, I understood their rationale. They were young, in love, and freshly out of university, and on top of that they did not want to stress us financially. Although he is our third son, Moeen was the first to marry. In 1979, they travelled to America to have their son Ibrahim, and returned to Cairo while I was there, so I

organized a party for my new grandson. In 1981, after Moeen graduated and finished his training year in Egypt, they went to Mary's hometown of Buffalo, New York, near the border with Canada. Moeen trained in hospitals for four years there before he was licenced to practice medicine; during this time, he was supported by his uncle. He is now a gynae-cologist/obstetrician at the Buffalo university and teaching hospital. They have three children, and he sends me money every month.

Fawaz finished high school in Egypt, and in 1971, he obtained a scholarship to study law in East Germany, where he completed his bachelor's degree, a master's degree, and a PHD. When he had finished his master's degree, he returned to Gaza and registered at a lawyer's office for training, and at the same time was offered a scholarship for his PHD. At first, he refused the scholarship and when we asked why, he told us that he had a girlfriend named Anke and that they were in love with each other. He said that if he returned, he might marry her. Now, since Moeen had married an American woman, Fawaz thought that we might be unhappy if he too did not marry a Palestinian woman, but instead married a German woman. I told him that Anke's nationality didn't matter, and the most important thing was her manners. He said that she was a very good and very clever young woman. I told him, "How could it come into your mind that we might disagree with you marrying a German? Aren't you afraid that in the future your own daughter might go abroad to study and meet somebody who might leave her because she is an Arab and do the same thing that you are doing to this girl? I believe that whatever you do, good or bad will happen to you, so go, start your studies, and marry this girl you love and who loves you." Fawaz travelled to Germany, and we

followed a month later, taking many symbolic Palestinian gifts. We met her family and celebrated their wedding, where she wore a Palestinian *tawb* I had brought as a gift. Fawaz and Anke now have three children.

In 1979, Ibrahim had an idea to help unemployed university and college graduates who were also registered refugees. The families of these graduates would have spent all their savings to put them through higher education and would be eager for them to start working to support their families, and, in turn, pay for the higher education of their younger siblings. These graduates couldn't get jobs in rich Arab oil countries because they did not have the necessary work experience. Ibrahim wanted to help them and their families. He proposed to the PLO that it start a program to pay for the salaries of two hundred graduates to be employed by the UNRWA every year, and his proposal was accepted. Then he spoke to the UNRWA, which adopted this initiative and began to give graduates work in different fields in the Gaza Strip for two years before replacing them with the next group. The project continued, with the PLO paying the graduates' salaries through Cyprus, from 1979 until the establishment of the Palestinian National Authority in the Palestinian territories in 1994. During that period, Ibrahim acted as a liaison between the UNRWA and the PLO; he contacted them when money arrived and worked with different areas of refugee affairs. It was known as the Abu Sitta Project for Refugees.

Ibrahim had worked with the PLO without a salary, and at the beginning of the 1980s, one of the PLO members spoke up on his behalf about this. He hadn't returned to work under the Israeli administration after resigning from the PLO and had never taken any money from the PLO for his

work, and thus he deserved compensation. So, the PLO office agreed to give him a pension every month, and this still continues to come.

I love Ibrahim. I love his strength, courage, fairness, and patience. He is the light of my life, so I try to make him happy, and when we are together, I feel that we are the happiest couple in the world. He always tells me that he likes to see my face first thing in the morning because I wake up smiling, and I am never sad or angry like some people. Many people have asked me why I don't look my age, and I always tell them it is my strong belief, trust, and faith in God. I am also an easy-going person who doesn't cause any problems for others that could stay on my conscience and keep me awake at night. I have been through many difficulties in my life: losing my mother and brothers, marrying a political figure who was always engaged in public duties, and raising young sons during wars, and Israeli occupation. I thank God that I was able to raise my children and save them from the brutality of the military occupation. I also took care of my health because when I lost my mother, I had to take care of myself. As a child and later in my life, I drank milk and juice and ate good food and exercised.

I was good with Ibrahim's family. I love them because they are very good to everyone and to me. I loved my mother-in-law, who died when she was one hundred and five years old. She was very good, generous, honest, and religious, and never ever turned away anyone in need. She always gave and was always smiling. When her son, Abdallah, was killed in Jordan during Black September and women cried and shouted in loud voices, she told them to calm down because it was God's choice and that what they were doing was

unacceptable. God gave her patience and she accepted the news as a believer in God's choice.

Once, in 1983, when she was ninety-five years old, we visited her, and when we were about to leave, I heard her calling me. She held my hand and said, "God bless you, Madeeha." Then she repeated this, and said, "God bless your children and your husband, and your health and money." I asked her to pray for Nasser, who was then doing an exam in Egypt through the American Embassy, and if he succeeded, he would continue his higher education in America. She told me to go and that he would pass his exam. As soon as I arrived home, I heard the telephone ring. There was nobody home because Azza, our youngest daughter, was studying medical lab technology in Germany, so I quickly answered the phone. The girl who had called told me that she was Nasser's friend and had just come from Egypt, and that he was the only one who had passed the exam. I couldn't believe it and remembered my mother-in-law's words.

We were not here during the first and biggest part of the first *Intifada*. In August 1987, Nasser married Hania, a Palestinian pharmacist who was born in America and studied there. He met her at the Al Makassed Hospital in Jerusalem while he was working there. Their wedding took place in a hotel in Jerusalem. At that time, travelling from Gaza to the West Bank or Jerusalem was easy, and many friends and relatives who attended the wedding were able to return to Gaza after midnight, after the wedding finished, but we stayed there overnight. Nasser and Hania worked for a while in Jerusalem and then applied for work in America. He travelled there in November 1987 and Hania followed him on the 13th of December, one week after the first *Intifada* started.

Life changed during the *Intifada*. Once again, the Israelis imprisoned people, and curfews were imposed every night from 8:00 PM to 6:00 AM, and many times during the day as well. People were fed up with the occupation, and the *Intifada* erupted to resist it. In fact, we didn't think the first *Intifada* would last for seven years, because during the years since the occupation started in 1967, we were used to frequent incidents in which many Palestinian civilians were killed by the Israeli army during demonstrations to protest the occupation. Usually, calm would return after the Israeli Army's heavy-handed suppression and violent reprisals subdued. A few months before the *Intifada*, Ibrahim tried to obtain permission to travel to Egypt and a few Arab countries and the Israelis always refused, but during the *Intifada* he was permitted to leave. In December 1987, we crossed the border to Egypt, and from there Ibrahim traveled to other places. We ended up staying there for three years, renewing our visas every six months.

Azza was on holiday in Egypt and before our departure from Gaza, she phoned to tell us that she would soon return home, but we told her not to because we were coming to Egypt, and we asked her to rent a flat for us in Cairo. She said she couldn't stay longer because of her work in a laboratory in Gaza, but we told her not to worry about that because of the many problems in Gaza. Also, she couldn't stay alone at home while we were away, given the dangerous situation and night raids during the *Intifada*. Although Fawaz was living on the first floor, she would still be alone. The situation in Gaza was getting worse and worse, so I stayed with her in Egypt, while Ibrahim travelled to Amman, Tunis, and other places.

Ibrahim worried about Azza and who she would marry, but I told him I wasn't worried because I believe in God and trust God. I have prayed and fasted since I was six years old, and I have always believed that, in the end, everything will work out by the will of God. Marriage is in God's hands. An Egyptian doctor at the Palestine Hospital in Cairo liked Azza and she liked him, too. But, she had heard that Palestinians working there had told him that it would be impossible for him to marry her because he was not Palestinian, so it was better not to think of Azza. However, Ibrahim told her to invite him over so we could meet him, and when he came, we were surprised by the appearance of a very tall and handsome man carrying a big box of chocolates.

He visited us often. Before Ibrahim travelled to Amman, I told him that it would not be acceptable for the doctor to keep visiting us while he was away, because people would gossip. So, the next night, Ibrahim asked him why he kept visiting, and he said he was waiting for a suitable time to ask to marry Azza. Ibrahim said this was a suitable time, and they became formally engaged that night. After they were married, he obtained his PHD in neurology, and he now works as a neurosurgeon in two hospitals in Cairo.

After my children married, I realized I needed to do something with my extra time other than eating, drinking, making social visits, and praying, so I first worked with the women's union. Then I left, but I felt I still had the energy and time to help the community. When I became seventy years old in 1994, I established a literacy centre for handicapped people who were sitting in their homes unable to do anything, and now it has become a big centre. And looking back at the last seven years and the achievements that

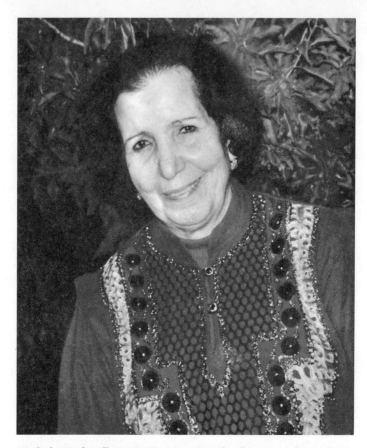

Madeeha Hafez Albatta in Gaza in 1995. The photo was taken at her home in Gaza City. Photo courtesy of Madeeha's family.

these people have made in that time, I feel proud of them, and of myself, but at the same time I don't feel that it has been seven years. It seems like yesterday, or last year, or at most two years ago. But time passes very quickly, and they have now reached the preparatory school level. I haven't visited them for a long time because of my health problems, but I should do so in the next few weeks. The teachers and students of this centre visit me on special occasions and they also came when I was sick, and now that the new academic

year has started, I am planning a surprise visit to them. Every time I travel, I use the opportunity to visit organizations to raise funds for this centre.

I have been to many places: Greece, Germany, Austria, and Canada, and the US. When I stayed in Buffalo for five months during the winter, I found Niagara Falls to be the loveliest view I have ever seen, especially with the snow and ice. I have also been to many other places in America: Chicago, Washington, Boston, and Ohio. I once had lunch at the World Trade Center with a nephew who worked there. Luckily, on the day the planes crashed into the buildings, he had forgotten his access card and couldn't enter his office, and he had gone home to fetch it. This saved his life. If he had been there, he would surely have been among the dead. I believe the fate of everyone—how, where, and when they die—is written. I am sure there were some people who only left that place a short time before the attack happened, while others entered the building at the same time it happened, so it was God's will that the first group would be saved and the second group would perish. There are always reasons for this, and the thing that saved my nephew's life was forgetting his card.

When the Declaration of Principles was signed,[1] Ibrahim was in Egypt and was supposed to accompany Chairman Arafat to Gaza for the first time on July 1, 1994, but for some reason he didn't, although he came on the afternoon of the same day. He still gives Chairman Arafat his recommendations and views of the situation, even these days when he prefers to stay at home and write about the Palestinian cause and work on his memoirs. He is also writing the speech for the declaration of the Palestinian state, which he even expects will be declared in the next few weeks. Nowadays, he

doesn't like to go out or give speeches or attend meetings. He also doesn't meet with journalists now. Although he respects them, he doesn't give any interviews.

Next month, we will go to Amman to celebrate the marriage of Aida's daughter to the son of Ibrahim's brother, Dr. Suleiman. Ibrahim told his brother that the parties should be held in Gaza because he believes that the Palestinian state will be declared. We hope this will happen, but if not, we will travel to Jordan to attend the party and be with my brother-in-law's family, especially since he always helped and supported us. I am worried about going to Amman via Egypt after crossing through the Rafah border, which will be a very difficult journey, but it is the only way that Palestinians can leave Gaza now. I travelled to Egypt in July for three weeks to visit Azza and her family, although Ibrahim told me that the trip would be hard. There were many people at the border, and I walked with them and took the crowded buses to the other side of the border, which took a very long time. But I know the situation now is even more complicated than in July.

I have only been to Khan Younis twice in the thirteen months since the beginning of this second *Intifada,* and both visits were necessary. Six months ago, my old friend died and I wanted to pay my respects to her family, so I left at 10:00 AM, stayed for half an hour and returned at midday. Luckily, the road was easy for travelling that day because it was our weekend and there were few cars waiting at the checkpoints. The second time was in October, when I went to the wedding of my brother's oldest son. It took two and a half hours to travel from Gaza to Khan Younis. A long queue of taxis and buses—you can't imagine the number— was going to the south, and every ten minutes the soldiers

changed the traffic lights to green to enable four or five
vehicles to cross, and then turned them back to red. It used
to take twenty minutes to travel from our house in Gaza City
to my brother's home in Khan Younis, but now the Israeli
soldiers have made it extremely difficult. It might take
hours, and sometimes days, if they close the Abu Holi, the
main checkpoint between Khan Younis and Deir Al Balah. By
the time we reached Khan Younis the wedding was almost
finished, so I stayed for half an hour, but I didn't enjoy it
because I was worried about getting back to Gaza.

While I was waiting at the checkpoint, I noticed the
destruction caused by the Israelis, and I closed my eyes
because I didn't want to see the horrible scene. I used to
know that road before they destroyed it. It was full of orange
and olive trees before. But when I looked at both sides of
the road, I didn't know where I was. I didn't know which
area had been orange trees and which had been olive trees,
because the Israelis have bulldozed the trees on both sides,
turning it into a complete desert. I couldn't believe my eyes,
so I closed them because I didn't want to see more horrible
things. Many families depended on these fields for their live-
lihoods and income. I was also surprised that the Israelis had
installed traffic lights. This was new for me. It was a really
difficult journey and I am afraid to go and pass through
that area again, so now I phone for news from time to time.
My nieces were also recently engaged in Khan Younis, but I
didn't go because of the problems on the way there, and now
I feel that our social life has been cut off.

This current *Intifada* is different from the last one. There
are many martyrs, almost the same number as during the
entire seven years of the first *Intifada*. But in this *Intifada*,
the Israelis want to destroy everything. Now they are

levelling the land, uprooting trees, demolishing houses, killing people—in an intentional and indiscriminate way. By these actions, the Israelis aim to destroy people's access to their livelihoods by uprooting trees and laying waste to the land. They also seek to inflict on the Palestinians a heavy toll of dead and injured, especially among children. They are destroying the economy of our people in so many ways—one is by preventing tens of thousands of workers from going to their work. They also forbid farmers from exporting their products, and it is the same with fishermen, and in all other sectors of the economy. They have committed many crimes since the 1948 war, but in this *Intifada* they are committing the worst of them. And this *Intifada* will not stop until we have a just solution for our problem.

The rest of the world has achieved independence and gained freedom and rights. There is no other occupation in the twenty-first century except the Israeli occupation in Palestine. We and the Israelis can live together as neighbours in independent states. States based on rights and respect, and peace and dignity. They can live within their borders and we can live within ours, with economic, cultural, and political relations between us. I wish America, with its blind support of Israel, would wake up and revise its thinking about why this is all happening. It accuses us of being terror-ists and violent people, but we are not. People and nations who defend themselves and their rights are not terrorists. Israel has violated the laws and commits all kinds of terror and massacres against us every day and nobody can stop them.

The Israelis can't speak about massacres and violence because they have committed many massacres and their hands are full of blood. Once, I was travelling with my son-in-law, who occupies the position of Justice Minister

under the PNA, and we were waiting in the VIP lounge while our papers were being processed. Some Israeli officers were also in the same room and we started talking. They asked us, "Was it acceptable for you Palestinians to kill Israeli soldiers who served in the Gaza Strip?"

I couldn't stand what I heard and asked them, "Was it acceptable that you killed fifteen hundred young men, among them my two brothers, in only one and a half hours in Khan Younis? Civilians who did nothing to you. If Palestinians killed one or two soldiers, it's nothing compared to the numbers you killed and massacred."

One of the officers said, "It wasn't us who killed them. It was the Druze soldiers[2] who committed that massacre, not us."

Unfortunately, or fortunately, a Druze officer was among them, and he said, "What you are saying is utter nonsense because we didn't join the Israeli army until March 1957, after the war started and finished, after you occupied Khan Younis and left Khan Younis. We did nothing in Khan Younis or any other place at that time because we weren't part of your army. So, don't put this on our shoulders." Then they started arguing and shouting in Hebrew at each other, while we sat watching and listening to them because we both understand Hebrew.

I am sure there are Israelis who want peace and security because they realize the advantage of having peace. They can't go to restaurants now, or take buses, or stand in the street, or go to coffee shops, but this peace can't be at our expense. They speak about violence and accuse us of being violent, but this violence is a reaction to their terror. Bush now speaks of a Palestinian state, and Perez is even starting to speak of a Palestinian state, but a demilitarized one. But I don't think Sharon wants to make peace. He's a war criminal

who started his crimes many years ago with massacres, along with the massacres he is committing every day in this *Intifada*.[3] The only language he knows is killing and terror. He has a black history of crime.

We are waiting and praying for the day when the whole world lives in peace and freedom, from the east to the west, and we are part of that world. I hope God answers our prayers and gives us freedom, especially in this holy month of Ramadan. And that next Ramadan, we can gather with our children who have returned from exile to build our independent state, because right now they are scattered everywhere in the world, using their skills and expertise to build other countries. So, I wish to have an independent state that includes them, and that they can help in building their state and helping their people. I wish the Arab states would unite and get rid of their authoritarian regimes. Although all these countries are now independent and have their own kings and presidents, in fact their people do not have the freedom they thought they would enjoy after their struggle to gain independence from the colonial occupiers. So, I wish these countries would wake up and get rid of their oppressive governments. I also wish they would support the Palestinian cause and people, because there are still some countries that deny entry to Palestinians, while allowing Israeli tourists to enter whenever they want. Before we ask for support from the outside world, the Arab and Muslim countries should support us.

I know that not much time remains for me in this life, but before I die, I wish from God to see my country free and independent, to see my children enjoy their lives in dignity, to see my people live in freedom, and to have a sovereign

state led by national and free leaders—a state we can be proud of.

I wish for the next generation to live better and more beautiful days than we lived, free from wars, tragedies, and suffering. Since I was born, there have always been wars, bombs, strikes, attacks, curfews, fears, and occupations, and sadly they continue to this day. We have spent all our lives with the Palestinian cause, and now I wish for a happy ending for the cause and the Palestinian people. I pray now especially and wish more than ever before, because I don't have much time left and the situation is very hard. In fact, it's the worst and hardest time for the Palestinian cause and people ever. Hopefully, this military occupation will come to an end soon, and our children and grandchildren can live in dignity and freedom with full rights, and then the curtain of the occupation can be pulled forever. These are my wishes.

Chronology of Events in Palestine

1516–1917

Palestine incorporated into the Ottoman Empire under Selim I on August 24, 1516, with its capital in Istanbul.[1]

1897

AUGUST

First Zionist Congress convened in Switzerland from August 29 to 31. It issues the Basel Programme calling for the establishment of "a home for the Jewish people in Palestine." It also establishes the World Zionist Organisation to work to that end.

1914

JULY–AUGUST

Outbreak of World War I as Austria-Hungary declares war on Serbia on July 28 and Germany declares war on Russia and France on August 1 and 3, respectively.

OCTOBER–NOVEMBER

The Ottoman state enters the war on the side of Germany when it begins a naval attack on the Russian Black Sea ports on October 29. Russia declares war four days later.

1916

MAY

Sykes-Picot Agreement is secretly signed, dividing Arab provinces of the Ottoman Empire between Britain and France.

1917

NOVEMBER

British Foreign Secretary Arthur James Balfour sends letter (Balfour Declaration) to Baron de Rothschild on November 2, pledging British support for the establishment of a Jewish national home in Palestine.

1918

SEPTEMBER

Palestine is occupied by Allied forces under British General Allenby.

OCTOBER

End of World War I on November 11, with the signing of the Treaty of Versailles.

1920

JULY

British civilian administration is inaugurated on July 1. Sir Herbert Samuel is appointed first High Commissioner.

1921

MARCH

Founding of *Haganah* (defence), the Zionists' illegal underground military organization.

1922

JULY

On July 24, the League of Nations Council approves Mandate for Palestine without consent of Palestinians.

1923

SEPTEMBER

British Mandate for Palestine comes officially into force on
September 28.

1929

AUGUST

Serious unrest occurs centring on al-Buraq Wall, also known as
the Wailing Wall, a site that holds significance for both Jews and
Muslims in the heart of old Jerusalem. In June 1930, the League of
Nations sends a fact-finding committee to investigate the reasons
behind the uprising. After five months of investigations, the
committee concludes that the area around the wall is an Islamic
endowment, but that the Jews can continue their prayers at the
wall with certain restrictions.

1935

OCTOBER

Irgun Zvai Leumi (National Military Organization), *Irgun* or IZL for
short, founded by Revisionist groups and dissidents from Haganah,
advocates a more militant policy against Palestinians.

1936

MAY

Great Palestinian Rebellion begins in April with the killing of two
Jewish people and a general strike.

AUGUST

On August 25, Lebanese guerrilla leader Fawzi Al Qawuqji enters
Palestine, leading 150 volunteers from Arab countries to help fight
the British.

1939

OCTOBER

The Stern Gang, or *Lochemay Herut Yisra'el* (LEHI; Fighters for the Freedom of Israel), is formed by dissident IZL members led by Avraham Stern.

1942

Formation of the Free Officers by Abd Al Nasser and others. This occurred in steps.

1944

JANUARY

Stern Gang assassinates Lord Moyne, British Minister of State, in Cairo.

1947

MAY

Appointment of eleven-member Special Committee on Palestine (UNSCOP) on May 15, with its first meeting on May 26.

SEPTEMBER

Arab League denounces UNSCOP partition recommendation on September 16.

Arab Higher Committee rejects partition on September 30.

OCTOBER

Jewish Agency accepts partition on October 4.

NOVEMBER

Partition Plan passed by UN Resolution 181 on November 29.

On November 30, Haganah calls up Jews in Palestine aged 17-25 to register for military service.

DECEMBER

Arab League organizes Arab Liberation Army (ALA), a voluntary force of Arab irregulars under guerrilla leader Fawzi Al Qawuqji, to help Palestinians resist partition, at a meeting on December 8.

1948

APRIL

Irgun and the Stern Gang, led by Menachem Begin and Yitzhaq Shamir, massacre 245-250 inhabitants of Deir Yassin village near Jerusalem on April 9.

MAY

British Mandate ends on May 15. Declaration of state of Israel comes into effect on May 14.

The US and USSR recognize the state of Israel on May 15 and 17, respectively.

UN Security Council appoints Count Folke Bernadotte as its mediator in Palestine on May 20.

Al Nakba begins on May 15.

JUNE-JULY

First Truce in the Arab-Israeli War lasts from June 11 to July 8.

JULY-OCTOBER

Second Truce is ordered by the UN Security Council on July 18 and lasts until October 15.

SEPTEMBER

UN mediator Count Bernadotte is assassinated in Jerusalem by Stern Gang on September 17.

DECEMBER

Israel Defence Forces (IDF) brigade attack on isolated Egyptian forces in Faluja pocket is repulsed.

UN General Assembly passes Resolution 194 (III) on December 11, declaring the right of Palestinian refugees to return.

1949

FEBRUARY

Israeli-Egyptian Armistice is signed on February 24: Egypt keeps coastal strip Gaza-Rafah and evacuates Faluja pocket.

1950

APRIL

On April 24, 1950, the Jordanian parliament officially declares the Unification of the West Bank and the Kingdom of Jordan, the Egyptian-Israeli Armistice Agreement is signed, and the territory now officially known as the Gaza Strip is placed under Egyptian military and administrative rule. While preventing political expression and organization, Egyptian policy preserves the Strip's Palestinian identity, keeping it separate from Egypt as a "Palestinian entity" pending implementation of the relevant UN resolution.

MAY

UN General Assembly establishes the UNRWA (UN Relief and Works Agency) based on Resolution 302 of December 8, 1949.

1951

SEPTEMBER

Yasser Arafat reorganizes the Palestinian Students' Union in Cairo.

1952

JANUARY

British along the Canal Zone attack an Egyptian police post in the city of Ismailia on January 25 and kill fifty Egyptians.

On January 26, more than 750 business establishments burn in Cairo, with thirty people killed and about a thousand injured.

JULY

Egyptian Revolution by the Free Officers, which overthrows the monarchy on July 23.

1953

AUGUST

Sharon, the Israeli commander of the UNIT 101, attacks Al Bureij camp in eastern Gaza and kills approximately forty Palestinians.

1954

JULY

British sign a treaty to evacuate their forces from Egypt.

1956

JULY

President Nasser nationalizes the Suez Canal on July 26.

OCTOBER

On October 29, 1956, the tripartite (Britain, France, Israel) invasion of Egypt—the Suez War—is launched. Israel occupies the Gaza Strip (declaring it to be an "integral part of the historical Jewish past") until March 7, 1957, when it is forced to withdraw by the United States and (to a lesser extent) the USSR. The four-month occupation was marked by clashes with the local population and is best remembered by Gazans for IDF "screening operations" in search of men involved with the *Fedayeen*; close to five hundred Palestinian civilians were killed in these operations, and scores of Palestinian fighters were summarily executed. In all, the IDF is estimated to have killed between 930 and 1,200 Palestinians before withdrawing from the Strip.

NOVEMBER

Israel occupies Gaza and most of the Sinai by November 2.

Israel commits a massacre in Khan Younis on November 3.

1957

MARCH

Israel withdraws from Sinai and Gaza by March 6-7. UN Emergency Force moves in simultaneously.

1959

JANUARY

Fatah is established by Yasser Arafat and associates.

JUNE

UN Secretary General (Hammarskjold) puts forth proposal A/4121 for the absorption of Palestinian refugees by the Middle Eastern states on June 15.

1962

OCTOBER

Johnson Plan for Palestinian refugee problem is proposed.

1963

JANUARY

First office is opened by Fatah in Algeria, headed by Khalil Al Wazir (Abu Jehad).

1964

JUNE

Palestine Liberation Organisation (PLO) is founded on June 1, with Ahmad Shuqeri as its first chairman.

1967

JUNE

Six Day War lasts from June 5 to 10. Israel begins military occupation of the West Bank and Gaza Strip of Palestine; as well as Sinai of Egypt and Golan Heights of Syria.

NOVEMBER

UN Security Council endorses Resolution 242 on November 22, calling on Israel to withdraw its army from the territories occupied in the 1967 war.

DECEMBER

Popular Front for the Liberation of Palestine (PLFP) is established, led by George Habash.

1970

SEPTEMBER

Military confrontation occurs between Jordanian army and Palestinian guerrillas ("Black September"), after Palestinian guerrillas hijack four planes on September 6 and 9. Two thousand Palestinians are killed and PLO leadership and troops are expelled from Jordan. PLO sets up new bases in Beirut.

Gamal Abd Al Nasser dies on September 29.

1971

DECEMBER

UN General Assembly Resolution 2787 recognizes the right of Palestinians to struggle for the recovery of their homeland on December 6.

1972

JULY

Ghassan Kanafani, a writer and a member of the Political Bureau of the PFLP, is killed when a bomb explodes in his car on July 8.

OCTOBER

PLO representative Wael Zwaiter is shot and killed in Rome on October 16.

1973

APRIL

Israeli raids in Beirut on April 10 result in the murder of three Palestinian resistance leaders: Kamel Nasser, Kamal Adwan, and Abu Yusuf Al Najjar.

OCTOBER

October or Yom Kippur War begins on October 6. Egypt and Syria fight to regain the Arab territories occupied by Israel in 1967.

UN Security Council Resolution 338 is adopted on October 22, and calls for an immediate ceasefire, the implementation of Security

Council Resolution 242 (1967) in all its parts, and negotiations for peace in the Middle East.

1975

APRIL

The 1975–1976 civil war in Lebanon starts on April 13.

1978

MARCH

The Israeli army attacks southern Lebanon on March 14–15, throwing 25,000 troops into a full-scale invasion, leaving scores of Lebanese villages devastated and seven hundred Lebanese and Palestinians, mainly civilians, dead.

SEPTEMBER

On September 17, Carter, Begin and Sadat sign the Camp David Accords, which propose a settlement of the Middle East conflict and a framework for the conclusion of an Egyptian-Israeli peace treaty.

1981

JULY

Israeli jets bomb PLO targets in Beirut on July 17, killing more than three hundred people.

1982

JUNE

On June 6, Israel invades Lebanon with an estimated 100,000 troops.

AUGUST

The evacuation of PLO troops from Lebanon begins on August 21, as about four hundred troops board a ship to Cyprus.

President-elect Bashir Gemayel and forty followers are killed in Beirut on September 14, a few days before his inauguration.

Over two thousand Palestinian refugees are slaughtered in the Sabra and Shatila refugee camps in Beirut on September 16.

1984

JANUARY

On January 11, the World Zionist Organisation executive body rejects the nomination of former Israeli Defence Minister Ariel Sharon as director of the Israeli immigration programme, citing his role in the massacre of civilians at the Sabra and Shatila refugee camps.

1985

MAY

On May 20, in agreement with Palestinians, Israel exchanges 1,150 Palestinian prisoners for three Israeli soldiers captured during the invasion of Lebanon.

OCTOBER

Israel bombs the Tunisian headquarters of the PLO on October 2, killing more than sixty people, in retaliation for the September 26 killing of three Israelis in Cyprus.

1987

JULY

Israeli military authorities ban Palestinians from fishing in the Gaza Strip area for an indefinite period.

DECEMBER

The *Intifada* begins on December 9. In Gaza, four Palestinians are killed and at least seven are injured when an Israeli truck collides with two vans of Palestinian workers returning from work in the Jabalya district of Gaza.

1988

JANUARY

On January 19, Israeli Defence Minister Yitzhak Rabin announces a new policy for dealing with the *Intifada*: "Force, might, beatings."

APRIL

On April 12, Major General Ehud Barak, deputy Chief of Staff, states that 4,800 Palestinian activists are being held in Israeli prisons, including nine hundred in administrative detention.

Palestinian leader Abu Jihad (Khalil Al Wazir) is assassinated at his home in Tunis on April 16.

In a report on April 17, *The Washington Post* reports that the Israeli cabinet approved the assassination of Abu Jihad (Khalil Al Wazir), and that the operation was planned by Mossad and Israel's army, navy and air force.

DECEMBER

During the first year of the *Intifada*, 318 Palestinians are killed, 20,000 wounded, 15,000 arrested, 12,000 jailed, and 34 deported, and 140 houses are demolished. Eight Israelis—six civilians and two soldiers—are killed.

1989

JULY

On July 12, economic adviser to the Chief of General Staff and Director of the Defence Ministry's Budget Department estimates that the cost of fighting the Palestinian uprising is expected to reach approximately 1 billion New Israeli Shekel by the end of the current fiscal year, in March 1990.

1990

MAY

Israeli gunman massacres seven Palestinian workers and injures scores of others at Rishon Lezion near Tel Aviv on May 20.

Iraqi troops invade Kuwait on August 2.

SEPTEMBER

Israeli military authorities raze twenty-six shops and seven homes, and seal four buildings in the Bureij refugee camp in response to the killing of an Israeli soldier.

1991

JANUARY

On January 14, the PLO's second top-ranking official, Abu Iyad (Salah Khalaf), is assassinated in Tunis. Abu al-Hol (Hay Abu al-Hamid) and Abu Mohammed (Fakhri al-Umari) are also killed.

MARCH

On June 18, the Tel Aviv district court sentences Ami Popper, a cashiered soldier, to seven consecutive life sentences plus twenty years in prison for the shooting to death of seven Palestinians in Rishon Lezion in May 1990.

APRIL

Israel releases 240 Palestinian prisoners.

1992

DECEMBER

Israel deports 415 Palestinian activists to Lebanon.

1993

JANUARY

The first round of secret Palestinian–Israeli talks on a draft declaration of principles in Norway begins on January 22.

SEPTEMBER

Chairman Arafat and Prime Minister Rabin exchange letters of mutual recognition on September 9.

The Israeli–Palestinian declaration of principles, also referred to as Oslo, is officially signed at the White House by Peres and Mahmoud Abbas on September 13. The declaration provides for a five-year transitional period of limited Palestinian self-rule to begin in Gaza and Jericho, after which final status talks (Jerusalem, refugees, settlements, borders) for a permanent settlement are to be held. The agreement affirms that the West Bank and the Gaza Strip constitute a single territorial unit.

1994

MAY

The Gaza–Jericho Autonomy Agreement (Cairo Agreement) is signed on May 4, outlining the first stage of Palestinian autonomy—in Gaza and Jericho—including Israeli redeployment and the establishment of a Palestinian self-governing Authority. Israel remains in control of the settlements, military locations and security matters. The stipulated interim period is to end on May 4, 1999.

The first Palestinian police forces arrive in self-rule areas on May 13.

JULY

Chairman Arafat returns to Gaza on July 1, accompanied by a limited number of Diaspora Palestinians, and swears in the first PNA ministers on July 5 at Jericho.

1995

SEPTEMBER

The Interim Agreement on the West Bank and the Gaza Strip (Taba or Oslo II Agreement) is signed in Washington on September 28. It outlines the second stage of Palestinian autonomy, extending it to other parts of the West Bank, divided into Area A (full Palestinian civil jurisdiction and internal security), Area B (full Palestinian civil jurisdiction, joint Israeli-Palestinian internal security), and Area C (Israeli civil and overall security control). The election and powers

of a Palestinian Legislative Council are determined. The target date for completion of further redeployment is October 1997, and the final status agreement date is October 1999.

NOVEMBER
Israeli Prime Minister Rabin is assassinated on November 4.

1996

JANUARY
The first Palestinian elections with an 88-member Palestinian Legislative Council are held on January 20, and Yasser Arafat is elected as the first president of Palestine.

1997

JANUARY
The Hebron Agreement (also known as the Hebron Protocol) is signed on January 17, in which Israel agrees to withdraw from 80 percent of the city, but will retain control over an enclave of 450 settlers and 35,000 Palestinians in the city centre.

1998

OCTOBER
The Wye River Memorandum, the agreement for the implementation of the Oslo II Agreement and resumption of final status talks, is signed on October 23. It divides the second redeployment provided by Oslo II into three phases, totalling 13 percent of the West Bank, and includes changes in the PLO Charter, the opening of the Gaza airport and safe passage, a reduction in the number of Palestinian police, and the release of Palestinian prisoners. Subsequently, Israel withdraws from 2 percent of the West Bank, near Jenin, the Gaza airport is opened, and some detainees, mostly criminals rather than political detainees, are released.

1999

The Sharm el-Sheikh Agreement for the implementation of the Wye River Memorandum is signed on September 4. It stipulates Israeli withdrawal in three stages from another 11 percent of the West Bank, the release of 350 Palestinian political prisoners, the opening of safe passages, and the beginning of permanent status talks on September 13, 1999 to reach a framework for a settlement by February 2000 and a final peace agreement by September 2000.

2000

SEPTEMBER

The Al Aqsa *Intifada* erupts on September 28 after Likud opposition leader Sharon makes a provocative visit to Al Aqsa Mosque with maximum security, and with thousands of forces deployed in and around the Old City of Jerusalem.

2001

JANUARY

From January 21 to 27 at the Taba Summit, peace talks between Israel and the Palestinian Authority aim to reach the "final status" of negotiations. Ehud Barak temporarily withdraws from negotiations during the Israeli elections.

FEBRUARY

Ariel Sharon is elected as prime minister on February 6 and refuses to continue negotiations with Yasser Arafat at the Taba Summit.

AUGUST

Abu Ali Mustafa, the General Secretary of the PFLP, is assassinated on August 27 by an Israeli missile shot by an Apache helicopter through his office window in Ramallah.

2002

MARCH

The Beirut Summit, held over March 27 and 28, approves the Saudi peace proposal.

MARCH–MAY

On March 29, Israeli forces begin Operation "Defence Shield," Israel's largest military operation in the West Bank since the 1967 war.

2003

APRIL

The quartet of the United States, European Union, Russia, and the United Nations propose a road map to resolve the Israeli–Palestinian conflict, proposing an independent Palestinian state.

SEPTEMBER

Mahmoud Abbas resigns from the post of prime minister on September 6.

2004

JULY

On July 9, the International Court of Justice issues an advisory opinion that the West Bank barrier is illegal under international law. The United Nations had also condemned the construction of the wall as "an unlawful act of annexation" on September 3, 2003.

NOVEMBER

Yasser Arafat dies at the age of 75 on November 11 in a hospital near Paris, after undergoing urgent medical treatment since October 29, 2004.

2005

JANUARY

On January 9, 2005, Abbas wins the Palestinian presidential elections by a wide margin.

Israel disengages from Gaza and removes its settlements from the Gaza Strip, but retains effective control over air, sea, and land access to the Strip.

2006

JANUARY

Ariel Sharon is incapacitated by stroke on January 4. He dies on January 11, 2014, having never emerged from his coma.

On January 25, the Islamic resistance movement, Hamas, wins the Palestinian elections and beats Fatah, resulting in an international and Israeli boycott of the new Palestinian government and imposing a blockade on the Gaza Strip.

2007

NOVEMBER

On November 27, the Annapolis Conference, for the first time, establishes a "two-state solution" as a basis for future talks between Israel and the Palestinian Authority.

2008–2009

DECEMBER 2008–JANUARY 2009

Israel launches a twenty-three-day war on the Gaza Strip on December 27.

2012

NOVEMBER

Israel launches an eight-day offensive on the Gaza Strip on November 14.

On November 29, the UN General Assembly passes a resolution granting the state of Palestine non-member observer status, an upgrade that allows the Palestinians to join UN bodies, such as the International Criminal Court (ICC), to investigate war crimes in Gaza.

2014

JULY

On July 8, Israel launches a fifty-one-day offensive on Gaza.

2017

DECEMBER

US president Donald Trump recognizes Jerusalem as the capital of Israel on December 6. The move is condemned by most of the world in a vote at the UN General Assembly on December 22.

2018

AUGUST

On August 29, the US State Department ends aid to the Palestinian refugee agency, UNRWA, reversing a policy of support by every US president since it was created about seventy-two years ago as a cornerstone of US support for stability in the Middle East.

MARCH

Mass protests start in the Gaza Strip on March 30 (better known as The Great March of Return), calling Israel to lift the eleven-year illegal blockade on Gaza and to allow Palestinian refugees to return to their villages and towns from which they were expelled back in 1948.

MAY

The US moves its embassy to Jerusalem on May 14 and protests sweep the Gaza Strip met by violent repression from Israel, resulting in the deaths of at least 60 and the injury of 2770 Palestinians in Gaza.

2019

MARCH

On March 25, US president Donald Trump recognizes the Syrian Golan Heights, occupied in 1967, as part of Israel.

On November 18, the US says it no longer considers Israeli settlements on the West Bank to be illegal.

2020

JANUARY

On January 28, the US administration reveals the "Deal of the Century," also called "Peace to Prosperity," a plan that jettisons the two-state solution—the international formula proposed to end the Arab-Israeli conflict. The plan, widely described as an attempt to get Palestinians to trade in their political demands for economic benefits, fails to acknowledge major political issues such as the occupation, the siege of Gaza, illegal settlements, and the refugees.

Notes

1. Phrase borrowed from Rosemary Sayigh's work *Voices: Palestinian Women Narrate Displacement*, online book, *Al Mashriq*, 2005/2007, https://almashriq.hiof.no/palestine/300/301/voices/.

2. Edward Said, *Covering Islam: How the Media and the Experts Determine How We See the Rest of the World* (New York: Pantheon Books, 1981), 154.

FOREWORD

1. Matthew Hughes, "Women, Violence, and the Arab Revolt in Palestine, 1936-39," *The Journal of Military History* 83 (2019): 500, https://bura.brunel.ac.uk/bitstream/2438/17614/5/FullText.pdf.

2. Ibid, 501.

3. As cited in ibid.

4. As cited in ibid., 502.

INTRODUCTION

1. UNRWA, "Where We Work, Gaza Strip," https://www.unrwa.org/where-we-work/gaza-strip.

2. BADIL, *Survey of Palestinian Refugees and Internally Displaced Persons 2016-2018*, Vol. IX (Bethlehem, Palestine: BADIL Resource Center for Palestinian Residency & Refugee Rights),

https://www.badil.org/en/publication/press-releases/90-2019/5013-pr-en-231019-55.html.

3. Salman Abu Sitta, *Mapping My Return: A Palestinian Memoir* (Cairo: The American University in Cairo Press, 2016), ix.

4. Ibid.

5. Mahmoud Darwish, "Those Who Pass Between Fleeting Words," *Middle East Report* 154, September/October 1988, https://merip.org/1988/09/those-who-pass-between-fleeting-words/.

6. Eóin Murray, "Under Siege," in *Defending Hope: Dispatches from the Front Lines in Palestine and Israel*, eds. Eóin Murray and James Mehigan (Dublin: Veritas Books, 2018), 30.

7. UNHCR, *The State of the World's Refugees 2006: Human Displacement in the New Millennium*, April 20, 2006, https://www.unhcr.org/publications/sowr/4a4dc1a89/state-worlds-refugees-2006-human-displacement-new-millennium.html.

8. United Nations, *Gaza in 2020: A Liveable Place?*, August 2012, https://www.unrwa.org/userfiles/file/publications/gaza/Gaza%20in%202020.pdf. See also Bel Trew, "The UN Said Gaza Would be Uninhabitable by 2020 – In Truth, It Already Is," *Independent*, December 29, 2019, https://www.independent.co.uk/voices/israel-palestine-gaza-hamas-protests-hospitals-who-un-a9263406.html; Donald Macintyre, "By 2020, the UN Said Gaza Would be Unliveable. Did It Turn Out that Way?" *The Guardian*, December 28, 2019, https://www.theguardian.com/world/2019/dec/28/gaza-strip-202-unliveable-un-report-did-it-turn-out-that-way.

9. Pinhas Rosenbluth, "The Jewish Right to Israel: An Ethical Approach," in *Who Is Left? Zionism Answers Back* (Jerusalem: The Zionist Library), 197.

10. Mark LeVine, "Tracing Gaza's Chaos to 1948," *Al Jazeera*, July 13, 2009, https://www.aljazeera.com/focus/arabunity/2008/02/2008525185737842919.html; Salman Abu Sitta, "Gaza Strip, the Lessons of History," in *Gaza as Metaphor*, eds.

Helga Tawil-Souri and Dina Matar (London: Hurst and Company, 2016), 90.

11. LeVine, "Tracing Gaza's Chaos to 1948."

12. Ilana Feldman, cited in ibid.

13. Benny Morris, *Israel's Border Wars, 1949–1956* (Oxford: Clarendon Press, 1993), 416.

14. Ihsan Khalil Agha, *Khan Yunis wa shuhada'iha* [*Khan Younis Martyrs*] (Cairo: Markaz Fajr Publishing, 1997).

15. Abu Sitta, "Gaza Strip, The Lessons of History," *Palestine Land Society*, 2016, http://www.plands.org/en/articles-speeches/articles/2016/gaza-strip-the-lessons-of-history.

16. Helena Cobban, "Roots of Resistance: The First Intifada in the Context of Palestinian History," *Mondoweiss*, December 17, 2012, https://mondoweiss.net/2012/12/roots-of-resistance-the-first-intifada-in-the-context-of-palestinian-history/.

17. CJPME, "Israeli Colonies and Israeli Colonial Expansion," *Canadians for Justice and Peace in the Middle East*, (CJPME) Factsheet Series No. 9, 2005, https://www.cjpme.org/fs_009.

18. Zena Tahhan, "The *Naksa*: How Israel Occupied the Whole of Palestine in 1967," *Al Jazeera*, June 4, 2018, https://www.aljazeera.com/indepth/features/2017/06/50-years-israeli-occupation-longest-modern-history-170604111317533.html.

19. Cobban, "Roots of Resistance."

20. *The New York Times*, "Israel Declines to Study Rabin Tie to Beatings," July 12, 1990, https://www.nytimes.com/1990/07/12/world/israel-declines-to-study-rabin-tie-to-beatings.html.

21. A phrase often used after the signing of the Oslo agreements. "Political Economy of Palestine," Institute for Palestine Studies, https://oldwebsite.palestine-studies.org/ar/node/198424.

22. Abu Sitta, *Mapping My Return*, 317.

23. Edward Said, cited in Abu Sitta, *Mapping My Return*, 187.

24. Abu Sitta, *Mapping My Return*, 299.

25. James Bennet, "Arafat Not Present at Gaza HQ," *New York Times*, December 3, 2001, https://www.nytimes.com/2001/12/03/international/arafat-not-present-at-gaza-headquarters.html.

26. Ghada Karmi, "'The Worst Spot in Gaza': 'You Will Not Understand How Hard it is Here' Until You See This Checkpoint," *Salon*, May 31, 2015, https://www.salon.com/2015/05/31/the_worst_spot_in_gaza_you_will_not_understand_how_hard_it_is_here_until_you_see_this_checkpoint/.

27. Ghada Ageel, "Gaza: Horror Beyond Belief," *Electronic Intifada*, May 16, 2004, https://electronicintifada.net/content/gaza-horror-beyond-belief/5078.

28. Dennis J. Deeb II, *Israel, Palestine, and the Quest for Middle East Peace* (Maryland: University Press of America, 2013), 36.

29. Mark Tran, "Israel Declares Gaza 'Enemy Entity,'" *The Guardian*, September 19, 2007, https://www.theguardian.com/world/2007/sep/19/usa.israel1.

30. Indeed, the announcement in early 2020 of the Trump-Netanyahu "deal of the century" now seems to have made Israeli unilateralism a mainstay of US foreign policy in the Middle East. For more details, see Avi Shlaim, "How Israel Brought Gaza to the Brink of Humanitarian Catastrophe," *The Guardian*, January 7, 2008, https://www.theguardian.com/world/2009/jan/07/gaza-israel-palestine; Shlaim's article was also published under "Background and Context," in *Journal of Palestine Studies* 38, no. 3 (Spring 2009): 223–39, doi:10.1525/jps.2009.xxxviii.3.223.

31. Ghada Ageel, "Introduction" in *Apartheid in Palestine: Hard Laws and Harder Experiences* (Edmonton: University of Alberta Press, 2016), xxx.

32. Ibid., xxvi.

33. Oxfam, "Timeline: The Humanitarian Impact of the Gaza Blockade," *Oxfam*, 2020, https://www.oxfam.org/en/timeline-humanitarian-impact-gaza-blockade.

34. For details, see Sara Roy, "The Gaza Strip: A Case of Economic De-Development," *Journal of Palestine Studies* 17, no. 1 (Autumn, 1987): 56–88.

35. Shlaim, "How Israel Brought Gaza to the Brink."

36. "World Bank Warns, Gaza Economy is Collapsing," *Al Jazeera*, September 25, 2016, https://www.aljazeera.com/news/2018/09/world-bank-warns-gaza-economy-collapsing-180925085246106.html.

37. Eva Illouz, as cited and discussed in Ghada Ageel, "Gaza Under Siege, The Conditions of Slavery," *Middle East Eye*, London, UK, January 19, 2016, https://www.middleeasteye.net/opinion/gaza-under-siege-conditions-slavery.

38. Ghada Ageel, "Where is Palestine's Martin Luther King? Shot or Jailed by Israel," *Middle East Eye*, London, June 26, 2018, https://www.middleeasteye.net/opinion/where-palestines-martin-luther-king-shot-or-jailed-israel.

39. Bel Trew, "The UN Said Gaza Would be Uninhabitable by 2020—In Truth, it Already Is," *The Independent*, December 29, 2019, https://www.independent.co.uk/voices/israel-palestine-gaza-hamas-protests-hospitals-who-un-a9263406.html.

40. David Halbfinger, Isabel Kershner, and Declan Walsh, "Israel Kills Dozens at Gaza Strip," *New York Times*, May 14, 2018, https://www.nytimes.com/2018/05/14/world/middleeast/gaza-protests-palestinians-us-embassy.html.

41. Mahmoud Darwish, "Those Who Pass Between Fleeting Words."

42. Edward Said, "Invention, Memory and Place," in *Landscape and Power*, ed. W.J.T. Michell (Chicago: The University of Chicago Press, 2002), 250.

43. Jonathan Adler, "Remembering the Nakba: The Politics of Palestinian History," *Jadaliyya*, July 17, 2018, https://www.jadaliyya.com/Details/37786.

44. Ilan Pappe, *The Ethnic Cleansing of Palestine* (Oxford: One World Publications, 2006), 231; Pappe attributes this term to Meron Benvenisti, *Sacred Landscape: The Buried History of the Holy Land Since 1948* (Berkeley: University of California Press, 2002).

45. As cited in John Randolph LeBlanc, *Edward Said on the Prospects of Peace in Palestine and Israel* (New York: Palgrave MacMilllan, 2013), 44.

46. Sonia Nimr, "Fast Forward to the Past: A Look into Palestinian Collective Memory," *Cahiers de Littérature Orale* no. 63-64 (January 2008): 340. doi:https://doi.org/10.4000/clo.287.

47. For more details, see Peter M. Jones, "George Lefebvre and the Peasant Revolution: Fifty Years On," *French Historical Studies* 16, no. 3 (Spring, 1990): 645-63.

48. Oral History Association (OHA), "Oral History Defined," OHA, https://www.oralhistory.org/about/do-oral-history/.

49. Paul Thompson, *The Voice of the Past: Oral History* (Oxford: Oxford University Press, 1978), 25, https://tristero.typepad.com/sounds/files/thompson.pdf.

50. Alistair Thomson, "Four Paradigm Transformations in Oral History," *The Oral History Review* 34, no. 1 (2007): 52-53.

51. As cited in Ramzy Baroud, "History from Below" (PHD dissertation, Exeter University, United Kingdom, January 2015), 28.

52. Rosemary Sayigh, "Oral History," 193.

53. Sherna Berger Gluck, "Oral History and al-Nakbah," *The Oral History Review* 35, no. 1 (2008): 68.

54. Ibid., 69.

55. Malaka Shwaikh, "Narratives of Displacement in Gaza's Oral History," in *An Oral History of the Palestinian Nakba*, eds. Nahla Abdo and Nur Masalha (London: Zed Books, 2018), 16,

https://www.researchgate.net/
publication/329130803_Narratives_of_Displacement_in_
Gaza's_Oral_History_2.

56. Edward Said, as cited in "The Role of the Public Intellectual,"
Alan Lightman, *MIT Communications Forum*, http://web.mit.
edu/comm-forum/legacy/papers/lightman.html.

57. Sayigh, "Oral History," 193.

58. Edward Said, "On Palestinian Identity: A Conversation with
Salman Rushdie (1986)," in *The Politics of Dispossession: The
Struggle for Self Determination, 1969–1994* (New York:
Pantheon Books, 1994), 126.

59. *PalestineRemembered.com*, "Nakba's Oral History Interviews
Listing," https://www.palestineremembered.com/OralHistory/
Interviews-Listing/Story1151.html.

60. Ahmad Sa'di and Lila Abu-Lughod, "Introduction: The Claims
of Memory," in *Nakba: Palestine, 1948, and the Claims of
Memory*, eds. Ahmad Sa'di and Lila Abu-Lughod (New York:
Columbia University Press, 2007), 3.

61. As cited in Lightman, "The Role of the Public Intellectual."

62. Rosemary Sayigh in Maria Fantappie and Brittany Tanasa,
"Oral Historian Rosemary Sayigh Records Palestine's
Her-Story in *Voices: Palestinian Women Narrate Displacement*,"
September 20, 2011, *W4*, https://www.w4.org/en/wowwire/
palestinian-women-narrate-displacement-rosemary-sayigh/.

63. Isabelle Humphries and Laleh Khalili, "Gender of Nakba
Memory," in *Nakba*, 209.

64. Ibid.

65. Ibid., 223.

66. Sayigh, *Voices: Palestinian Women*.

67. Fatma Kassem, *Palestinian Women: Narrative Histories and
Gender Memory* (London: Zed Books, 2011), 1.

68. Ibid., vi.

69. Sayigh, *The Palestinians*.

70. Sayigh, *Voices: Palestinian Women*.

71. Abu Sitta, *Mapping My Return*, 155.

72. For more details, see Ghada Ageel, "Where is Palestine's Martin Luther King?"

73. UN Human Rights Office of the High Commissioner (UN Human Rights), *The UN Independent Commission of Inquiry on the 2018 Gaza Protests*, UNOHCHR, February 28, 2019, https://www.ohchr.org/EN/NewsEvents/Pages/DisplayNews.aspx?NewsID=24226&LangID=E.

1 CHILDHOOD DAYS

1. The annotations in this and the following chapters have been provided by the editors to add context to the story and are not the narrator's words. In addition, although the narrator's story has been translated, her thoughts and opinions herein are her own and are expressed in her words.

2. In August 1897, the first Zionist Congress in Switzerland issued the Basel Programme "to create for the Jewish people a home in Palestine secured by public law." It also established the World Zionist Organisation to work to that end. For more details, see Mahdi F. Abdul Hadi, ed., *Documents on Palestine, Volume I, From the Pre-Ottoman/ Ottoman Period to the Prelude of the Madrid Middle East Peace Conference* (Jerusalem: Palestinian Academic Society for the Study of International Affairs, 1997), 11-14.

3. On July 24, 1922, the League of Nations Council approved the Mandate for Palestine, and on September 29, 1923, the British Mandate for Palestine came officially into force. See Walid Khalidi, ed., *All That Remains: The Palestinian Villages Occupied and Depopulated by Israel in 1948* (Washington: Institute for Palestine Studies, 1992), 573; Walid Khalidi, ed., *From Haven to Conquest: Readings in Zionism and the Palestine Problem Until 1948* (Washington DC: Institute for Palestine Studies, 1982).

4. For details, see Roza I.M. El-Eini, *Mandated Landscape: British Imperial Rule in Palestine, 1929-1948* (London: Routledge, 2006); Sayigh, *The Palestinians*.

5. Al Azhar Al Sharif (or Al Azhar) is one of the world's oldest universities. It was founded in Cairo in AD 970 by the Fatimid Dynasty. For over a millennium, it has been a highly respected centre of Islamic and Arabic language learning. Other old Arab universities include Al Zaytounah (Tunisia, 734 AD), the Qarawiyyun in Fez (Morocco, 859 AD), and Al Mustansiryah (984 AD) in Iraq.

6. Formally Bir Al Saba', it was renamed Beersheba after the State of Israel was created in 1948.

7. Unlike in Beersheba, where the population was mostly Bedouin, most Palestinian women in villages and cities didn't cover their faces.

8. The title "Sheikh" is used to refer to Muslim scholars with a high level of Islamic knowledge and to those scholars who graduated from Al Azhar University.

9. *Tawb* refers to a traditional long embroidered gown with long sleeves worn by Palestinian women. Each Palestinian village had a particular embroidery pattern that distinguished it and its people from other villages.

10. *Shash* refers to a traditional Palestinian women's long headdress, which covers the upper body to the waist. It is sometimes twisted and tied at the waist of a *tawb* like a belt.

11. Martyr, *Al Shahid* in Arabic, refers to someone who was killed or sacrificed his life for his country or for just causes.

12. The 1930 invasion of a plague of locusts in Palestine (covering an area one mile wide and fifteen miles long) is well documented. Trenches, pits, flame throwers, and a small army of soldiers were used to combat the invasion and to save orange and cotton crops. The eradication effort closed with a feast that included camel racing and celebrations. For images that document the feasting, see the article by Stefanie Wichhart,

which discusses both the 1915 and 1930 locust plagues. "The 1915 Locust Plague in Palestine," *Jerusalem Quarterly* 56 & 57 (2013): 29–39, Columbia University, Center for Palestine Studies, https://www.palestine-studies.org/sites/default/files/jq-articles/JQ%2056-57%20The%201915%20Locust.pdf.

13. By the mid-1930s, the British Mandate had allowed in an alarming number of European Jewish immigrants (comprising about 30 percent of the population in 1936 compared to 9 percent in 1917), which laid the groundwork for the great Arab Revolt that lasted from 1936 to 1939. When the general strike, which lasted for six months, was declared at the start of the Arab Revolt, national committees were formed in every region of Palestine to fight the British and the Zionist militia groups, in order to stem the flood of Jewish immigrants, which threatened the survival and independence of the Palestinian people. By 1939, the British had quashed the revolution. For more details, see Abu Sitta's book, *Mapping My Return*, 42; Rawan Damen's 2008 documentary film, "Al Nakba," *Aljazeera*, https://interactive.aljazeera.com/aje/palestineremix/films_main.html; and Khalidi, *All That Remains*, 574.

14. For details, see 'Abd al-Wahhab Kayyali, *Wathā 'iq al-Muqāwama al-Filastīniyya al-'Arabiyya did al-Ihtilāl al-Britānī wa al-Zioniyya, 1918–1939* [Documents of the Palestinian Arab Resistance against the British and Zionist Occupation] (Beirut: Institute for Palestine Studies, 1967).

15. This occurred throughout Palestine. See John Loxton, typescript memoirs in Private Papers Collection, Middle East Centre, St. Antony's College, Oxford, cited in A.J. Sherman, *Mandate Days: British Lives in Palestine, 1918–1948* (Baltimore: John Hopkins University Press, 2001), 119.

16. The Al Mawasi area (two kilometres from Khan Younis) is a strip of land one kilometre wide that extends along the Gaza coastal road for a distance of twelve kilometres, from Deir Al-Balah to Khan Younis, all the way to Rafah. Among the

agricultural sectors in the Gaza Strip, Al Mawasi is considered one of the most important, as the residents depend on agriculture as their only source of livelihood.

17. This story was recorded before the redeployment of Israeli settlements/colonies in the Gaza Strip in September 2005.

18. Al Hamidiyah is the most famous and oldest market, or *souk*, in Damascus. It was built in 1780 under the rule of the Umayyad Sultan Abdul Hamid, from whom the name of the market was adopted. Prior to the 2011 uprising, many world leaders visited the souk, including former president Bill Clinton, King Abdullah of Jordan, and the then Turkish prime minister (now president) Recep Tayyip Erdoğan. The past nine years of warfare, destruction, and displacement have shattered both Syrian society and the economy and slowed activities in the *souk*, which currently depends on the locals and some Arab visitors.

2 SCHOOL DAYS

1. On May 15, 1948, the British Mandate ended, and the declaration of the State of Israel came into effect, leading to the expulsion and dispossession of hundreds of thousands of Palestinians and the destruction of Palestinian society. See Khalidi, *All That Remains*, 577.

2. For more details, see Avi Shlaim, *Collusion Across the Jordan: King Abdullah, the Zionist Movement, and the Partition of Palestine* (New York: Columbia University Press, 1988); Ilan Pappe, *The Rise and Fall of a Palestinian Dynasty: The Husaynis, 1700-1948* (London: Saqi Books, 2010); Rashid Khalidi, *The Iron Cage: The Story of the Palestinian Struggle for Statehood* (Boston: Beacon, 2006).

3. Refers to the proposal by UN mediator Count Bernadotte, on September 16, 1948, for a new partition of Palestine: an Arab state to be annexed to Transjordan and to include Negev, Al Ramle, and Lydda; a Jewish state in all of Galilee; the

internationalization of Jerusalem; the return of or compensation for refugees. This was rejected by the Arab League and Israel. See Khalidi, *All That Remains*, 578.

4. From December 22, 1948 to January 6, 1949, the Israelis launched Operation Horev to drive Egyptians out of the southern coastal strip and Negev. Israeli military forces moved into Sinai, until British pressure forced their withdrawal. An Israeli attack on Rafah ended by ceasefire on January 7th. See Khalidi, *All That Remains*, 579. For more details on the December 25th battle, please see Abu Sitta, *Mapping My Return*, 91.

5. United Nations Relief and Works Agency for Palestine Refugees in the Near East, established by the UN General Assembly, based on Resolution 302 of December 8, 1949, to assist Palestinian refugees. See also, Abdul Hadi, *Documents on Palestine, Volume I*, 195 and 373.

3 MARRIAGE

1. The remains of a caravanserai built during the Mamluk period by the Arab Younis to rest his army, while travelling from the south to the north of Palestine to fight in the Crusades. Khan Younis is named after him.

2. On August 31, 1955, Israelis attacked the Khan Younis police station with orders to "kill as many enemy soldiers as possible." They killed seventy-two and wounded fifty-eight. See Morris, *Israel's Border Wars*, 350.

4 MASSACRE

1. On November 2, 1956, Israelis occupied Gaza and most of the Sinai, attacked Qalqilya in the West Bank, and massacred villagers from Kafr Qassem. On March 8, 1957, Israel withdrew from Gaza and Sinai, and the United Nations Emergency Force moved in. See Abdul Hadi, *Documents on Palestine, Volume I*, 374.

2. The story was recorded in 2001.

3. See Baruch Kimmerling, *Politicide: Ariel Sharon's War Against the Palestinians* (London: Verso, 2003), 55.

4. See Meron Rapoport, "Into the Valley of Death," *Haaretz*, February 8, 2007, http://www.haaretz.com/israel-news/into-the-valley-of-death-1.212390; Martin Cohn, "An Israeli General Reopens Old Wounds with Revelations About the Massacre of Egyptian PoWs," *Toronto Star*, October 8, 1995; Richard H. Curtiss and Donna B. Curtiss, "Israel's Hush-Up Machine in Action: Denying Story Israel Executed Egyptian Prisoners," *Washington Report on Middle East Affairs*, May–June 2007, 28–29; Robert Fisk, *The Great War for Civilisation: The Conquest of the Middle East* (London: Fourth Estate, 2005), 1132.

5. See Anis F. Kassim, ed., *The Palestine Yearbook of International Law, 1998–1999*, Law Volume 10, (Netherlands: Kluwer Law International, The Hague, 2000).

6. See Muhammed Magdy, "Egyptian Court Issues Verdict to Prosecute Israel," *Almonitor*, February 3, 2017, http://al-monitor.com/pulse/originals/2017/02/egypt-court-order-israel-soldiers-torture-wars-1.html and http://www.nytimes.com/1995/09/21/world/egypt-says-israelis-killed-pow-s-in-67-war.html.

7. The Israeli army withdrew from Beit Hanoon in the Gaza Strip after it was occupied in 1948. See Benny Morris, *1948: A History of the First Arab-Israeli War* (London: Yale University Press, 2008); Ramzy Baroud, "For the Love of Egypt: When Besieged Palestinians Danced," *Global Research*, March 3, 2011, https://www.globalresearch.ca/for-the-love-of-egypt-when-besieged-palestinians-danced/24078.

8. For more details, see H.F. Ellis, "Reflections on Suez: Middle East Security," in *Suez 1956: The Crisis and its Consequences*, William Roger Lewis and Roger Owen, eds. (Oxford: Clarendon Press, 1989), 347–63; Peter L. Hahn, *Caught in the Middle East: US Policy Toward the Arab-Israeli Conflict, 1945–1961* (Chapel

Hill and London: University of North Carolina Press, 2004); Fisk, *The Great* War, 1127–38.

9. See Yazīd Sāyigh, *Armed Struggle and the Search for State: The Palestinian National Movement* (Washington: Institute for Palestine Studies, 1997), 66.

5 OCCUPATION

1. Madeeha, the narrator, told us this story while we sat in this house with her in 2001.

2. See William B. Quandt, Fuad Jabber, and Ann Mosely Lesch, *The Politics of Palestinian Nationalism* (London: University of California Press, 1973).

3. On August 2, 1952, the Israeli Law of Nationality affirmed the Israeli Law of Return and legislated that resident non-Jews could acquire citizenship only on the basis of residence if they could prove they were Palestinian, or by naturalization. Palestinian Arabs remaining under Israeli occupation literally became foreigners in their own country, as proving residence was, in practice, often impossible to fulfil. Most Arab residents had no proof of citizenship, having surrendered their identity cards to the Israeli Army during or after the war. Abdul Hadi, *Documents on Palestine, Volume I*, 373.

4. On June 5, 1967, Israel began its military occupation of the West Bank and Gaza Strip of Palestine, Sinai of Egypt, and Golan Heights of Syria. See Abdul Hadi, *Documents on Palestine, Volume I*, 375.

5. For more details, see Abu Sitta's book, *Mapping My Return*, 257–58.

6 BLACK SEPTEMBER

1. Black September was a bloody confrontation that took place in late September 1970 between the Jordanian army and the Palestinian resistance movement led by the PLO. The fighting lasted a week, until a truce was brokered under the leadership

of Abd Al Nasser, who died shortly after, on September 28, 1970. See Said K. Aburish, *A Brutal Friendship: The West and the Arab Elite* (New York: St. Martin's Press, 1997), 227; Christopher Dobson, *Black September: Its Short, Violent History* (New York: Macmillan, 1974).

2. See John Bulloch, *The Making of a War: The Middle East from 1967 to 1973* (London: Longman, 1974), 67.

7 1973 WAR

1. The October War began on October 6th, when Egypt and Syria fought to regain the Arab territories occupied by Israel in 1967. See Abdul Hadi, *Documents on Palestine, Volume I,* 376.

2. A fortification line built along the eastern coast of the Suez Canal after the 1967 war to control the area, based on the idea of then Israeli Chief of Staff Haim Bar-Lev. See Kimmerling, *Politicide,* 60.

3. On October 22nd, the UN Security Council (UNSC) adopted Resolution 338, calling for a cease fire and an immediate end to the fighting between Israel and the Arab countries. The following day, on October 23rd, the UNSC issued Resolution 339, confirming the ceasefire and directing that UN observers be dispatched to the front. On October 24th, the UNSC issued Resolution 340 to confirm the ceasefire—its third in less than four days. This was followed by shuttle diplomacy.

8 WAITING FOR THE CURTAIN TO RISE

1. This refers to the Palestinian–Israeli Declaration of Principles on Interim Self-Government Authority (DOP), also known as the Oslo 1 Accord, signed in Washington on September 13, 1993. See Abdul Hadi, *Documents on Palestine, Volume II, From the Negotiations in Madrid to the Post-Hebron Agreement Period* (Jerusalem: Palestinian Academic Society for the Study of International Affairs, 1997), 145.

2. The Druze are a monotheistic, esoteric, ethno-religious group that originated in Western Asia. They are now found primarily in Syria, Lebanon, and Israel, with small communities in Jordan and elsewhere.

3. For details, see Alexander Mikaberidze, *Atrocities, Massacres and War Crimes: An Encyclopaedia, Volume I* (California: ABC-CLEO, Library of Congress Catalogue, 2013), 545; Kimmerling, *Politicide*, 156–57; David Harb, *West Meets East: A Primer into the Israeli/Palestinian Conflict* (US: Xlibris Corporation, 2010); Human Rights Watch, "Israel: Ariel Sharon's Troubling Legacy: Evaded Prosecution Over Sabra and Shatilla Massacres," January 11, 2014, https://www.hrw.org/news/2014/01/11/israel-ariel-sharons-troubling-legacy.

CHRONOLOGY OF EVENTS IN PALESTINE

1. The following works were consulted when compiling this chronology of events in Palestine: Walid Khalidi, ed., *All That Remains: The Palestinian Villages Occupied and Depopulated by Israel in 1948*, (Washington, DC: Institute for Palestine Studies, 1992); Mahdi F. Abdul Hadi, ed., *Documents On Palestine, Volume I: From the Pre-Ottoman/Ottoman Period to the Prelude of the Madrid Middle East Peace Conference* (Jerusalem: Palestinian Academic Society for the Study of International Affairs, 1997); Said K. Aburish, *A Brutal Friendship: The West and the Arab Elite* (New York: St. Martin's Press, 1998); *PASSIA Diary 1999* (Jerusalem: Palestinian Academic Society for the Study of International Affairs, 1998); *PASSIA Diary 2001* (Jerusalem: Palestinian Academic Society for the Study of International Affairs, 2000); Ilan Pappe, *The Ethnic Cleansing of Palestine* (Oxford: Oneworld Publications, 2006); Rashid Khalidi, *The Iron Cage: The Story of the Palestinian Struggle for Statehood* (Boston: Beacon Press, 2006); Linda Butler, "A Gaza Chronology, 1948–2008," *Journal of Palestine Studies* 38, no. 3 (2009): 98–121, doi:10.1525/jps.2009.XXXVIII.3.98; "A Lot of

Process, No Peace: A Timeline of 20 Years of Post-Oslo Meetings, Agreements, Negotiations and Memorandums," *Perspectives: Political Analyses and Commentary from the Middle East & North Africa* 5 (December 2013), 5–8; Amira Hass, *Drinking the Sea at Gaza: Days and Nights in a Land Under Siege* (New York: Henry Holt and Company, 2014); *PASSIA Diary 2018* (Jerusalem: Palestinian Academic Society for the Study of International Affairs, 2017); "Palestine: What Has Been Happening Since WWI," *Al Jazeera*, May 14, 2018, https://www.aljazeera.com/focus/arabunity/2008/02/20085251908164329.html; Eóin Murray and James Mehigan (eds.), *Defending Hope: Dispatches from the Front Lines in Palestine and Israel*, (Dublin: Veritas Books, 2019); Chloé Benoist, "'The Deal that Can't be Made': A Timeline of the Trump Administration's Israel-Palestine Policy," *Middle East Eye*, January 28, 2020, https://www.middleeasteye.net/news/deal-cant-be-made-timeline-trump-administrations-israel-palestine-policy; Rashid Khalidi, *The Hundred Years' War on Palestine: A History of Settler Colonialism and Resistance, 1917–2017* (New York: Metropolitan Books, 2020).

Glossary

'Abaya: Long, loose covering open at the front, traditionally worn
by men, but recently has also come to mean a long, usually black
covering worn by women.

Abu: Father (of); generally used with the name of a man's firstborn
son rather than his first name; e.g., Abu Ahmad is the father of
Ahmad, his first son.

Al Mawasi: A one-kilometre wide area situated two kilometres
from Khan Younis that extends along the Gaza costal road for a
distance of twelve kilometres, from Dir Al-Balah to Khan Younis,
all the way to Rafah. Considered one of the most important
agricultural sectors in the Gaza Strip, as the residents depend on
agriculture as their only source of livelihood.

Al Muntar: The highest place in Gaza, north-east of Gaza City.

Arqila: Traditional Arab water pipe, also called *sheesha* or *narqila*.

Beik: *Beik* or *Bey* is a Turkish title, and traditionally referred to
leaders, rulers, or a man in a position commanding respect. It
follows the name and is used generally with first names and not
with last names. Used in modern Turkish language as a kind of
honorific after a man's first name, as a means of showing cour-
tesy and respect.

Burnous: A long, hooded robe.

Diwan (pl. dawaween): Traditional men's gathering place where the
mukhtar of the extended family solved disputes, and where male
guests were welcomed, ate, and slept.

Du'a': Central to Muslim life and refers to supplication. It is an act of worship, of remembering Allah and calling upon Him for help.

Dunum: Measurement of land used in Palestine, equal to 1,000 m² or 1/11 hectare.

'Eid: Feast.

'Eid al Adha: Feast of Sacrifice to commemorate Ibrahim's test of faith when he almost sacrificed his son Isma'il.

'Eid al Fitr: Feast to celebrate the end of the holy month of Ramadan.

'Eqal: The black cord tied around the *kofiyyah* or *hatta* to keep it in place.

Fedayeen (sing. Feda'i): Resistance fighters. In this book, *Fedayeen* refers to those who left their families and homes and were organized and trained and became wanted men, as opposed to villagers and citizens who organized themselves to defend their land against enemy attacks.

Hajj: Literally means pilgrimage. It is the fifth pillar of Islam, the annual pilgrimage to Mecca that Muslims are expected to make at least once in their lifetime. Also used as a title to refer to a Muslim person who has successfully performed the Hajj to Mecca, or as an honorific title for a respected elder man.

Hatta: Traditional Arab men's headdress; also called *kofiyyah*.

Hummus: Crushed chickpeas mixed with sesame paste, garlic, lemon juice, olive oil, and eaten with bread; a traditional dish of the people of *Sham*.

Intifada: Literally means shaking or shake off. The popular Palestinian uprising against the Israeli occupation, which started on December 9, 1987 and ended in 1993 with the signing of the Declaration of Principles. The second, or Al Aqsa, *Intifada* started in September 2000 and ended in 2006.

Jalabiya (pl. jalabiyaat): Traditional Arab men's dress of a long cotton gown.

Khan: (also caravanserai): A place where merchant caravans, or travellers and their animals rested overnight on their journey.

Sham: The Levant region, referring to the countries located along the eastern Mediterranean.

Maleem/Qersh: Small denominations of Palestinian currency; a *qersh* was equal to 1/100 Palestinian pound of the time (before the *Nakba* and the destruction of Palestine); *maleem* was 1/10 of a *qersh*.

Martyr (*Al Shahid* in Arabic): Refers to a person killed or who sacrificed their life for their country or for just causes.

Mulokhia: A type of mallow, the leaves of which are finely chopped and made into a popular Palestinian soup.

Muezzin: Muslim crier who proclaims the hours of prayer from the minaret of the mosque.

Mukhtar (pl. makhateer): Male head and decision-maker of an extended family or clan.

Nakba: The catastrophe, referring to the mass expulsion of Palestinian Arabs from British Mandate Palestine during Israel's creation between 1947 and 1949.

Qersh: See *Maleem*.

Piaster: Monetary unit (*qersh* in Arabic), equal to 1/100 of a Palestinian pound of the time (before the *Nakba* and the destruction of Palestine).

Ramadan: Islamic holy month, during which there is fasting during daylight hours and a meal at nightfall and before daybreak.

Sheikh: The title *Sheikh* is used to refer to Muslim scholars with a high level of Islamic knowledge and to those scholars who graduated from Al Azhar University.

Shabbat: Jewish sabbath.

Sham: During the Ottoman Empire, the people of Jordan, Palestine, Lebanon and Syria were known as the people of *Sham* (the Levant).

Shari'a: Islamic religious law.

Sharkas: Minority group in Jordan believed to be descended from Mamluks, who originally came from the Caucasus. They shared the same culture and language of the Ottoman Turks.

Shash (pl. shashat): Traditional Palestinian women's long head-dress, which covers the upper body to the waist. Sometimes twisted and tied at the waist of a *tawb* like a belt.

Sumud: Steadfastness.

Tawb (pl. tiab): Traditional Palestinian women's long embroidered gown with long sleeves. Each Palestinian village had a particular embroidery pattern that distinguished it and its people from other villages.

Tawjihi: Graduating or senior certificate from high school, the results of which determine whether the student is eligible for university study.

Um: Mother (of); generally used with the name of a woman's firstborn son rather than her first name; e.g., Um Ahmad is the mother of Ahmad, her first son.

Bibliography

Abdo, Nahla, and Nur Masalha, eds. *An Oral History of the*
Palestinian Nakba. London: Zed Books, 2018.

Abdul Hadi, Mahdi F. ed. *Documents on Palestine Volume I From the Pre-Ottoman/Ottoman Period to the Prelude of the Madrid Middle East Peace Conference*. Jerusalem: Palestinian Academic Society for the Study of International Affairs, 1997.

———. *Documents on Palestine, Volume II: From the Negotiations in Madrid to the Post-Hebron Agreement Period*. Jerusalem: Palestinian Academic Society for the Study of International Affairs, 1997.

Aburish, Said K. *A Brutal Friendship: The West and the Arab Elite*. New York: St. Martin's Press, 1998.

Abu Sharif, Bassam. *Arafat and the Dream of Palestine: An Insider's Account*. New York: Palgrave Macmillan, 2009.

Abu Sitta, Salman. "Gaza Strip: The Lessons of History." In *Gaza as Metaphor*, edited by Helga Tawil-Souri and Dina Matar. London: Hurst and Company, 2016.

———. "Gaza Strip: The Lessons of History." *Palestine Land Society*, 2016. http://www.plands.org/en/articles-speeches/articles/2016/gaza-strip-the-lessons-of-history.

———. *Mapping My Return: A Palestinian Memoir*. Cairo: The American University in Cairo Press, 2016.

Adler, Jonathan. "Remembering the Nakba: The Politics of Palestinian History." *Jadaliyya*, July 17, 2018. https://www.jadaliyya.com/Details/37786.

Ageel, Ghada, ed. *Apartheid in Palestine: Hard Laws and Harder Experiences*. Edmonton: University of Alberta Press, 2016.

———. "Gaza: Horror Beyond Belief." *Electronic Intifada*, May 16, 2004. https://electronicintifada.net/content/gaza-horror-beyond-belief/5078.

———. "Gaza Under Siege, The Conditions of Slavery." *Middle East Eye*, January 19, 2016. https://www.middleeasteye.net/opinion/gaza-under-siege-conditions-slavery.

———. "Where is Palestine's Martin Luther King?" *Middle East Eye*, June 26, 2018. https://www.middleeasteye.net/opinion/where-palestines-martin-luther-king-shot-or-jailed-israel.

Agha, Ihsan Khalil. *Khan Yunis wa shuhada'iha [Khan Younis Martyrs]*. Cairo: Markaz Fajr Publishing, 1997.

BADIL. *Survey of Palestinian Refugees and Internally Displaced Persons 2016-2018*, Vol. IX. Bethlehem, Palestine: BADIL Resource Center for Palestinian Residency & Refugee Rights, 2019. https://www.badil.org/en/publication/press-releases/90-2019/5013-pr-en-231019-55.html.

Barghouti, Mourid. *I Was Born There, I Was Born Here*. New York: Walker & Company, 2012.

Baroud, Ramzy. "For the Love of Egypt: When Besieged Palestinians Danced." *Global Research*, March 3, 2011. http://www.globalresearch.ca/for-the-love-of-egypt-when-besieged-palestinians-danced/24078.

———. "History from Below." PHD diss., Exeter University, United Kingdom, January 2015.

———. *My Father Was a Freedom Fighter: Gaza's Untold Story*. London: Pluto Press, 2010.

———, ed. *Searching Jenin: Eyewitness Accounts of the Israeli Invasion*. Seattle: Cune Press, 2003.

Bennet, James. "Arafat Not Present at Gaza Headquarters." *New York Times*, December 3, 2001. https://www.nytimes.com/2001/12/03/international/arafat-not-present-at-gaza-headquarters.html.

Benoist, Chloé. "'The Deal that Can't be Made': A Timeline of the Trump Administration's Israel-Palestine Policy." *Middle East Eye*, January 28, 2020. https://www.middleeasteye.net/news/deal-cant-be-made-timeline-trump-administrations-israel-palestine-policy.

Benvenisti, Meron. *Sacred Landscape: The Buried History of the Holy Land Since 1948*. Berkley: University of California Press, 2002.

Bulloch, John. *The Making of a War: The Middle East from 1967 to 1973*. London: Longman, 1974.

Butler, Linda. "A Gaza Chronology, 1948–2008." *Journal of Palestine Studies* 38, no. 3 (2009): 98–121. doi:10.1525/jps.2009.XXXVIII.3.98.

Canadians for Justice and Peace in the Middle East. "Israeli Colonies and Israeli Colonial Expansion." CJPME Factsheet Series No. 9, 2005. https://www.cjpme.org/fs_009.

Chaitin, Julia. "Oral History." *SAGE Encyclopedia of Qualitative Research Methods*. Accessed January 22, 2020. doi:10.4135/9781412963909.n301.

Cobban, Helena. "Roots of Resistance: The First Intifada in the Context of Palestinian History." *Mondoweiss*, December 17, 2012. https://mondoweiss.net/2012/12/roots-of-resistance-the-first-intifada-in-the-context-of-palestinian-history/.

Cohn, Martin. "An Israeli General Reopens Old Wounds with Revelations About the Massacre of Egyptian POWs." *Toronto Star*, October 8, 1995.

Curtiss, Richard H., and Donna B. Curtiss. "Israel's Hush-Up Machine in Action: Denying Story Israel Executed Egyptian Prisoners." *Washington Report on Middle East Affairs*, May–June 2007, 28–29.

Damen, Rawan. "Al Nakba." *Al Jazeera*. 2008. Documentary film.
https://interactive.aljazeera.com/aje/palestineremix/films_
main.html.

Darwish, Mahmoud. "Those Who Pass Between Fleeting Words."
Middle East Report 154, September/October 1988. https://merip.
org/1988/09/those-who-pass-between-fleeting-words/.

Deeb II, Dennis J. *Israel, Palestine, and the Quest for Middle East
Peace*. Maryland: University Press of America, 2013.

Dobson, Christopher. *Black September: Its Short, Violent History*.
New York: Macmillan, 1974.

Eilts, Hermann Frederick. "Reflections on Suez: Middle East
Security." In *Suez 1956: The Crisis and its Consequences*, edited
by William Roger Lewis and Roger Owen, 347-63. Oxford:
Clarendon Press, 1989.

El-Eini, Roza I.M. *Mandated Landscape: British Imperial Rule in
Palestine, 1929-1948*. London: Routledge, 2006.

El-Haddad, Laila. *Gaza Mom: Palestine, Politics, Parenting, and
Everything In Between*. Charlottesville, VA: Just World Books,
2010.

Fisk, Robert. *The Great War for Civilisation: The Conquest of the
Middle East*. London: Fourth Estate, 2005.

Gluck, Sherna Berger. "Oral History and al-Nakbah." *The Oral
History Review* 35, no. 1 (2008): 68-80.

Hahn, Peter L. *Caught in the Middle East: US Policy toward the Arab-
Israeli Conflict, 1945-1961*. Chapel Hill: University of North
Carolina Press, 2004.

Halbfinger, David M., Isabel Kershner, and Declan Walsh.
"Israel Kills Dozens at Gaza Strip as US Embassy Opens in
Jerusalem." *New York Times*, May 14, 2018. https://www.nytimes.
com/2018/05/14/world/middleeast/gaza-protests-palestinians-
us-embassy.html.

Harb, David. *West Meets East: A Primer into the Israeli/Palestinian
Conflict*. Bloomington, IN: Xlibris Corporation, 2010.

Hass, Amira. *Drinking the Sea at Gaza: Days and Nights in a Land Under Siege*. New York: Henry Holt and Company, 2014.

Hroub, Khaled. *Hamas: Political Thought and Practice*. Washington, DC: Institute for Palestine Studies, 2000.

Hughes, Matthew. *Britain's Pacification of Palestine: The British Army, the Colonial State, and the Arab Revolt, 1936-1939*. Military History Series. Cambridge: Cambridge University Press, 2019.

Human Rights Watch. "Israel: Ariel Sharon's Troubling Legacy: Evaded Prosecution Over Sabra and Shatilla Massacres." January 11, 2014. https://www.hrw.org/news/2014/10/11/israel-ariel-sharons-troubling-legacy.

Humphries, Isabelle, and Laleh Khalili. "Gender of Nakba Memory." In *Nakba: Palestine, 1948, and the Claims of Memory*, edited by Ahmad H. Sa'di and Lila Abu-Lughod, 207-28. New York: Columbia University Press, 2007.

Ibrahim, Youssef M. "Egypt Says Israelis Killed P.O.W.'s in '67 War." *New York Times*, September 21, 1995. http://www.nytimes.com/1995/09/21/world/egypt-says-israelis-killed-pow-s-in-67-war.html.

"Israel Declines to Study Rabin Tie to Beatings." *New York Times,* July 12, 1990. https://www.nytimes.com/1990/07/12/world/israel-declines-to-study-rabin-tie-to-beatings.html.

Jones, Peter M. "George Lefebvre and the Peasant Revolution: Fifty Years On." *French Historical Studies* 16, no. 3 (Spring, 1990): 645-63.

Karmi, Ghada. *In Search of Fatima: A Palestinian Story*. London: Verso, 2009.

——. "'The Worst Spot in Gaza': 'You Will Not Understand How Hard it is Here' Until You See This Checkpoint." *Salon*, May 31, 2015. https://www.salon.com/2015/05/31/the_worst_spot_in_gaza_you_will_not_understand_how_hard_it_is_here_until_you_see_this_checkpoint/.

Kassem, Fatma. *Palestinian Women: Narrative Histories and Gender Memory*. London: Zed Books, 2011.

Kassim, Anis F., ed. *The Palestine Yearbook of International Law, 1998-1999*, Volume 10. The Hague: Kluwer Law International, 2000.

Kayyali, 'Abd al-Wahhab. *Wathā 'iq al-Muqāwama al-Filastīniyya al-'Arabiyya did al-Ihtilāl al-Britānī wa al-Zioniyya, 1918-1939* [Documents of the Palestinian Arab Resistance against the British and Zionist Occupation]. Beirut: Institute for Palestine Studies, 1967.

Khalidi, Rashid. *The Hundred Years' War on Palestine: A History of Settler Colonialism and Resistance, 1917-2017*. New York: Metropolitan Books, 2020.

———. *The Iron Cage: The Story of the Palestinian Struggle for Statehood*. Boston: Beacon, 2006.

Khalidi, Walid, ed. *All That Remains: The Palestinian Villages Occupied and Depopulated by Israel in 1948*. Washington, DC: Institute for Palestine Studies, 1992.

———. *Before Their Diaspora: A Photographic History of the Palestinians, 1876-1948*. Washington, DC: Institute for Palestine Studies, 1984.

———, ed. *From Haven to Conquest: Readings in Zionism and the Palestine Problem Until 1948*. Washington DC: Institute for Palestine Studies, 1982.

Kimmerling, Baruch. *Politicide: Ariel Sharon's War Against the Palestinians*. London: Verso, 2003.

LeVine, Mark. "Tracing Gaza's Chaos to 1948." *Al Jazeera*, July 13, 2009. https://www.aljazeera.com/focus/arabunity/2008/02/2008525185737842919.html.

Lightman, Alan. "The Role of the Public Intellectual." *MIT Communications Forum*. http://web.mit.edu/comm-forum/legacy/papers/lightman.html.

"A Lot of Process, No Peace: A Timeline of 20 Years of Post-Oslo Meetings, Agreements, Negotiations and Memorandums." *Perspectives: Political Analyses and Commentary from the Middle East & North Africa*, 5 (December 2013): 5-8.

Louis, William Roger and Roger Owen, eds. *Suez 1956: The Crisis and its Consequences*. Oxford: Clarendon Press, 1989.

Macintyre, Donald. "By 2020, the UN Said Gaza Would be Unliveable. Did It Turn Out that Way?" *The Guardian*, December 28, 2019. https://www.theguardian.com/world/2019/dec/28/gaza-strip-202-unliveable-un-report-did-it-turn-out-that-way.

Magdy, Muhammed. "Egyptian Court Issues Verdict to Prosecute Israel." *Al-Monitor*, February 3, 2017. http://al-monitor.com/pulse/originals/2017/02/egypt-court-order-israel-soldiers-torture-wars-1.html.

Mikaberidze, Alexander, ed. *Atrocities, Massacres and War Crimes: An Encyclopaedia*. Volume I. California: ABC-CLEO, 2013.

Morris, Benny. *1948: A History of the First Arab–Israeli War*. London: Yale University Press, 2008.

———. *Israel's Border Wars, 1949–1956*. Oxford: Clarendon Press, 1993.

Murray, Eóin, and James Mehigan, eds. *Defending Hope: Dispatches from the Front Lines in Palestine and Israel*. Dublin: Veritas Books, 2018.

"Nakba's Oral History Interviews Listing." *PalestineRemembered*, March 31, 2004. https://www.palestineremembered.com/OralHistory/Interviews-Listing/Story1151.html.

Nimr, Sonia. "Fast Forward to the Past: A Look Into Palestinian Collective Memory." *Cahiers de Littérature Orale* no. 63–64 (January 2008): 338–49. doi:10.4000/clo.287.

Oral History Association. "Oral History: Defined." No date. https://www.oralhistory.org/about/do-oral-history/.

Oxfam. "Timeline: The Humanitarian Impact of the Gaza Blockade." No date. https://www.oxfam.org/en/timeline-humanitarian-impact-gaza-blockade.

"Palestine: What Has Been Happening Since WWI." *Al Jazeera*, May 14, 2018. https://www.aljazeera.com/focus/arabunity/2008/02/20085251908164329.html.

Palestinian Academic Society for the Study of International Affairs.
PASSIA Diary 1999. Jerusalem: PASSIA, 1998.

———. *PASSIA Diary 2001.* Jerusalem: PASSIA, 2000.

———. *PASSIA Diary 2018.* Jerusalem: PASSIA, 2017.

Pappe, Ilan. *The Ethnic Cleansing of Palestine.* Oxford: Oneworld
Publications, 2006.

———. *The Rise and Fall of a Palestinian Dynasty: The Husaynis,
1700–1948.* London: Saqi Books, 2010.

Quandt, William B., Fuad Jabber, and Ann Mosely Lesch. *The
Politics of Palestinian Nationalism.* Berkley: University of
California Press, 1973.

Rapoport, Meron. "Into the Valley of Death." *Haaretz,*
February 7, 2007. http://www.haaretz.com/israel-news/
into-the-valley-of-death-1.212390.

Roy, Sara. "The Gaza Strip: A Case of Economic De-Development."
Journal of Palestine Studies 17, no. 1 (Autumn, 1987): 56–88.

Sa'di, Ahmad H., and Lila Abu-Lughod. "Introduction: The Claims
of Memory." In *Nakba: Palestine, 1948, and the Claims of
Memory,* edited by Ahmad H. Sa'di and Lila Abu-Lughod, 1–24.
New York: Columbia University Press, 2007.

Said, Edward W. *Covering Islam: How the Media and the Experts
Determine How We See the Rest of the World.* New York: Pantheon
Books, 1981.

———. "On Palestinian Identity: A Conversation with Salman
Rushdie (1986)." In *The Politics of Dispossession: The Struggle for
Palestinian Self Determination, 1969–1994.* New York: Pantheon
Books, 1994.

———. "Permission to Narrate." *Journal of Palestine Studies* 13, no. 3
(Spring, 1984): 27–48.

Sayigh, Rosemary. "Oral History, Colonialist Dispossession, and
the State: the Palestinian Case." *Settler Colonial Studies* 5, no. 3
(2015): 193–204.

———. "Palestinian Camp Women as Tellers of History." *Journal of
Palestine Studies,* 27, no. 2 (Winter, 1998): 42–58.

———. *The Palestinians: From Peasants to Revolutionaries*. London: Zed Books, 1979.

———. "Voices: Palestinian Women Narrate Displacement." *Al-Mashriq*, 2005/2007. https://almashriq.hiof.no/ palestine/300/301/voices.

Sāyigh, Yazīd. *Armed Struggle and the Search for State: The Palestinian National Movement, 1949–1993*. Washington, DC: Institute for Palestine Studies, 1997.

Sherman, A.J. *Mandate Days: British Lives in Palestine, 1918–1948*. Baltimore: John Hopkins University Press, 2001.

Shlaim, Avi. "Background and Context." *Journal of Palestine Studies* 38, no. 3 (Spring 2009): 223–39. doi:10.1525/jps.2009. xxxviii.3.223. Also published as "How Israel Brought Gaza to the Brink of Humanitarian Catastrophe." *The Guardian*, January 7, 2009. https://www.theguardian.com/world/2009/jan/07/ gaza-israel-palestine.

Shwaikh, Malaka Mohammad. "Gaza Remembers: Narratives of Displacement in Gaza's Oral History." In *An Oral History of the Palestinian Nakba*, edited by Nahla Abdo and Nur Masalha, 277–93. London: Zed Books, 2018.

Tahhan, Zena. "The Naksa: How Israel Occupied the Whole of Palestine in 1967." *Al Jazeera*, June 4, 2018. https://www. aljazeera.com/indepth/features/2017/06/50-years-israeli- occupation-longest-modern-history-170604111317533.html.

Tessler, Mark. *A History of the Israeli-Palestinian Conflict*. 2nd ed. Bloomington: Indiana University Press, 2009.

Thomson, Alistair. "Four Paradigm Transformations in Oral History." *The Oral History Review* 34, no. 1 (2007): 49–70.

———. "Memory and Remembering in Oral History." In *The Oxford Handbook of Oral History* edited by Donald A. Ritchie, 77–95. Oxford: Oxford University Press, 2010.

Thomson, Alistair, and Robert Perks. *The Oral History Reader*. New York: Routledge, 1998.

Thompson, Paul. *The Voice of the Past: Oral History*. Oxford: Oxford University Press, 1978.

Trew, Bel. "The UN Said Gaza Would be Uninhabitable by 2020—In Truth, it Already Is." *The Independent*, December 29, 2019. https://www.independent.co.uk/voices/israel-palestine-gaza-hamas-protests-hospitals-who-un-a9263406.html.

Wichhart, Stefanie. "The 1915 Locust Plague in Palestine." *Jerusalem Quarterly* 56 & 57 (2013), 29–39. https://www.palestine-studies.org/sites/default/files/jq-articles/JQ%2056-57%20The%201915%20Locust.pdf.

United Nations. *Gaza in 2020: A Liveable Place?* August 2012. https://www.unrwa.org/userfiles/file/publications/gaza/Gaza%20in%202020.pdf.

United Nations High Commissioner for Refugees. *The State of the World's Refugees 2006: Human Displacement in the New Millennium*. April 20, 2006. https://www.unhcr.org/publications/sowr/4a4dc1a89/state-worlds-refugees-2006-human-displacement-new-millennium.html.

United Nations Office of the High Commissioner for Human Rights. *The UN Independent Commission of Inquiry on the 2018 Gaza Protests*. February 28, 2019. https://www.ohchr.org/EN/NewsEvents/Pages/DisplayNews.aspx?NewsID=24226&LangID=E.

United Nations Relief and Works Agency for Palestine Refugees in the Near East. "Where We Work, Gaza Strip." No date. https://www.unrwa.org/where-we-work/gaza-strip.

"World Bank Warns, Gaza Economy is 'Collapsing.'" *Al Jazeera*, September 25, 2016. https://www.aljazeera.com/news/2018/09/world-bank-warns-gaza-economy-collapsing-180925085246106.html.